LENDERS
TO THE
EXHIBITION

Anonymous
Boston Athenaeum
Cincinnati Art Museum
The Cleveland Museum of Art
Eric Denker and Wendy Livingston
Essex Institute, Salem, Massachusetts
Peter Hastings Falk
High Museum of Art
The Library of Congress
Museum of Fine Arts, Boston
National Museum of American Art, Smithsonian
 Institution
National Museum of American History, Smithsonian
 Institution
The New York Public Library
The Parrish Art Museum, Southampton, New York
Pennsylvania Academy of the Fine Arts
Philadelphia Museum of Art
Roger Genser–The Prints and the Pauper
Rona Schneider
Smith College, Northampton, Massachusetts
Syracuse University Art Collection
Worcester Art Museum

SPONSORS
OF THE
CATALOGUE

Mary Blackwell Alexander, *The Ritz-Carlton, Buckhead*
Spring Asher, *Chambers & Asher*
Barbara B. Balser, *Management Compensation Group*
Beverly Hart Bremer, *Beverly Bremer Silver Shop*
Lucinda W. Bunnen
Wicke Chambers, *Chambers & Asher*
Lily Grace M. Dozier, *Atlanta Women's News*
Cathy S. Fine
Fay Gold, *Fay Gold Gallery*
Sally S. McDaniel
Margaret B. Perdue
Harriet Sanford, *City of Atlanta Bureau of Cultural Affairs*
Judy N. Tabb, *Carr, Tabb & Pope*
Roz White

TOUR ITINERARY

The Woodmere Art Museum	June 11, 1988, to August 21, 1988
The Hudson River Museum of Westchester	October 30, 1988, to February 12, 1989
National Museum of American History, Smithsonian Institution	March 15, 1989, to May 31, 1989

Copyright 1988 High Museum of Art
All rights reserved
Published by the High Museum of Art
Atlanta, Georgia

Edited by Kelly Morris and Amanda Woods
Designed by Jim Zambounis
Type set by Katherine Gunn
Printed by Williams Printing, Atlanta

ISBN 0-939802-45-7

PHOTO CREDITS

High Museum of Art: cover, pages 8, 22, 28, 32; Rona Schneider: pages 9, 30, 34; National Museum of American History, Smithsonian Institution: pages 10, 14; Syracuse University Art Collection: page 11; Museum of Fine Arts, Boston: pages 12, 13, 18, 20, 24, 25; Cincinnati Art Museum: page 15; Library of Congress: pages 16, 20, 29; The New York Public Library: pages 17, 21, 22, 27, 36; Sophia Smith Collection, Smith College: page 17; Eric Denker and Wendy Livingston: pages 19, 24, 31; Boston Athenaeum: page 19; National Academy of Design, New York City: page 19; The Grunwald Center for the Graphic Arts, Wight Art Gallery, U.C.L.A.: page 21; Peter Hastings Falk: pages 24, 30; Pennsylvania Academy of the Fine Arts: pages 24, 26; The Parrish Art Museum: pages 26, 36; Worcester Art Museum: page 28; East Hampton Free Library: page 32; National Museum of American Art, Smithsonian Institution: page 33; © 1987 The Art Institute of Chicago: page 35; Roger Genser–The Prints and the Pauper: page 37.

Cover illustration: 100. Mary Nimmo Moran, *'Tween the Gloaming and the Mirk When the Kye Come Hame*

American Women of the Etching Revival

Phyllis Peet

February 9 - May 9, 1988

High Museum of Art
Atlanta, Georgia

PREFACE

In celebration of the hundredth anniversary of two landmark exhibitions of women etchers in Boston and New York, the High Museum of Art pays tribute to the artists in *American Women of the Etching Revival*. I would like to thank our guest curator, Phyllis Peet, who has done groundbreaking research on a topic which has long been kept in the dark. Etching, a demanding process, was assumed to have been the domain of male printmakers, with only a few exceptions. Peet dispels that myth, identifying at least seventy women who pursued etching, many earning their living in that field. These women artists often studied printmaking in the same schools and academies as men and frequently showed their work in the same exhibitions. It is revealing that their work was included in many published portfolios of etching.

In the last ten years, art historians have rediscovered the names of many women artists who were active in the eighteenth and nineteenth centuries in America. In this catalogue, Phyllis Peet provides new biographical information on thirty-five women etchers and places them in the context of the Etching Revival in America.

We are grateful to Phyllis Peet for her painstaking work in organizing this exhibition and producing the manuscript for the catalogue. Also, I want to thank Spring Asher and Wicke Chambers, who solicited the funds for the catalogue from Atlanta businesswomen and other community leaders. To each of them a special thanks.

Gudmund Vigtel
Director

FOREWORD

Before 1877, most American artists considered etching suitable for reproducing paintings but not a proper medium for creating original art. This attitude changed radically during the last two decades of the nineteenth century, when, inspired by English and French etching, American men and women artists produced thousands of original prints which kept publishers, dealers, and collectors in a frenzy of activity. This era is generally referred to as "the Etching Revival."

Probably the most enticing quality of etching is its freedom of line. During the Etching Revival, artists experimented with tools and materials, creating unusual effects which enhanced the picturesque landscapes and evocative figure studies which were popular subjects.

Etching clubs in major American cities gave artists the opportunity to exhibit their works. Sylvester Rosa Koehler, curator at the Museum of Fine Arts in Boston, was an enthusiastic supporter of American etchers, often showing their works at the Boston Museum. His exhibition *Women Etchers of America* in 1887 was a milestone, for it was the first exhibition devoted exclusively to women's work to be held in an art museum. The exhibition included 413 etchings by twenty-five artists. The response was so favorable that the Union League Club in New York recreated the exhibition, under the same title, the following year, adding about 100 works by eleven additional women artists.

American Women of the Etching Revival celebrates the centennial anniversary of these two exhibitions. It is impossible to recreate either exhibition because many of the works by these women etchers can no longer be found in private or public collections. We have included many of the prints which were in the original exhibitions, and have added prints made at a later date. We located prints by twenty-one of the thirty-five artists who were in the historic New York exhibition. Louise Prescott Canby, Florence May Esté, Katherine Levin Farrell, Mary Cummings Brown Hatch, and Gertrude Rummel Hurlbut are represented by only one or two prints, the only etchings we could locate.

Phyllis Peet has done a thorough job of researching the social and cultural conditions of women artists in the nineteenth century. She has gone back to primary sources, locating letters and diaries of these women artists, corresponding with descendants, scouring the archives of institutions where these women studied, and surveying the exhibition catalogues of the period to reveal the high percentage of women showing their works in institutions, expositions, and clubs. This is a kind of primary research that is needed in the evolution of a feminist perspective of art history. It is important that exhibitions of women artists be done so that art historians will better under-

stand the lives and works of women artists. Once this foundation is laid, art historians will know the art and culture of the past and present more fully, and women will be included in all exhibitions.

I applaud the women who funded the publication of the catalogue. The feminist viewpoint of art history has only been explored and written about over the last fifteen years, and publications like this one will further that work.

It is fitting that this centennial observance should originate in Atlanta. As early as 1895, Atlanta recognized women in the arts in the Cotton States Exposition, a world's fair which included a Woman's Building where female artists exhibited their artwork. This year, to commemorate the two hundredth anniversary of the United States Constitution in 1987-88, Atlanta will host a conference entitled *Women and the Constitution: a Bicentennial Perspective* at the Jimmy Carter Library. Distinguished women leaders will discuss the legal and political status of women from 1787 to the present. The topics of the 1988 conference—the politics of exclusion and women's rights—are variations of the same issues women faced in the nineteenth century. The women of the American Etching Revival sought to reach beyond these issues, and redefine "a woman's proper sphere."

Judy L. Larson
Curator of American Art

5

ACKNOWLEDGEMENTS

This exhibition of American women artists of the Etching Revival has grown out of my work on women printmakers of the nineteenth century. Judy Larson, Curator of American Art at the High Museum of Art, who supported and encouraged me while I wrote my doctoral dissertation, suggested the idea for the exhibition and has been tirelessly committed to organizing it and to arranging for showings at other museums. I want to express my special thanks to Gudmund Vigtel, Director of the High Museum, whose enthusiasm and support for the project have made it a most pleasant and rewarding task.

The staff of the High Museum has been exceptionally energetic and efficient in preparing the exhibition, especially Jackie Benson, Assistant to the Curator of American Art, who saw to details of both exhibition and catalogue, acquired the photographs, and proofread the manuscript and checklist; Liz Lane, Researcher, who organized the search for etchings and for institutions to share the exhibition; Kelly Morris, Editor, and Amanda Woods, Assistant Editor, who edited the manuscript and coordinated the catalogue's publication; Jim Zambounis, who designed the catalogue; Marjorie Harvey, Manager of Exhibitions, who coordinated the traveling tour and offered valuable suggestions in the installation at the High Museum; and Frances Francis, Registrar, who coordinated the loans. And my sincere thanks go to Wicke Chambers and Spring Asher, who, along with Margaret Denny and Donna Dacus of the High Museum Development Department, undertook the task of raising funds for the catalogue. I am also deeply grateful to each of the women who made a substantial donation toward the publication of the catalogue.

My advisor at U.C.L.A., Professor E. Maurice Bloch, has strongly supported and encouraged my interest in and research on the role of women in the visual arts, and I am very grateful to him. I am also indebted to the individuals and institutions from whom I have received generous assistance over the past six years. For the women etchers project I want specifically to acknowledge the help and camaraderie of Betty Blum, Eric Denker, Peter Hastings Falk, Roger Genser, William D. Hoyt, Nancy Mowll Mathews, Kaycee Benton Parra, and Rona Schneider, all of whom share my interest in the history of women printmakers. I also want to thank Sally Pierce of the Boston Athenaeum, Marcy Silver of the Museum and Library of Maryland History, Georgeanna Linthicum of the Baltimore Museum, Sue Reed of the Museum of Fine Arts, Boston, Kristin L. Spangenberg of the Cincinnati Art Museum, Kathleen Jacklin of Cornell University, Dorothy L. King of the East Hampton Free Library, Robert Weis of the Essex Institute, Carol Pulin and Bernard Reilly of the Library of Congress, Abbey Terronnes of the National Museum of American Art, Helena Wright of the National Museum of American History, Roberta Waddell of The New York Public Library, Michael Schantz of the Woodmere Art Museum, Stephanie Stit of the National Museum of Women in the Arts, Maureen O'Brien and Christine Engel of the Parrish Art Museum, Susan L. Boone of the Sophia Smith Collection, Smith College, Lisa N. Peters of the Spanierman Gallery, David Prince of Syracuse University, and David Acton of the Worcester Art Museum.

I owe a special gratitude to Joan Hodgson, Betty Rentz, and the reference librarians at the University of California at Santa Cruz, librarians Marnell Hillman and Peter Warshaw of Cabrillo College and the staff of the Santa Cruz Public Library for their expert and gracious assistance.

I especially want to thank my husband, Charles Peet, for his devoted support and editorial advice and assistance in completing this project.

Phyllis Peet
Guest Curator

CONTENTS

Most illustrations show prints with margins cropped.

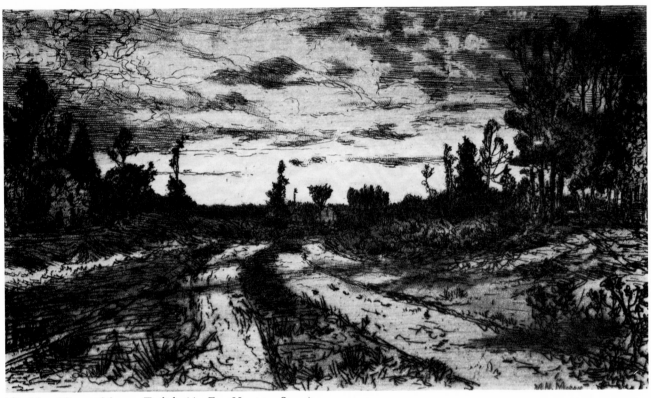

101. Mary Nimmo Moran, *Twilight (An East Hampton Scene)*

AMERICAN WOMEN OF THE ETCHING REVIVAL

When the announcement was made that a special exhibition of the work of the women etchers of America would be held at the Museum of Fine Arts, a good many people must have been surprised to think that there could be enough of that sort of thing to make an exhibition of. Their wonder at it will not be less when they see two rooms full of etchings and learn that the oldest of the lot does not date farther back than 1869. The exhibition, which opens today, to continue two months, is made up of no less than 388 numbers. It has the distinction of being the first exhibition of the kind ever held.[1]

Boston Transcript, November 1887

The *Women Etchers of America* exhibition opened at Boston's Museum of Fine Arts on November 1, 1887. In addition to the 388 etchings by twenty-three artists listed in the catalogue, the exhibition included twenty-four unlisted prints by Mary Cassatt which arrived too late to be entered in the catalogue. This was the first time that Cassatt's etchings, drypoints, and aquatints were exhibited in the United States. An etching by Mrs. Lucia Gray Swett Alexander also was added after the catalogue went to press. The following year an enlarged version of the show, which included 509 etchings by thirty-five artists, was held at the Union League Club in New York.

Women Etchers of America was the first comprehensive exhibition of the work of women artists by an American art institution.[2] Organized by Sylvester Rosa Koehler, curator of prints for the Boston Museum and the most energetic proponent of etching in America, it drew attention to two remarkable developments: a large number of American women had become professional artists, and they had produced a sufficient quantity of notable work to earn institutional acknowledgement.

An early indirect achievement of the American women's movement, the exhibition documented many professional women etchers for the first time. But when the Boston Museum exhibited women's art separately from men's, it established a precedent for art institutions which is still controversial. Several of the women etchers, including Mary Cassatt, were opposed to segregating women's art, and their attitudes continue to inform the debate today which has centered around the new National Museum of Women in the Arts in Washington, D.C.

Since 1850 thousands of American women had entered printmaking professions. Their success had contributed substantially to society's acceptance of art as a career for women and made inevitable the involvement of American women painters in the Etching Revival of the 1880s. However, producing art outside the home did not become an acceptable occupation for women until social reformers, responding to industrial

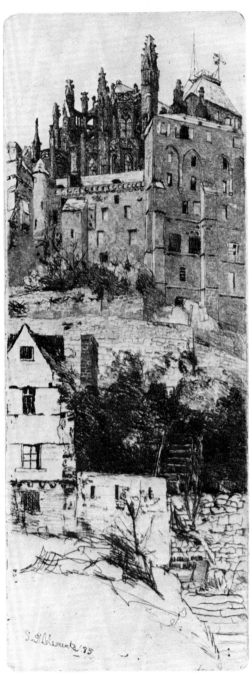

33. Gabrielle DeVaux Clements, *Up the Steps, Mont St. Michel*

9

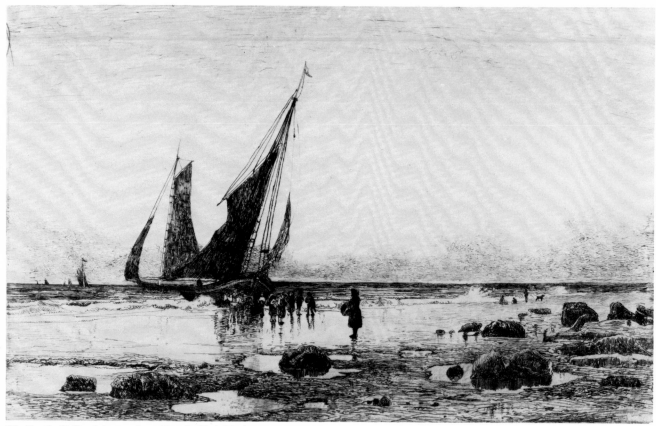

88. Emily Kelley Moran, *Long Beach, York Harbor, Maine*

needs and catering to the proprieties which dictated how and where a woman could work, organized, beginning in 1848, schools of design to train the many single, "superfluous" women who had been displaced by industrialization from traditional jobs. To exploit the burgeoning publishing industry's early demand for wood engravers and lithographers and the later need for photographers, the philanthropic founders of these schools, by the early 1850s, had instituted training in printmaking, along with drawing and designing, for middle-class women who needed to be self-supporting. The achievements of the schools and their graduates stimulated the emergence of professional women artists in all fields of art by the late nineteenth century. Etching was particularly attractive to women because of the recent success of women wood engravers and lithographers and because of its varied possibilities as an expressive medium.

Most women who became professional artists chose to observe the social proprieties. They usually practiced as modestly and privately as they could and were far less visible to the public than their male colleagues. For instance, Emily Kelley Moran, one of the first women to experiment with etching in the 1870s, exhibited her etchings relatively few times. She received little notice from art reviewers or the public, preferring, as was explained by Frances Benson in 1893, to observe "women's proper sphere":

> Peter Moran's wife was one of his best students, but has always been reluctant to enter the public lists. She has done a large number of etchings, noticeable for boldness of line and picturesque effects, but it has been more to keep in touch with her husband than to acquire fame or fortune.[3]

The *Women Etchers of America* exhibition was designed to show as many etchings by women artists as possible. Koehler wrote in his essay for the Boston exhibition's catalogue that the women etchers exhibit had not been juried and that all the works sent to the Museum had been hung. In an 1895 article in the *Philadelphia Press*, painter-etcher Blanche Dillaye criticized Koehler for allowing the public to see the beginning efforts of the women etchers:

> Admirable work surprised and impressed the public with its artistic instinct, its sincerity of purpose, its feeling for the value of line. At the same time the exhibition was unfair through too liberal an acceptance of experimental plates, which should be relegated to the obscurity of early struggles. Power and capacity should be judged by the height we are able to reach in our best and most lofty moments.[4]

Though Koehler had shown "first attempts" in organizing another landmark exhibition for the Boston Museum, the 1881 *Exhibition of American Etchings*, which had heralded the advent of the Etching Revival in the United States, Dillaye

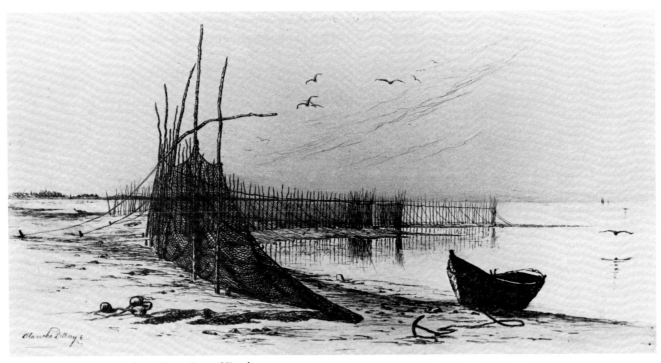

34. Blanche Dillaye, *Fishing Weirs, Bay of Fundy*

was concerned that women's etchings might be judged inferior to men's if the documentary style of the women etchers exhibition was misunderstood.

Koehler pointed out that some artists who had been invited to send etchings to the exhibition had chosen not to participate. In her *Philadelphia Press* article on women etchers Dillaye implied that many artists had not participated in the women etchers exhibition because they had observed "women's proper sphere":

There are many other Philadelphia women whose names should be equally associated with the art, but that the spirit of modesty and retirement which seems to be in the air of the Quaker City has restrained them from exhibiting.[5]

She also noted that there were "others who have been overlooked simply from ignorance of their existence."[6]

In the enlarged New York exhibition the following year Cassatt and Alexander as well as eleven other artists were added to the new catalogue together with an essay by art critic Mariana G. van Rensselaer. The Alexander etching had been drawn from the Boston Museum's collection, and the twenty-four Cassatt etchings, aquatints, and drypoints were lent by New York collector and dealer Samuel P. Avery. Only one woman listed in the New York catalogue, Sarah Cole, was not a contemporary etcher. A landscape painter and the sister of

landscape painter Thomas Cole (1801-1848), she is considered to be the first woman etcher in America. However, the four etchings by her listed in the catalogue as "Proofs of plates etched in 1844" did not appear in the show because the owner of the plates, painter and etcher John M. Falconer (1820-1903), did not provide impressions from them.[7]

In her introduction to the catalogue, van Rensselaer noted that "no artist who was appealed to failed to answer as desired" and described the Union League Club's unjuried approach—which was similar to Koehler's—to organizing the show:

It has not been gathered in any critical spirit. The desire has been to reveal what the women etchers of America have accomplished—not what, in the belief of any judge, is the best they have accomplished. It was felt that a broadly inclusive collection, one as nearly complete as time and pains could make it, would be the most interesting to the public that could possibly be formed; and it was likewise felt that it was but right that a class of workers who had shown such energy in treading a newly opened path should be allowed to say—as many individuals as possible, and each individual as fully as she saw fit—in what manner and to what degree they had achieved success. Every artist whose name could be discovered was therefore asked to send all the works which she was willing to exhibit; and all that have been received have been catalogued with the dates of their execution as furnished by their makers, and placed on exhibition.[8]

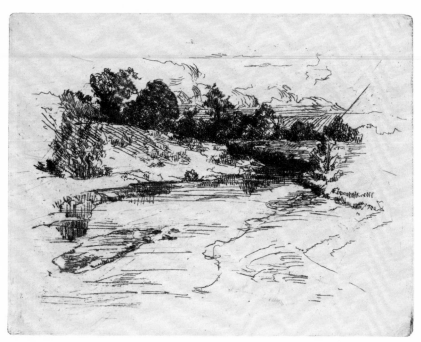

116. Martha Scudder Twachtman, *A Ruin on Mill Creek, Cincinnati*

WOMEN AS PROFESSIONAL ARTISTS

Women artists had been entering their etchings in exhibitions since 1880 (Eliza Greatorex, since 1868) but had received relatively little publicity. Sylvester Koehler had included eight women in his 1881 *Exhibition of American Etchings* at the Boston Museum of Fine Arts. Mary Nimmo Moran, Eliza Greatorex, and Anna Lea Merritt had exhibited in the New York Etching Club's first exhibitions in 1880, and etchings by women, sometimes as many as eleven women, had been included in each of its subsequent exhibitions. Yet only Mary Nimmo Moran and Edith Loring Peirce Getchell were ever elected members.

Discouraged because the art world usually denied the seriousness of their professionalism and continued to place and judge them separately, many women did not enter competitions for exhibition opportunities. Even those women who did exhibit acquiesced to the demand for a low profile.

The public, and many in the art world, held the belief that women were strictly amateur artists. As late as the 1880s, very few women professional artists had been acknowledged by the communications media and the art establishment. Most artists who had received publicity for their work were women like Queen Victoria who were prominent for other reasons. In both Europe and America it was thought that women artists were dilettantes who made art for pleasure only. With few exceptions, however, only the nobility and the wealthy had the luxury of time to practice as amateurs. It has become clear during the past ten years that in fact for centuries many European and American women earned their livings and often supported families as artists.

Though van Rensselaer in her introduction to the 1888 catalogue declared that "woman's work need no longer be tested in any condescending mood," her opening statement is condescending, contributing to the assumption that all nineteenth-century women artists were amateurs:

> A peculiar degree of interest attaches to the work of women in the arts—it is so short a time since they entered the lists as genuine workers, displayed more than the passing enthusiasm and feeble accomplishment of the *dilettante*, and showed their wish and established their right to be judged in the same temper and by the same standards as their brethren.[9]

Koehler's catalogue for the women etchers exhibition acknowledged earlier European women printmakers and distinguished between those who had worked for a living and those who had had leisure time to etch. He pointed out that etching was being mistaken as a pastime "fit for the amateur":

> It is significant, furthermore, that of the one hundred and fourteen European etchers enumerated in the interesting catalogue of designs, engravings, etc., executed by women, issued some years ago by Messrs. Frederick Muller & Co., of Amsterdam, nearly one third are titled women,—among them Madame de Pompadour, Queen Christina of Sweden, the wives of Frederick the Great, and of the Emperor Joseph II., three Austrian arch-duchesses, and Queen Victoria,—who evidently filled their elegant leisure by toying with the point in the belief, too prevalent even to-day, that etching is an easy accomplishment, fit for the amateur.[10]

Except for a few women of prosperous families, American women had not often had leisure to practice art as a pastime even when their education had included drawing or painting lessons. Dilettantism was fashionable later in the century among upper-class women who indulged in art as a hobby, but

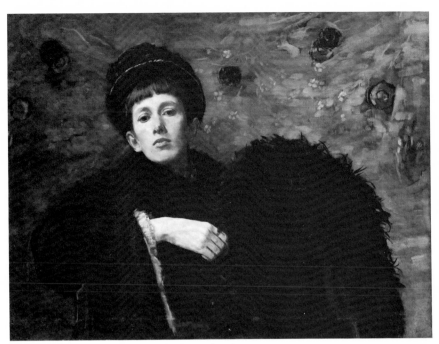

Ellen Day Hale, *Self-Portrait in Oil*, 1885, oil on canvas,
Museum of Fine Arts, Boston.

the notion that all women artists were amateurs obscured and
denigrated the professionalism of American women artists,
including printmakers, who had substantially increased in
number during the nineteenth century.

Seymour Haden in England, Milton Yale (one of the
founders of the New York Etching Club), and Daniel S. Young
(a founder of the Cincinnati Etching Club) were physicians,
and although they were occasionally referred to as amateurs
because they did not earn their livings by art, they were taken
seriously as artists and treated as art professionals. Yet women's
work in etching, comparable in intent and quality, was not
accorded the same recognition and respect. Women were
discouraged from participating and competing in professional
art activities, and critics, dealers, and museum people did not
regard their work as professional and therefore did not consider
it seriously.

Many of the artists who exhibited with the *Women Etchers of
America* were trying to earn their livings by art. Most had
formal training, had participated in exhibitions, organiza-
tions, and the camaraderie of the art world, and were seriously
committed to winning acknowledgement as professional
painters and etchers.

In contrast to the thirty-five women etchers catalogued by
their contemporaries in the 1888 version of the *Women Etchers
of America* exhibition, I have found over seventy American
women who, during the 1880s and 1890s, had training in
etching and considered etching part of their professional work.
I am sure there were many more. Of those seventy women, all
of whom were also painters, at least fifty were single and were
trying to earn their livings as artists during the time they were
practicing etching. Of those who are known to have married,
at least ten did so after beginning their professional careers as

artists.[11] Only two, Martha Scudder Twachtman and May
Electa Ferris Smith, did not pursue art as a career after
marriage, though Scudder Twachtman continued on a more
casual basis.

While Sylvester Koehler's effort on behalf of women may be
seen as a progressive gesture of recognition and encourage-
ment, its effect may have been to relegate women to a separate
social and economic sphere. In organizing the *Women Etchers
of America* exhibition in 1887, Koehler followed the precedent
of the Women's Pavilion at the 1876 Centennial. By segregat-
ing women's art, he reinforced the ideology of a separate sphere
for women in art just as their work was flooding the market.

The next year (1888) Koehler listed as a single entry all the
prints by women which he had selected to send to the Ohio
Valley Centennial Exposition for the Graphic Arts Section of
the National Museum in Washington, D.C. (now the National
Museum of American History, Smithsonian Institution). The
etchings by men were listed in the catalogue individually, by
artist, but women's etchings were entered in the catalogue as
"Frames 85 to 94 contain(ing) etchings by some of the leading
women etchers of America, of whom there are quite a num-
ber," followed by a list of their names.[12] Far from feeling
slighted, Ellen Day Hale wrote to Koehler at the time of the
Ohio exhibition that as a result of her etchings having been
shown in his exhibitions she had "attained the glory of having
a pupil in etching."[13] In a second letter she expressed to him
her appreciation for what he was doing for women etchers:

> I should think you would feel very much gratified by the success
> the exhibition of Women's Etching has had in its various
> forms. I must say, it far surpassed my expectation, and I feel
> that we are under great obligations to you for it.[14]

43. Margaret M. Taylor Fox, *The Cove*

ART TRAINING FOR WOMEN ETCHERS

The many women painters who during the Etching Revival made etching part of their professional careers are representative of the thousands of middle-class women who became printmakers—wood engravers, lithographers, and photographers as well as etchers—in the second half of the nineteenth century. In 1848, Sarah Worthington King Peter (1800-1877), an American philanthropist who in 1846 had founded a home for destitute women who had turned to prostitution, established the Philadelphia School of Design for Women to train women who needed to earn a living. Within a year of its opening, the School of Design added wood engraving and lithography to its curriculum. As schools of design were established in other cities, so were printmaking courses. When etching became popular in the late 1870s and early 1880s, courses in etching were organized.

Peter Moran (1841-1914), who had been teaching landscape painting at the Philadelphia School of Design for Women since 1874, taught an etching class for many years at the School after the 1882-83 exhibition of the Philadelphia Society of Etchers. His students, among whom were Louise Prescott Canby and Margaret M. Taylor (Fox), had become interested in etching as a result of the exhibition and an accompanying lecture by visiting British etcher Francis Seymour Haden (1818-1910).

The School of Design had a work-study program which allowed students to use its studio space even after graduation.

Taylor entered the School in 1880, and continued to work and take classes there after she had graduated. While at the School in 1884 she was commissioned by the Philadelphia Art Union to etch *The Pasture Land* (catalogue no. 45) for distribution to its members. She also produced six plates to illustrate Oliver Goldsmith's *The Deserted Village* (Philadelphia: J. B. Lippincott Co., 1888). Taylor took classes and used the School as a professional base until 1892-93, when she married and continued her career in the Maryland-Washington, D.C. area.

In 1878 Louise Féry (b. 1848), a French immigrant who had exhibited several times in the Paris Salon, taught etching for the Ladies' Art Association in New York. In 1881 the Art Association hired Thomas Moran (1837-1926) to teach the class. At the Western Reserve School of Design for Women, founded in 1882 and probably the first women's art school to include men (there were ten men and sixty-five women enrolled in 1884-85), R. Spencer Gray taught etching. The coeducational McMicken School of Design (Cincinnati Art Academy) did not offer an etching class until 1890, when it was taught by former student Lewis Henry Meakin (1850-1917).

The Chicago Academy of Fine Arts (now the Art Institute of Chicago), where approximately two-thirds of the students were women, offered etching in 1879 within six months of its opening. John H. Vanderpoel (1857-1911) taught etching, and etchers Annie C. Shaw and Alice D. Kellogg Tyler (1866-1900) taught drawing and painting. Virgil Williams (1830-1886) taught etching at the California School of Design

(now the San Francisco Art Institute). He and a student, Evelyn (Eva) Almond Withrow (1858-1928), sent etchings to Koehler's 1881 *Exhibition of American Etchings*. Neither the National Academy of Design nor the Art Students' League in New York offered etching until the spring of 1894, when James D. Smillie (1833-1909) volunteered to teach a course in the hope that it would revive interest in etching.[15] The course was not resumed after the summer break, but Smillie established an etching class at the National Academy in 1898. Charles Frederick William Mielatz (1864-1919) took over the class in 1904, when etcher Anne Wilson Goldthwaite (1869-1944) was a student.

Some liberal arts colleges like Smith, a woman's school, and the coeducational schools of fine art at Syracuse and Yale Universities included etching in their art curricula in the 1880s. John Henry Niemeyer (1839-1932), who had exhibited in the 1881 Boston etching show, traveled between Yale in New Haven, Connecticut, and Smith College in Northampton, Massachusetts, to teach etching in both art departments.

Unlike wood engraving and lithography, in which the training was almost always institutionalized for women, etching could be learned both inside and outside the classroom. In Cincinnati an etching club formed in 1879 was, in effect, the city's etching school. Mary Louise McLaughlin, Martha Scudder (who married John H. Twachtman), Clara Fletcher (active in the 1870s and 1880s), and Caroline Lord (1860-1927) learned to etch with other club members, including Meakin, Henry F. Farny (1847-1916), and John H.

Twachtman (1853-1902).

The 1882-83 Philadelphia Society of Etchers exhibition and Seymour Haden's lecture on etching also inspired the Philadelphia Sketch Club, whose members included Stephen Parrish (1846-1938), Peter Moran, and Edith Loring Peirce (Getchell), to initiate an etching class in its quarters on February 20, 1883. Late that year, Stephen Parrish invited five former students of Thomas Eakins (1844-1916) at the Pennsylvania Academy of the Fine Arts–Gabrielle Clements, Blanche Dillaye, Edith Loring Peirce (Getchell), Phoebe Davis Natt, and Elizabeth Fearne Bonsall (1861-1956)–to meet weekly at his studio in the Artists' Fund Society building so he could teach them etching. Dillaye described her experience with Parrish and the professional stimulation the women artists had received from him:

> . . . we received the critical advantage of his superior knowledge and technical guidance. Happy hours, never to be forgotten! spent in the white light of his etching window and in the kindly sympathy of his personal interest. We came to him quite ignorant of the subject, I being the only one who had attempted a plate. Under this wise master we were soon initiated into the intricacies of a wayward medium and began to show the result of a valuable training, so that in the Spring of the same year Edith Loring Peirce (now Mrs. Getchell) and I had exhibits on the walls of the Paris Salon, and a month or two later, at the Third Annual Exhibition of the Society of Painter-Etchers of London.[16]

Parrish rented his studio to his etching students in the

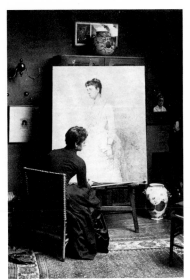

Mary Louise McLaughlin in her Studio, photograph, Cincinnati Art Museum, gift of Theodore A. Longstroth.

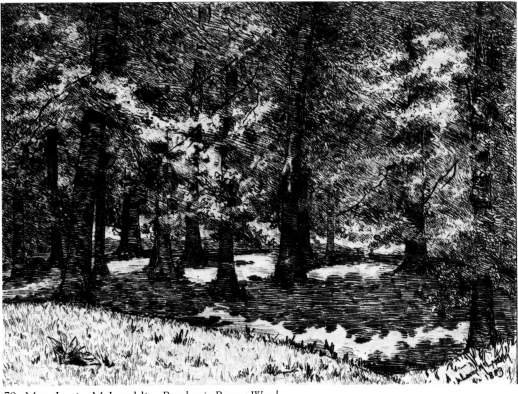

79. Mary Louise McLaughlin, *Beeches in Burnet Woods*

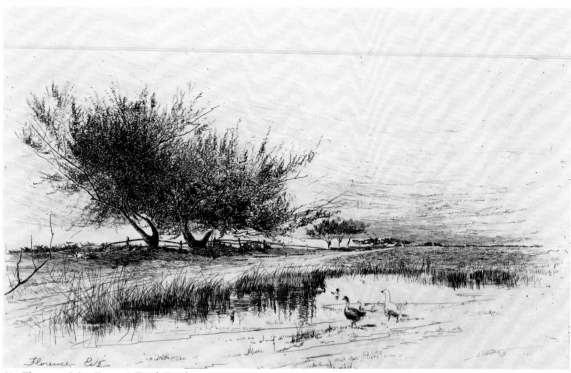

41. Florence May Esté, *A Duck Pond*

summer of 1884 when he went abroad for two years. Florence May Esté joined the group and learned etching from Dillaye and the other students.[17] Esté may have etched *A Duck Pond* (catalogue no. 41) during this period in Parrish's studio.

Clements taught another of Eakins's former pupils, Margaret Lesley (Bush-Brown), to etch in October 1883, after Lesley, who later married sculptor Henry Kirke Bush-Brown (1857-1935), returned from three years' study in Europe. In 1884 the New York Etching Club accepted for exhibition Lesley's *Study of a Girl's Head* (probably her 1883 portrait of Ellen Day Hale, catalogue no. 5), which may have been her first print. While she was studying etching with Clements, Lesley received a visit from her distant cousin Ellen Day Hale of Boston, who had traveled to Philadelphia in order to take classes at the Pennsylvania Academy.

Hale did not become interested in etching until the summer of 1885, when she and Clements were touring France. They, Anna P. Dixwell, and Elizabeth Boott (1846-1888),[18] who married Frank Duveneck in 1886, had studied in Paris at the Académie Julian that spring, when Hale resumed her work of two years earlier, which had been interrupted by illness.

In August, while they were visiting the village of Chartres, Hale wrote to Lesley (Bush-Brown) about her work:

How I wish you were here! . . . now that you etch I think you would enjoy it more than ever, and carry out your copper-plates just as Gabrielle carries hers. As for me I am not yet bitten by nitric acid, and am doing nothing more exciting than charcoal drawings, of which I hope to dispose some day, if I'm lucky. I always have some chance of selling a few, and it is a better chance than I should have with sketches in colour.[19]

Hale's teachers, William Morris Hunt and Helen Knowlton, had encouraged their students to develop in their work the broad effects and painterly qualities of the Barbizon School and had influenced Hale to make charcoal, which was particularly suited to the Barbizon style, an important part of her work. During Hale's tour of France with Knowlton and Margaret Lesley (Bush-Brown) in the summer of 1881, she had drawn in charcoal *The Marketplace, Dives, Normandy* (catalogue no. 66). Knowlton had made a similar drawing (now in the Worcester Art Museum) while they were in Normandy, and in the mid-1880s Lesley made an etching, *A Market in Normandy* (catalogue no. 3), probably from a drawing she had made on the 1881 trip.

A week after Hale had begun her August 6, 1885, letter to Lesley, she added that she had been persuaded to etch. The enthusiasm she expresses in her letter about this first etching experience suggests that she had been inspired to etch by Clements and the beauty of Chartres as well as the incentive to sell both etchings and charcoal drawings of the site:

I spoke too soon, my Meggy, for what do you suppose? Led on by Gabrielle's persuasions I have actually begun my first plate!! And queer enough it is likely to be. Pretty soon she is coming in to bite her own and mine. She is etching a beautiful thing by the river, and I am doing the town gate. . . .[20]

Her view of the Chartres town gate, *Porte Guillaume, Chartres* (catalogue no. 71), was one of two of her etchings selected for exhibition with the New York Etching Club in 1886. The following year, and also in 1888, she entered it and other etchings she had made in the summer of 1885 in the *Women*

Etchers of America exhibition. In *Porte Guillaume*, as well as in Hale's charcoal drawings, the influence of Hunt and Knowlton is evident.

But several other sources also influenced Hale, including, in her composition and heavy contrast between dark and light, *The Kitchen* and other etchings by Whistler. In her *Village Street, Mont St. Michel*, a scene on the street where she, Clements, and Clements's mother stayed in late August 1885, she is clearly influenced by Meryon and by Whistler's more expressive line in his similar *Street at Saverne* of 1858. In a letter to her parents Hale described the village street on which she and the Clementses had rented a house:

> You would both be enchanted with this place. . . . We are living in a tall stone house, which fronts on the one street of the village, and which backs on the parapet which surrounds the town on the sea side. From Gabrielle's window and mine we look sheer up to the Abbey church on the top of the hill, with all the conventual buildings below it, walls below that, and rank above rank of little houses below still. When we can't do anything else, therefore, we are not sorry to work out of the window.[21]

Traveling, studying, and living abroad were perhaps even more important to American female artists in the nineteenth century than they were to male artists. Going abroad not only gave women the same opportunities as men to see large quantities of important art, obtain more varied and prestigious art

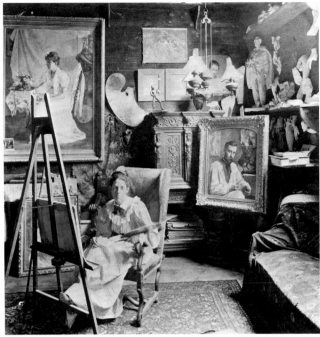

Margaret Lesley Bush-Brown in her studio at "Littlebrook," New York, 1894, photograph, Sophia Smith Collection, Smith College.

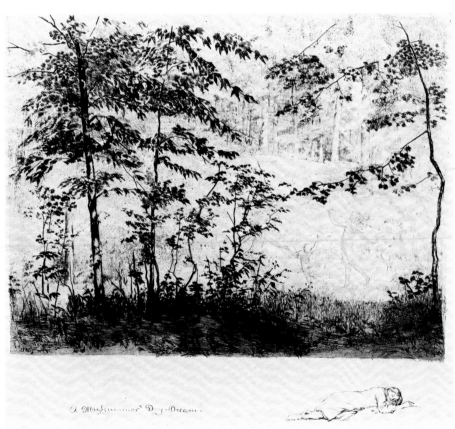

4. Margaret White Lesley Bush-Brown, *A Mid-Summer Day Dream*

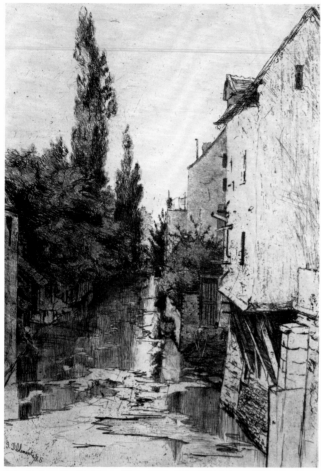

24. Gabrielle DeVaux Clements, *The Old Moat, Chartres*

Even after the private, tuition-charging academies in Paris had agreed to accommodate women students (the free Ecole des Beaux Arts would not, until 1897), they often charged women twice as much as they were charging men.[23] In addition, the Boston Art Students' Association reported that living in Paris could cost women up to $400 a year more than men. The Association estimated that a man could live in Paris on $800 to $1,000 a year while a woman would need $1,000 to $1,200. "Where there are 20 cheap restaurants that men can go to, there is but one for women."[24]

The proliferation of travel articles and books for Americans in the nineteenth century included many written by women or directed specifically to women artists. Before she and her daughters, Eleanor and Kathleen, went to Munich to study in 1870, Eliza Greatorex had read Anna Mary Howitt Watts's *An Art Student in Munich* (1853).[25] Margaret Bertha Wright, in an article on Parisian art training in *The Art Amateur*, criticized the large quantity of impractical advice written for women artists:

> Great deal of advice is written every year to the young women artists of America upon a subject of surpassing interest to them all—that of going abroad to study. I have read acres upon acres of this advice, stretching over the whole newspaper press of our country, and I have been many times struck by its wholly impractical nature, by its vague wabbling about the neighborhood of important facts, without actually touching upon them, and, above all, by the thoughtlessness with which it usually encourages young women to the dangerous experiment of living and studying in Paris on the smallest possible means. I have seen the minimum given in such figures as would make the experienced stare with amazement.[26]

WOMEN ETCHERS WORKING ABROAD

Many women etchers spent years studying and working abroad. Pennsylvania Academy students Peirce (Getchell), Dillaye, Lesley (Bush-Brown), Mary Franklin, Clements, Esté, and Cassatt went to Europe immediately after they had finished the Academy's course. Lesley (Bush-Brown), Clements, Hale, and Dixwell studied at Julian's in the 1880s after it was opened to women. Etcher Caroline A. Lord of Cincinnati also studied at Julian's in the early 1890s. The Greatorexes studied privately in the studios of artists in Paris and also in Munich, where there were no academies open to women.[27] Most of the women etchers spent summers, and often years, working abroad. The painter-etchers who settled permanently in Europe included Mary Cassatt, Eliza, Kathleen, and Eleanor Greatorex, Florence Esté, and Anna Lea Merritt.

Mary Cassatt and Eliza Greatorex, both living in Paris, began to etch seriously during 1879. However, there is no evidence that they knew one another and their work has little in common. Greatorex, who had always sketched from nature in her travels in Europe and the American West, made etchings almost everywhere she went, whereas Cassatt, who had traveled almost as much as Greatorex but without sketching from nature, had only recently begun to carry a sketchbook in which she recorded views of contemporary life, not scenery.

training, and discover exotic subject matter, but also enabled them to assert their independence as artists and to demonstrate the seriousness of their commitment to art. Going abroad for professional reasons was especially bold for women since they had greater expenses as well as more problems to cope with in studying and living away from home than did men.

Because the free European art academies were closed to women in the nineteenth century, women had no choice but to pay for private teachers or enroll in private academies which charged a fee. Etcher Phoebe Davis Natt wrote an article on Paris art schools for *Lippincott's Monthly Magazine* in 1881 while she was studying privately with Jean-Jacques Henner (1829-1905) and Léon Joseph Bonnat (1833-1922). She summed up the opportunities for women students in Paris:

> Most of the prominent artists either visit studios or have their own, into which they admit male students, and in whose work they take a great and kindly interest. In a few cases there are separate courses for ladies, in some the classes are mixed, but nowhere are there the same liberal and generous arrangements for women's work as on our side of the Atlantic. . . .[22]

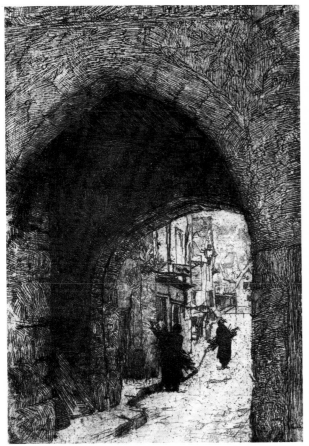

71. Ellen Day Hale, *Porte Guillaume, Chartres*

75. Ellen Day Hale, *A Woman of Normandy*

Both artists had family members around them, but Cassatt, influenced by modernism, is the only one of all the American women etchers who made her family the subject of her etchings. Greatorex and most of the other American etchers were primarily interested in following the landscape tradition.

Because Cassatt's primary concern was with style and the formal qualities of art, her travels had been a search for methods and ideas. Greatorex traveled in search of natural and architectural subject matter and inspiration from nature. Both artists succeeded in having professional careers, and both exhibited and promoted their prints as an important part of their artistic productions, but Cassatt, who was more progressive at a time when the art world was undergoing vast changes, became much better known.

Greatorex, who had experimented with etching in New York, learned to use etching for its own sake from Charles Henri Toussaint (1849-1911) in Paris.[28] She also sought advice from Maxime Lalanne (1827-1886), author of the influential *A Treatise on Etching* (1866) and proponent of "purist," linear etching. Her mid-1870s views of New York had been documentary in nature, but in France she adopted the Barbizon artists' methods and attitudes and began to work toward a personal, poetic interpretation of the landscape. Her European views, sketchy and full of light, include *The Pond, Cernay-la-ville*

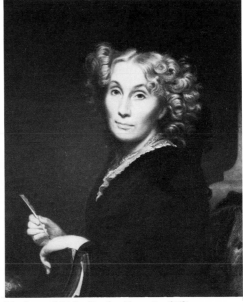

Ferdinand T. L. Boyle, *Portrait of Eliza Greatorex*, 1869, oil on canvas, Collection of the National Academy of Design, New York City.

19

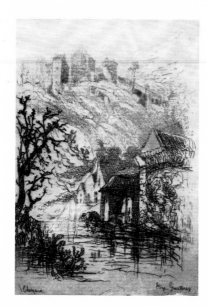

58.
Eliza Pratt Greatorex,
Chevreuse

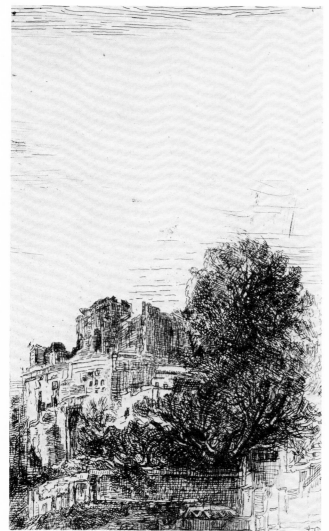

63. Eliza Pratt Greatorex, *Rome, Italy*

(catalogue no. 62), which she sent home for Sylvester Koehler to publish in the *American Art Review* in 1881. Greatorex also etched scenes similar to those of her collotypes *Near the Theatre, Ober-Ammergau* (catalogue no. 61) and *Church of Ober-Ammergau* (catalogue no. 59) in her memoirs of her earlier trip, *Homes of Ober-Ammergau* (Munich: Jos. Albert, 1872). One of her etchings of Cernay-la-ville was accepted in the Paris Salon of 1881–the year after Cassatt showed her prints in the Impressionists' exhibition.

Greatorex returned to New York for almost four years before she settled permanently in Paris. In the mid-1880s she produced etchings of New York in the looser, painterly, light-imbued style of the Barbizon artists and often depicted contemporary rather than historical features. When the Greatorexes returned to Europe in 1886, Eliza produced etchings of Italy and Norway.

Mary Cassatt had begun to etch in earnest for *Le Jour et la Nuit*, a deluxe journal of etchings planned by Edgar Degas but never published. When her prints were exhibited for the first time in the United States in the *Women Etchers of America* show they were listed in the New York version of the catalogue as "Twenty-four unfinished studies." Executed during the two years she and the French etchers were excitedly working toward producing *Le Jour et la Nuit*, these untitled experimental states were apparently considered "unfinished" when contrasted with the show's other prints, which had been conceived firmly within the landscape and portrait styles popular in America during the Etching Revival.

Because of Cassatt's relationship to Impressionism, her modern subject matter of contemporary life, and the primarily experimental quality of her prints, she had little in common with other American etchers. She and, a few years later, J. Alden Weir (1852-1919) chose to follow the lead of Whistler and etch their family members unsentimentally absorbed in everyday domestic life. Cassatt, like Whistler, was concerned not with reproducing the scene but with having an image with which to experiment. Following Whistler's practice, she did not bother to reverse the scene of her preparatory drawing for *Under the Lamp* (catalogue no. 14) when she drew it on the etching plate.

In addition to drypoint and methods of manipulating the ink which most American etchers were using, Cassatt employed soft-ground etching, aquatint, and a variety of other techniques which enabled her to experiment with form, tonal effects, and naturalistic renderings of light and shade. For instance, in *The Visitor* (catalogue no. 16), she pressed fabric against the ground for texture in the garment of the figure on the left. She used tonal methods to translate her essentially linear, realistic pencil and crayon study of her mother and sister (catalogue no. 14) into an almost abstract depiction of light and shadow in her soft-ground and aquatint of *Under the Lamp* (catalogue no. 15).

The Avery collection shown in the *Women Etchers of America* exhibition included a representative selection of Cassatt's early prints.[29] Heavily tonal images like *Mlle. Luguet Seated on a Couch* (catalogue no. 12) and *Under the Lamp*, with their contrasting light areas textured by lines, dashes, and dots,

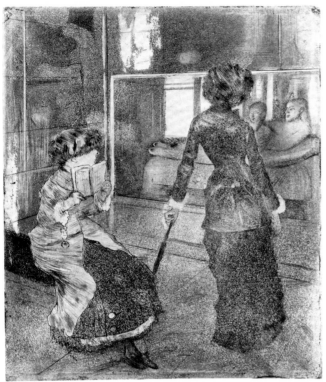

Edgar Degas, *Mary Cassatt at the Louvre: Musée des Antiques*, etching, The Grunwald Center for the Graphic Arts, Wight Art Gallery, U.C.L.A., gift of Mr. and Mrs. Fred Grunwald.

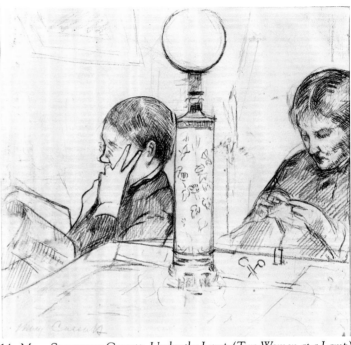

14. Mary Stevenson Cassatt, *Under the Lamp (Two Women at a Lamp)*

were modern in style but related in their expressive, free use of printmaking processes to Mary Nimmo Moran's traditional landscapes *Twilight* (catalogue no. 101) and *'Tween the Gloaming and the Mirk* (catalogue no. 100), which had been executed with retroussage, sandpaper, scotch stone, and roulette at about the same time Cassatt had produced her images. Peirce (Getchell) also etched some very tonal prints in the early 1880s, but like Moran's, they are traditional in their sense of color, space, and composition. In her 1884 *Solitude* (catalogue no. 54), for instance, Peirce (Getchell) used wiping and retroussage to create the local color effects of watercolor painting without the use of aquatint.

Examples of Cassatt's economic, linear early drypoints, such as *Katherine Cassatt* (catalogue no. 9), were also hung in the *Women Etchers of America* exhibition. These sketchy images with their impressionistic line work and heavy shadows are forerunners of her highly simplified, strongly linear, Japanese-influenced drypoints of the 1890s, such as *The Bonnet* (catalogue no. 8). Stylistically they also were a modernist contrast to more traditional images like Mary Louise McLaughlin's lively *Head of a Girl* (catalogue no. 80). McLaughlin, living in Cincinnati, worked in color monotypes in the early twentieth century (see catalogue no. 81).

The reviewer of the women etchers exhibition for *The Critic* especially praised Cassatt for having mastered Manet's ability to convey a sense of color and vibrancy in black and white—a

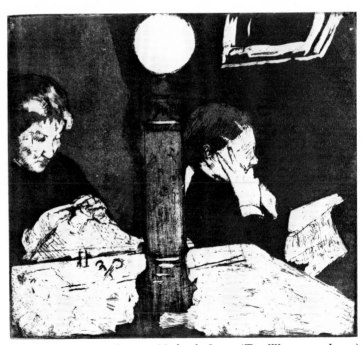

15. Mary Stevenson Cassatt, *Under the Lamp (Two Women at a Lamp)*

8. Mary Stevenson Cassatt, *The Bonnet*.

80. Mary Louise McLaughlin, *Head of a Girl*

distinctive quality of Impressionist etching:

> The most interesting plates in the way of artistic progressiveness are the drypoints of Miss Mary J. Cassatt, the Paris-American impressionist. Some of her plates are remarkable as examples of the aquatint process, and are strong in individuality as well as in execution. There is something of Whistler in them, and much of Manet; and there is subtle force of color pervading the lines. The aquatint process may be only a workman's trick, in the opinion of certain purists in etching; but it is very valuable as a means of producing impressive effects.[30]

The vitality of the Parisian art community continued to inspire Cassatt to produce forward-looking prints. Her exemplary set of ten color drypoint and aquatints in the style of Japanese woodblock prints, including *The Letter* and *Maternal Caress* (catalogue nos. 11, 13), must have influenced the color experiments of Gabrielle Clements and Ellen Day Hale in the 1920s and 1930s (see catalogue nos. 29, 30, 31, 65, 69). Like Cassatt, who made color etchings based on the images she was using in her mural for the Woman's Building in the 1893 World's Columbian Exposition (*Gathering Fruit*, catalogue no. 10), Clements (who painted a mural, *Harvest*, based on the same fruit-picking theme for the Ladies' Reception Room of the Columbian Exposition's Pennsylvania State Building) also made aquatints in color of subjects from church murals she

painted in the 1920s and 1930s.

Since Cassatt's early involvement with the modern movement had set her apart from other American printmakers, her work went unrecognized by most of the American collectors of Etching Revival prints. In describing the modernism of her subject matter art writer Frank Linstow White said: "Her subjects are of the slightest–most of them sketches of female life–but they are executed with wonderful succinctness. . . ."[31]

Sylvester Koehler included eight of Cassatt's etchings in the selection he prepared for the Ohio Valley Centennial Exposition in 1888. In October 1891, six months after she introduced her color prints in Paris, Frederick Keppel exhibited in his New York gallery a selection of her black-and-white etchings as well as her set of color prints. But in 1892 Cassatt wrote to her dealer, Paul Durand-Ruel, expressing disappointment that none of her color sets had sold in America.[32] In a letter to his son, Joseph, a day later, she expressed gratitude that she had sold some of the prints in France and reiterated her regret that her work did not sell in her own country:

> I am very glad you have any sale for them in Paris. Of course it is more flattering from an Art point of view than if they sold in America, but I am still very much disappointed that my compatriotes have so little liking for any of my work.[33]

Because Cassatt had been so independent in her travel, selection of teachers, learning experiences, and associations, and because she had met Degas and formed a close friendship with him at a crucial time in her career, she was able to develop her skills as an artist with less pressure on her to conform to tradition in art than most other women artists experienced. Of course, most of the women painter-etchers were from middle-class or upper-middle-class families, were relatively independent, and had at least some economic freedom. But Cassatt was exceptionally independent and confident, opening herself to the new ideas of the Independents when her fellow American artists of the 1870s apparently took little interest in the Independents' activities.

Like Cassatt's prints, Anna Lea Merritt's etchings differed greatly from the other work in the women etchers show. Also an upper-middle-class Philadelphian, Merritt, in contrast to Cassatt, who studied at the Pennsylvania Academy, had not even known about the opportunities to study art at the Academy or the Philadelphia School of Design for Women when she was growing up. As a young adult, she settled permanently in England, returning home for a few months each year. In England she was influenced by the Pre-Raphaelites and by English portrait and illustration traditions.

Merritt had studied art in Italy, Germany, and Paris while she and her sisters traveled with their parents, but was most influenced by her English teacher (whom she married the year he died), art critic and restorer Henry Merritt (1822-1877), and his circle of friends, including William Holman Hunt (1827-1910), whose work she had admired as a child, Sir Edward Burne-Jones (1833-1898), Dante Gabriel Rossetti (1828-1882), and George Frederic Watts (1817-1904).

She began to etch by teaching herself, determined to produce the illustrations for the memorial to her deceased husband, *Henry Merritt: Art Criticism and Romance, with Recollections and Twenty-three Etchings by Anna Lea Merritt* (London: C. Kegan Paul & Co., 1879), a collection of art criticism and fiction which he had published anonymously during his lifetime. She later wrote:

> I may say that until I held the etching needle, I had never drawn a *line*. When designing, instead of drawing I had always painted a small sketch, probably because of never having attended art school.
>
> Quite recently I had read Hamerton's book on etching, and now at the British Museum examined etchings by Van Dyck and Rembrandt, preferring Rembrandt. I found out where to buy the tools and began. The portrait of Mr. Merritt, which was very soon etched, quite amazed Mr. Kegan Paul. He asked me to do others for other memoirs–also he wished I could produce at least twenty-two more etchings to illustrate our book. This I succeeded in doing–half of the etchings are careful copies of little pen-sketches which had finished Mr. Merritt's letters to me during my winters in America–most of them exquisite compositions. The rest were my own designs to illustrate *Robert Dalby* and the *Professor*.[34]

Merritt had technical help with her etching from Charles West Cope (1811-1890), a member of the London Etching Club (founded in 1838) whose etching exemplified the highly finished quality of that period, and Elizabeth Ruth Edwards, who printed Merritt's trial proofs for her as she had printed etchings for her own husband, Edwin Edwards (1823-1879).

Most of Merritt's forty-six etchings (plus a variety of states of some of the etchings) in the *Women Etchers of America* exhibition were portraits executed in a relatively tight, realistic style in which she attempted to adhere to the Pre-Raphaelite dictum that the drawing of a subject should be as true to nature as possible. They included portraits of Sir Gilbert Scott (one of two which Sylvester Koehler had published in the *American Art Review*) and Louis Agassiz (catalogue nos. 84, 83). When Koehler made a point of featuring her etching for a second time in the *American Art Review*, he wrote:

> As a rule it is the custom of the REVIEW to open each monthly number with a fresh article, and to relegate continuations, or such articles as form parts of a series already begun, to more remote pages. If this maxim is disregarded in the present instance, it will hardly be necessary to offer an excuse. The fact that the subject of this notice is the first American woman who appears prominently before the public as an etcher would be sufficient to explain why the place of honor is given to her work and its discussion, even if the quality of that work were not as high as it actually is. . . . The marvellous combination of delicacy and strength in the modelling of [Sir Gilbert Scott's] head is such that this plate may justly claim rank among the best of modern etched portraits.[35]

Two of Merritt's etchings in the *Women Etchers of America* exhibition were typical Pre-Raphaelite allegorical subjects after her own paintings, *Eve* (*Eve Repentant*) (catalogue no. 82), her diploma etching for the London Society of Painter-Etchers, and *St. Cecilia* (*St. Cecilia Asleep*) (catalogue no. 85). Both of these etchings had been published in New York by Christian Klackner in 1886, the year before the women etchers show.

SUBJECTS: PORTRAITS AND LANDSCAPE

Portraits and figure subjects are relatively rare in the work of the women etchers. In addition to Cassatt and Merritt, only Katherine Levin Farrell and Ellen Oakford etched many portraits or figure pieces. Mary Louise McLaughlin etched a few portraits, including *Head of a Girl*. We have found no prints by Mary Franklin, who traveled from Athens, Georgia, to study at the Pennsylvania Academy and learned to etch from Stephen J. Ferris (1835-1915) before she went to Paris, and Lilian Taylor Kiliani, but each entered only figure or portrait studies in the *Women Etchers of America* exhibition. Although she often painted the figure in oils and murals, Gabrielle Clements made only two portrait etchings. Henry Russell Hitchcock published one, *A Tramp*, in his deluxe etching portfolio, *Some Modern Etchings*, which also included Levin Farrell's *The Clarinet Player* after Hugo Kauffmann. Ellen Day Hale, who had worked on at least one portrait etching earlier, etched *The Willow Whistle* (catalogue no. 73) in 1888 and made several portrait etchings and a drypoint, *A Woman from Normandy* (catalogue no. 75),[36] in 1889.

Hale based *The Willow Whistle* on a drawing (catalogue no. 73) from an albumen photograph (catalogue no. 72) which

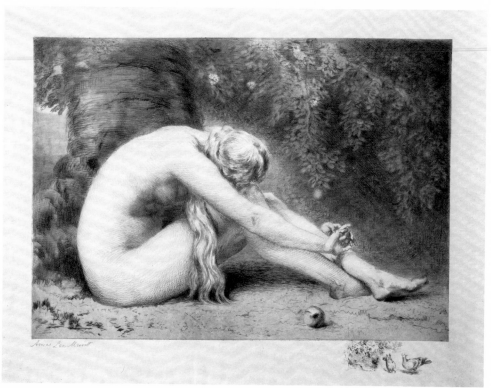

82. Anne Massey Lea Merritt, *Eve (Eve Repentant)*, 1887, after a painting of 1885 by the artist

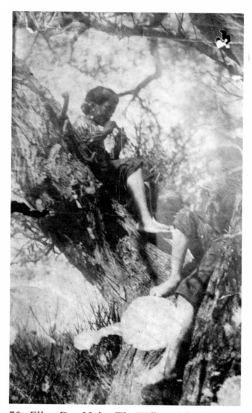

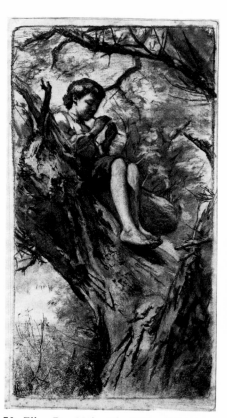

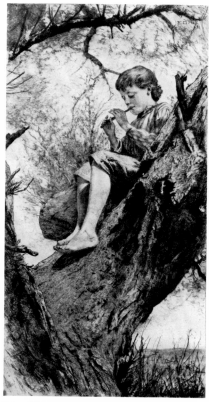

72. Ellen Day Hale, *The Willow Whistle*

73. Ellen Day Hale, *The Willow Whistle*

74a. Ellen Day Hale, *The Willow Whistle*

24

she had taken the summer before. In a very tight, detailed, meticulous drawing style, she reproduced the qualities of the photograph, including the areas where it is slightly out of focus. Hale altered her composition to eliminate one of the two boys who had posed for the photograph at her summer home. She drew the remaining boy with the same introspective expression, his head and eyes cast downward as he plays his handmade whistle. The same thoughtfulness and solitary dignity appear in the faces and poses of figures in her paintings and several other etchings.

Hale's use of this tight drawing style, in contrast to the broad, bold style which she had learned from Hunt, was undoubtedly due to her interest in photography and may have been inspired by her six months in Paris in 1885 when she studied at the Académie Julian under William A. Bouguereau (1825-1905) and Tony-Robert Fleury (1837-1912). Hale wrote to Margaret Lesley (Bush-Brown) in November 1885 that she had spent all but two weeks of her six months in Paris practicing drawing:

> You know six months at Julian's was more than I planned for, so that I have a delightful feeling of completion about that affair, the more as I really did make progress, and feel myself a stronger draughtsman than I was. I should have been sorry had it not been so, for unmitigated drawing at school certainly ought to have that effect! I only painted two weeks of my six months there, and then, par parenthesis, I painted most abominably. Now, though of course I wish I had had more knowledge and experience of the Academy figure, yet I feel that I have had a pretty fair show; for I certainly was one of the best draughtsmen they had in the class, –in certain ways,– when I left it; and Tony's criticism of my five or six last studies was hardly at all about drawing and principally about effect. So I feel much freer than I have done for years, and much more my own mistress. . . .[37]

Florence Esté had traveled back and forth between the United States and France before she settled in Paris permanently. She was strongly influenced by the European tradition of personal interpretation of the landscape handed down from Jacob Ruysdael through Barbizon artist Théodore Rousseau. Blanche Dillaye wrote about an etching by Esté, *The Centenarian*, a dramatic portrait of a blasted tree trunk. Though it was accepted in the 1893 Paris Salon, I have not found an impression of it. The image is reproduced in Dillaye's *Philadelphia Press* article:

> The *Centenarian* excited warm commendations when hung in the Paris Salon of 1893. The feeling for motive is strongly shown in the work of Miss Este, who looks upon nature, not as a "subject," but discerning its spiritual side. About the bare limbs of a tree is the fluttering last leaf that trembles on its topmost bough: she weaves a sentiment which endows the whole with beauty and gives to it a human touch, which makes something within us vibrate.[38]

Martha Scudder and John Twachtman carried etching plates with them as they toured Europe after their marriage in 1881. *A Dordrecht Canal* and *A View of the Meuse* (catalogue nos. 115, 117) demonstrate the influence of the freedom of the Munich school which Twachtman and Frank Duveneck had

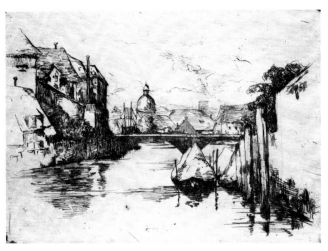

115. Martha Scudder Twachtman, *A Dordrecht Canal*

brought to Cincinnati. Scudder and Twachtman learned to etch with the Cincinnati Etching Club in 1879-80. She wrote to Koehler at that time describing how she worked from nature:

> Allow me the liberty of sending you proofs of my latest etchings. The landscapes are done directly from nature. . . . They are not well printed as it cannot be done here but they will . . . give you an idea of the work.[39]

Her 1880 Cincinnati landscape, *A Ruin on Mill Creek* (catalogue no. 116), one of several etchings by women purchased in 1888 by the Boston Museum of Fine Arts, looks almost abstract with its flattened space and emphasis on design when compared to landscapes by other American etchers. Scudder Twachtman's etchings are probably fewer than ten, perhaps half of her husband's relatively small number of plates.

Many Americans traveled to etch the landscape both abroad and at home. Scenes in Holland and France were the most popular European subjects because American artists were inspired by the Dutch seventeenth-century and French Barbizon etchers. Landscapes of Long Island (especially East Hampton–the "American Barbizon"), the coastal areas of Massachusetts and New Jersey, and rural Pennsylvania were popular American subjects.

Both Dillaye and Edith Loring Peirce Getchell, like their teacher Stephen Parrish, looked closely at the broad, open vistas and descriptive detail of the Dutch. Dillaye was most influenced by Dutch seventeenth-century etching and by Johan Barthold Jongkind (1819-1891), whose work brought together the ideas of the Dutch, the Barbizon artists, and the Impressionists. There is also a strong Luminist quality in her work. Dillaye and Peirce Getchell both experimented with retroussage, but Dillaye relied far more on line for her atmospheric effects. Both were very prolific and strongly committed to etching. Dillaye entered thirty-eight impressions from twenty-nine plates and Peirce Getchell exhibited fifty-seven impressions from forty-three plates in the *Women Etchers of America* show.

25

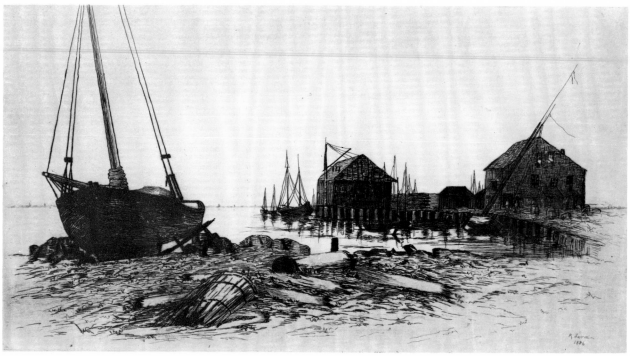

42. Katherine Levin Farrell, *South Dartmouth Wharf*,

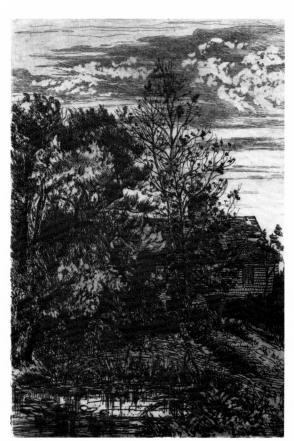

78. Gertrude Rummel Hurlbut, *Near East Hampton, L. I.*,

Among Dillaye's strongest images are the harbor scenes which she searched out wherever she went. In these as well as in her landscapes she often employed a typically Dutch open horizontal composition and used line with very subtle retroussage to create atmospheric effects. In *Low Tide on a Dutch River* (catalogue no. 36), she bathed the composition in the clarity of Dutch light, but in *Mist on the Cornish Coast* (catalogue no. 38), she took inspiration from the French to emphasize weather and atmosphere, enveloping the scene in the heavy mist typical of a foggy day along the coast of England. She used line to produce most of the ethereal effects of the damp shroud, depicting the ship half in and half out of the dense haze.

Dillaye subscribed to the ideas of "purist" etching, exemplified by *Mist on the Cornish Coast*, which Whistler had put forth in his *Propositions* of 1886. In a lecture delivered to the Congress of Women at the World's Columbian Exposition in 1893 she expressed her views on etching. She disapproved of the use of tools of other intaglio processes and placed her emphasis on simplicity:

> Etchers can not rely on an attractive exterior to cover up paucity of thought; flowery additions and superfluous methods they leave to other mediums. They should come at once to the vital truth; they should select the essentials and leave the nonessentials to them; there should be no joy in appearing to do a simple thing in a difficult way; they should prefer simplicity always, for in this simplicity lies the sublimity of their art.[40]

Peirce Getchell used retroussage far more extensively and heavily than Dillaye. In two of her most widely exhibited and published prints, *The Road to the Beach, at Nonquitt, Mass.* and

26

the second state of *Solitude* (catalogue nos. 53, 54), descriptive tinting is used to render the objects of the landscape in their characteristic tonal qualities rather than to produce dense overall atmospheric effects. In contrast to Mary Nimmo Moran's highly dramatic portrayal of nature in *'Tween the Gloaming and the Mirk* (catalogue no. 100), Peirce Getchell created landscapes of quiet, somber mood. *The Critic* said her etchings "owe a good deal to artificial printing" but acknowledged that they were "none the less original and artistic."[41] J. R. W. Hitchcock, in *Etching in America*, compared the "artificial printing," or wiping, process she employed to attain shades representing the color of each object to roulette because both etchings departed from "the auto-graphic drawing which is the peculiar charm of etching."[42] Peirce Getchell used Stephen Parrish's press for the first impressions from the plate for *The Road to the Beach, at Nonquitt, Mass.*, but for a large edition published by Frederick Keppel, a printer was commissioned and she supervised the work.

Peirce Getchell took direct inspiration from Rembrandt's *The Three Trees* when she selected the particular spot at Peck's Beach off the coast of New Jersey in 1884 for the watercolor upon which she based *Solitude*. In translating the watercolor painting into an etching, which was her usual practice, she experimented with inking and wiping the plate.[43] She left far less ink on the plate for her rare first state of *Solitude*.

When *Solitude* was included the next year in *Gems of American Etchers* (which incorporated plates from two previous portfolios, *Original Etchings of American Artists* and *Twenty Original America Etchings*, in which *Solitude* had appeared for the first time), it was accompanied by a new text, emphasizing the influence of the Barbizon artists on *Solitude* and Peirce Getchell:

> . . . it corresponds to a certain mood of the mind. The mood in this case is melancholy, which all the elements of the scene conspire to produce: the flat, monotonous stretch of country, the poverty of the vegetation, the heavy black slump of trees which looms up in the distance like a foreboding of evil in the future, the cold dull sky reflected by the pool in the foreground, even the faint light which breaks through the veil of clouds at the horizon, like a last glimmer of departing hope.
>
> It is the highest achievement of landscape to work thus upon the feelings,—an achievement which lifts it from the mere reproduction of outward forms to the level of lyrical poetry.[44]

Despite this praise, the unidentified author suggested that Peirce Getchell should not make a practice of emphasizing the solemn mood of nature but instead should work within

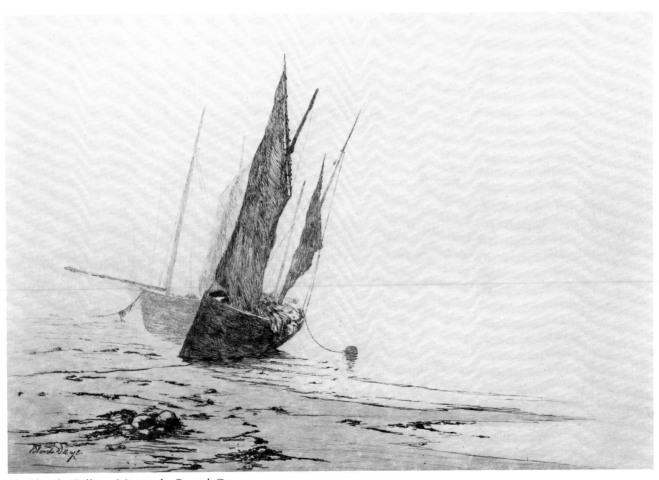

38. Blanche Dillaye, *Mist on the Cornish Coast*,

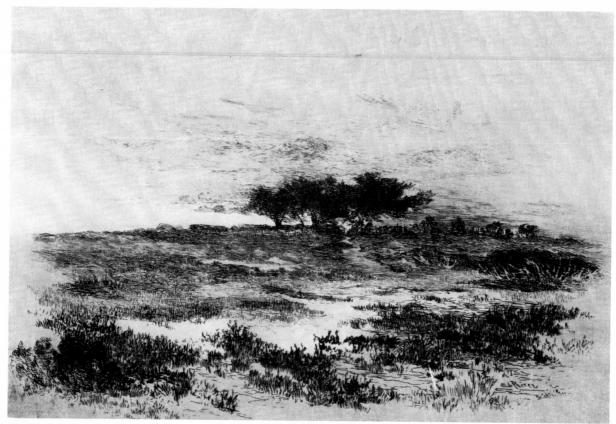

54. Edith Loring Peirce Getchell, *Solitude (Peck's Beach, New Jersey)*

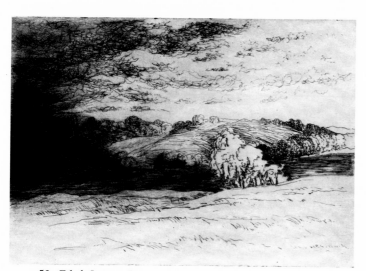

52. Edith Loring Peirce Getchell, *Premonition of Storm*

"women's proper sphere" and bring "joy" to people:

> We trust, however, for the sake of the artist as well as the public, that she will not confine herself to such notes of sadness. There are other, more joyous moods, which landscape is quite as capable of expressing. And as the world is sorely in need of pure joy, why may it not look for it to the gentler sex, the flowers of heaven?[45]

She did not succumb to pressure from this prestigious publication but instead continued, like most of the other late nineteenth-century etchers, to produce landscape etchings with serious, pensive content. The quiet mood prevailed in the etchings she produced in the early twentieth century, such as her 1902 winter landscape *Impatient Pussy Willows* (catalogue no. 50). She had evolved into a more "purist" etcher and placed a stronger emphasis on the etched line than she had in her early prints. With line and the white of the paper she created a sense of flattened space with emphasis on pattern and design. That year (1902) Will Jenkins described her style as essentially linear in an essay on modern etching and engraving for *The Studio*:

> A practioner of the brilliant uses of line, the work of Edith Loring Getchell is vigorous, original and effective without affectation. . . . Her hand is particularly sympathetic to all that is beautiful in foliation and growth of trees, atmospheric or climatic conditions of light, and those subtleties of nature best adapted to expression with the point.[46]

28

Gabrielle Clements often depicted scenes of an altered landscape or seascape. In *The Return, Gloucester* (catalogue no. 32), which she etched from her summer home, she emphasized the working aspects of ships and harbors rather than the poetic, romantic side which Parrish and Dillaye etched. Instead of depicting strictly pastoral or poetic landscapes like Lesley (Bush-Brown), Dillaye, and Peirce Getchell, she etched scenes such as *Rockport Quarry* in 1884, which *Harper's Monthly* reproduced the next year, and *The Mill Race* (catalogue no. 22), in which she contrasted a romantic view of nature with the rapid flow of a mill race.

Although these works are clearly indebted to Dutch and French etching, both photography and Japanese art exerted a strong influence on Clements's choice of pictorial devices. Space in *The Mill Race*, for instance, is flattened and tilted toward the viewer. And the inspiration for her composition in *The Return, Gloucester* is the cut composition of photography and Japanese art. Her flattened space, high horizon line, and cut view of the shore are all very much like the devices which Whistler used in his Thames etchings and which many American etchers incorporated into their own work.

Clements also etched a miniature version of *The Return*. She and Hale collaborated on two miniature etching portfolios for L. Prang & Co. in the late 1880s—one of the Massachusetts shoreline and one of Newport, Rhode Island (*Newport; Six Etchings . . .*, catalogue nos. 18, 19, 20, 21, 23, 70). Hale etched a series of the California missions to earn money when she was living in California in the early 1890s. Living in Baltimore and teaching at the Bryn Mawr School, Clements became well known for a documentary series of views of Baltimore which she was commissioned to etch between 1895 and 1931 by the Bendann Galleries.

But the teaching and the Baltimore series were Clements's bread-and-butter work. She and Hale were very excited about experimenting with printing their soft-ground etchings and aquatints in color in the 1920s. They based their etchings on drawings and photographs they had made while traveling in Palestine, Egypt, Syria, and South Carolina. Hale translated René Ligeron's *Original Engravings in Colors* (Paris, 1924), on which they based their color etching techniques.

Clements wrote extensive descriptions of the process she used to create *The Ravine, Tryon, North Carolina* (catalogue nos. 26-31), which she drew on one of her trips to Charleston, South Carolina, where she and Hale spent winters. Each color experiment was unique, like a monoprint, although she used the same plate with the same etched image. She applied different colors to the plate *à la poupée* for each printing, with some final impressions going through the press several times. The method was similar to that which Cassatt had developed in 1891, but Cassatt used two, three, or four plates for each image while Clements used one. Clements's use of color, which differed from impression to impression, was far more experimental and painterly. While Cassatt's impressions differed one from the other only in subtle ways that signaled their selective, hand-printing process, each of these experiments by Clements was dramatically different from any other in color, application of the color, and mood.

Hale's niece, Nancy Hale, in a book about her artist-par-

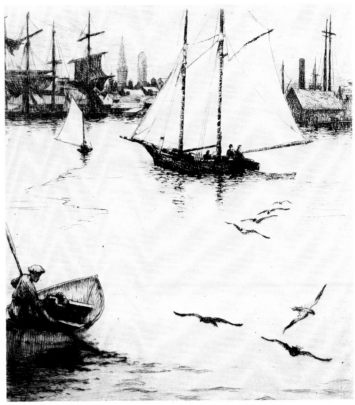

32. Gabrielle DeVaux Clements, *The Return, Gloucester, Massachusetts*

ents, Philip and Lilian Westcott Hale, described how her aunt, mother, and Clements printed their plates, with great care and precision, on a press set up under the skylight in Ellen Day Hale's Rockport studio, which she shared with Clements:

> I sat with a book in my lap and watched. The old ladies gave themselves to "process"—the preparing and printing of plates—with a peculiar, gay intensity. In their eccentric garb they hurried about the huge studio, lowering a plate into the nitric acid bath by means of a cradle made of string; applying black ink to an etched plate with a rag-covered roller, or colored inks to an aquatint—printed similarly except that spaces instead of lines were etched, to give an effect like watercolor. All together—my mother, too—they might print a take, one of them with infinite care setting a plate face down upon wet paper on a padded bed, another slowly, slowly turning the spokes of the great wheel as it moved the platen over the bed; another taking notes throughout to record each step in the process, so a final edition could be printed uniformly. Afterward they all clustered around to examine critically the result achieved. The atmosphere—brisk, fresh, precise—was permeated by the smell of the nitric acid bath.[47]

Hale and Clements exhibited frequently in local exhibitions —in the Gloucester-Rockport area art colony, in the Washington-Baltimore area where they each lived for years, and in Charleston—more welcoming environments for women than the highly competitive national scene. They and Peirce Getchell also exhibited with the Society of American Etchers

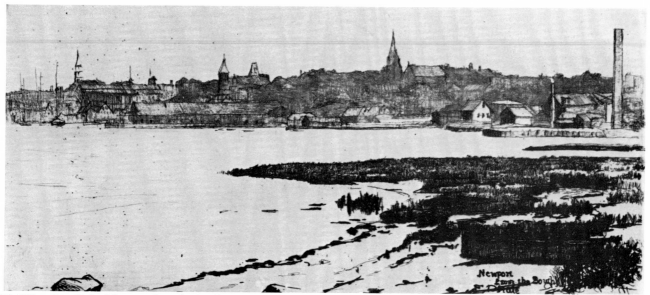

70. Ellen Day Hale, *Newport from the South*

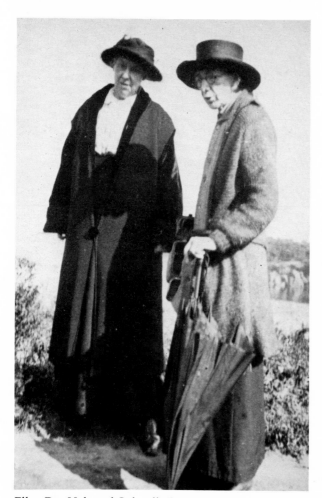

Ellen Day Hale and Gabrielle DeVaux Clements, ca. 1930

and the Chicago Society of Etchers, a large national organization founded in 1910. Often working with Hale and Clements were younger artists Margaret Yeaton Hoyt, Lesley Jackson, Theresa F. Bernstein, and her husband, William Meyerowitz. The group exhibited their color etchings at the J. B. Speed Art Museum in Louisville, Kentucky, and the U.S. National Museum in Washington, D.C., in the 1930s.

During their winters in Charleston, Hale and Clements trained a new generation of women etchers, one of whom was Elizabeth O'Neill Verner (1883-1979). Like the Rockport group, Verner carried on the work of the Etching Revival artists in the early twentieth century. After attending the Pennsylvania Academy, Verner, with Charleston landscape painter Alice Ravenel Huger Smith (1875-1945), who became well known for her color woodblock prints, formed an etching club in Charleston and invited Bertha Jaques (1863-1941), founder of the Chicago Society of Etchers, to visit Charleston to lecture on etching. Jaques, who had learned to etch after seeing etchings at the 1893 Columbian Exposition, and the Chicago Society were responsible for the revival of etching in the early twentieth century.

The most prominent of the women etchers in the late nineteenth century, Mary Nimmo Moran, did not live to participate in the next etching revival. During the late nineteenth century, however, she, and not Mary Cassatt, reflected American taste and attracted more attention from critics and writers than other female (and most male) etchers. She was almost always singled out and often unequivocally praised for the strength and experimental quality of her etchings.

Thomas Moran trained Mary Nimmo Moran in art after their marriage in 1862,[48] and she practiced drawing and oil and watercolor painting before she learned to etch in 1879. The Morans traveled to Europe, including England and Scotland, to study paintings and to sketch and develop ideas for pictures.

30

Mary accompanied Thomas on some of the trips he made to fulfill illustrating commissions, including one to the West in 1872 and two to Florida, in 1877 and 1887.

Mary assisted Thomas in his work, cared for their children, and managed their household, which limited her activities as an artist. She exhibited only her etchings extensively, and although she was a member of the New York Etching Club she did not participate in the camaraderie of the artists' organizations open to women or exclusively for women. Since Thomas traveled frequently, primary responsibility for their three children and their home life fell to Mary. She also acted as Thomas's manager during his absences. In an undated letter she describes some of her varied responsibilities:

> I never had so many things to do. . . . I have been trying to make little carpets fit big rooms and new dresses out of old ones for the children until I hardly know what I am about. Then I had to get my Studio in order for *My Class* and opened the Season last Wednesday there is only five now but I expect two

or three more. I have nice little desks for them to draw on and have invested about twenty dollars in models for me, so you see I have gone right into business.

> Since Cousin Kate and I were over we went off to East Hampton. And then when she went home I went to Easton with her to make another Etching and now you can easily understand why you have not seen me. . . .[49]

The drawing school for children was one of Mary Moran's many efforts to add to the family's income. She also had at least one student in etching, Zella DeMilhau (1867-1954). As Anna Lea Merritt wrote in "A Letter to Artists: Especially Women Artists": "The chief obstacle to a woman's success is that she can never have a wife. Just reflect what a wife does for an artist. . . ."[50]

Mary Moran made etchings after three of Thomas's paintings to illustrate his 1886 exhibition catalogue and helped him execute finished drawings from sketches he made on trips for illustrating commissions. He referred routinely to her custom-

69. Ellen Day Hale, *Milk Wagon, Cairo (Milk Delivery, Cairo)*

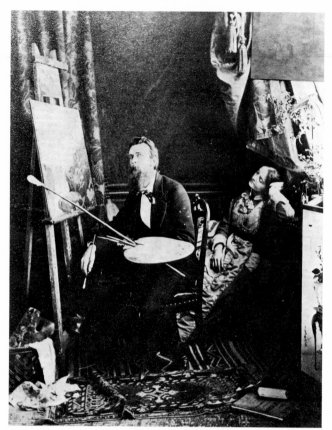

Thomas and Mary Nimmo Moran in their Newark, New Jersey, Studio, 1876, photograph, East Hampton Free Library.

Thomas Moran, *The Old Bridge Over Hook Pond, East Hampton*, 1907, oil on canvas, lent by the West Foundation, High Museum of Art.

ary assistance in an August 1873 letter written on one of his many western trips:

> Work hard to improve your drawing dear as I shall have plenty of work for you this coming winter. 70 drawings for Powell, 40 for Appleton, 4 for Aldine, 20 for Scribners all from this region beside the water colors and oil pictures.[51]

In an autobiographical note Mary Moran observed, "I may say I have always been my Husband's pupil,"[52] but her talent and achievement in etching earned her his full respect, as described by their daughter Ruth:

> His wife was the best critic he ever had. She encouraged all his efforts and aided in developing his almost superhuman capacity for work. "When she criticized my pictures," he says, "she knew why and she was always right."[53]

Both Mary and Thomas Moran admired J. M. W. Turner's art. Thomas reproduced in oil and in etching a Turner painting, which they owned, of Conway Castle, Wales. They visited Conway Castle while they were in Great Britain in the summer of 1882, and each made etchings of it. In London they met John Ruskin (1819-1900), who purchased many of their etchings.

Ruskin's dictum that a good etching had to make dramatic use of light and shade influenced Mary Moran as early as 1880, when she produced *Twilight–East Hampton* (catalogue no. 101), using several methods to create extremely dramatic atmospheric effects. *Twilight* (the frontispiece and one of two etchings in the New York version of the *Women Etchers of America* catalogue) and *'Tween the Gloaming and the Mirk* (catalogue no. 100) display her most daring uses of mixed media. The retroussage is so rich in these works that they can almost be related to paintings in the same sense as monotypes. In fact, Nimmo Moran's sense of color and drama in *'Tween the Gloaming and the Mirk* inspired Thomas to translate it into oil, adding a figure, in 1907. Entitled *The Old Bridge*, the oil painting is in the collection of the High Museum of Art. Mary also etched a linear version of the same scene in *Evening*, 1881 (catalogue nos. 91, 92), creating poetic, but far less dramatic, atmospheric qualities.

When she exhibited *Twilight* in the 1882-83 Philadelphia Society of Etchers exhibition, it was praised for its exceptional tonal qualities:

> Among these, as among any other group of American artists, the work of Mrs. Mary Nimmo Moran demands particular notice. I doubt whether in the work of any etcher in America or in Europe are to be found more painter-like qualities than hers exhibit, and if I were asked to select the etching by an American artist which exhibited these qualities in the greatest profusion, I should unhesitatingly name her *Twilight at East-hampton*. Her work is not always equal to this it is true–nobody is always at his best–but I am inclined to regard such work as this as about the high-watermark of etching in America.[54]

Her 1884 series of etchings of East Hampton, Long Island, where the Morans had built a home and studio and resided six months of each year, epitomized "pure" line etching (see catalogue nos. 93, 94, 95, 99) much as *Twilight* epitomized the use of tonal processes (without aquatint) in etching.

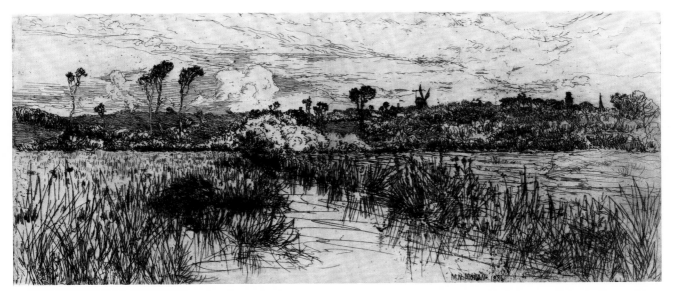

94. Mary Nimmo Moran, *The Haunt of the Muskrat, East Hampton*

Sylvester Koehler chose one of the series, *The Haunt of the Muskrat–East Hampton* (catalogue no. 94), to illustrate *Etching: an outline of its technical processes and its history with some remarks on collectors and collecting . . .* (New York: Cassell & Co., 1885).

Koehler expressed his exceptionally high regard for her work when he published *Solitude* (catalogue no. 97) in the 1881 *American Art Review*:

> In etching Mrs. Moran finds a language that accords entirely with her ideas and modes of expression. She treats her subjects with poetical disdain of detail, but with a firm grasp of the leading truths that gives force and character to her work. While her etchings do not display the smoothness that comes from great mechanical dexterity, her touch is essentially that of a true etcher,–nervous, vigorous and rapid, and bitten in with a thorough appreciation of the relations of the needle and acid, preferring robustness of line to extreme delicacy. The influence of her husband's example is plainly visible in all she does, even in the restlessness that pervades most of her plates. But with this peculiarity are also coupled the other admirable qualities of Mr. Moran's work,–the vivid suggestion of color, and mixing of light and air, as of a sunshiny but windy day, when cloud shadows are scattered all over the landscape and break up its unity.[55]

Koehler described some of the qualities of *Solitude* which relate it and most of Mary Moran's work to the Barbizon style: its expression of poetic and general "truths" in nature, its depiction of atmospheric light and attention to qualities of the weather, and its overall light effects which distract from any emphasis on structure. Its intimate, quiet scene and its title (which interprets the scene to the viewer) are typical of Barbizon etchings. The pensive image of the pond had already appeared in the paintings of the Hudson River School artists.

For the Morans' joint retrospective exhibition of etchings at Klackner's gallery in New York in 1889, the reviewer for The

Critic wrote:

> Though husband and wife, each, as not well-known to amateurs, sees and interprets nature in a different way. Mr. Moran likes complicated and difficult subjects, composes in the Turneresque manner, and is master of a technique equalled for range and subtlety by few living etchers. Mrs. Moran's work is bolder, broader and more often displays sympathy with the ordinary aspects of nature.[56]

A SEPARATE SPHERE FOR WOMEN

Several critics praised Mary Moran's etchings for their masculine qualities. The *New York Daily Herald* reprinted a critique from the *London Daily News* of April 4, 1881, and remarked with surprise that Mary Nimmo Moran's "work is so masculine that the *Daily News* critic takes it for that of a man."[57]

In her 1883 article on American etchers in *Century Magazine*, Mariana van Rensselaer wrote:

> Her work would never reveal her sex–according, that is, to the popular idea of feminine characteristics. It is, above all things, direct, emphatic, bold–exceeding in these qualities, perhaps that of any of her male co-workers.[58]

Van Rensselear described Moran's etching *Solitude* as a "preeminently manly" piece of work and used masculinity as a standard in judging both *Twilight* and her Royal Society of Painter-Etchers diploma print, *The Goose Pond–East Hampton*:

> . . . [*Solitude*,] with its tall, thin tree-trunks cutting sharply against a background of half dark foliage and half pale sky, and its solid, well-contrasted effects of light and shadow, is a preeminently manly piece of work. The *Goose Pond* . . . is quite as good, though not so original in motive, while the largest plate yet etched by her, the *Twilight* . . . is even finer.[59]

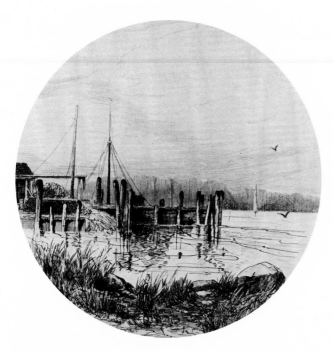

114. Edith Penman, [*Moorings*]

Print dealers Frederick Keppel and Frank Roullier chose to quote from this portion of van Rensselaer's statement in their sales catalogue, perhaps believing that Moran's prints would sell better if their manly qualities were emphasized. In 1932 Elizabeth Luther Cary also described the assertiveness of Moran's work as masculine:

> From the boldness of the line and the frank and rugged style throughout I should think it must have been Mary Nimmo, the wife and pupil of Thomas, who surpassed her husband in all of the points which are usually counted masculine.[60]

And within a few years of Moran's death one writer even declared that her style had gone beyond the boldness he saw in men's work:

> Her work was direct, emphatic, and bold to a point even that would not be attempted by male workers in the same line of art. Her own intimate force of character, her broad, skillful treatment of her subjects, and her wise avoidance of affectation and incongruities resulted in the production of plates that had about them no suggestion of a woman's hand.[61]

One way women expressed their determination to be taken seriously as professional artists was, of course, through style and form. Perhaps Mary Nimmo Moran adopted artistic qualities which were thought to be manly or masculine to draw serious attention to herself and to her work. Her expressive, bold, assertive style is a statement about herself as a committed professional artist.

Moran's prints have not been collected in proportion to her production and fame, but complete sets of etchings by her and by Cassatt have been saved. For most women etchers, however,

we have found no impressions of many of the titles which are recorded in exhibition catalogues. As far as we have been able to determine, not even one print survives by Sarah Cole, Anna P. Dixwell, Mary Franklin, Eleanor Greatorex, Lilian Taylor Kiliani, Eleanor Matlack, Alice E. Morley, Phoebe Natt, Anne Parrish, Clara V. Richardson, Margaret Ruff, and Annie C. Shaw, most of whom exhibited with the New York Etching Club.

We have almost no information from the artists' records on numbers of impressions and sales. Anna Lea Merritt reported to Koehler in 1879 that the proofs of *Ellen Terry as Ophelia*, of which she had printed twenty-five impressions on Japan paper before turning her plate over to *The Etcher* for publication, were a success when they were offered for sale.[62] According to Eliza Greatorex's brother-in-law, William D. Despard, "her best etchings" up to 1880 had been sold abroad.[63]

A variety of prints have been deposited in museums and libraries one, and sometimes several, at a time. But much of what does exist in public collections can be credited to Sylvester Koehler. He arranged for the *American Art Review* to donate to the Boston Museum of Fine Arts impressions from plates published between 1879 and 1881, including works by Eliza Greatorex, Merritt, and Mary Nimmo Moran. He solicited gifts from the artists for the Boston Museum and the U.S. National Museum. At the time of the *Women Etchers of America* exhibition in 1887 the Boston Museum formed a committee, probably at the suggestion of Koehler, which selected fifteen prints from the show for purchase. Koehler gave his personal collection to the Boston Museum in 1898, shortly before his death. It included etchings by ten women.

Samuel P. Avery continued to collect Cassatt's prints after the women etchers exhibition, buying her 1890 drypoints and 1891 color prints through a dealer in Paris almost as soon as they came from the press. But Avery's European Salon orientation and fast pace in collecting brought few American women etchers to his notice. The only other etchings by American women in his monumental collection were works by Eliza Greatorex and Mary Nimmo Moran.

Dealer-publisher Frederick Keppel gave to the New York Public Library many etchings from his collection of prints, including works by about thirty American women as well as contemporary and earlier European women. But Philadelphia collector Charles Henry Hart, who delivered a lecture entitled "Some lessons of encouragement from the lives of American women artists" to the graduates of the Philadelphia School of Design for Women in 1906, apparently owned very little art by American women and only one print, Merritt's *Ophelia*.

Following the *Women Etchers of America* exhibition, women's etchings were exhibited together in two special groups at the 1893 World's Columbian Exposition in Chicago. Frederick Keppel gathered from his own and other collections a selection of etchings (and a few wood engravings) by European and American women to exhibit in the Woman's Building. In the Pennsylvania Building, etchings by Philadelphia women were hung by Emily Sartain (1841-1927) and her committee to decorate the Ladies' Parlor. Sartain commissioned two of the painter-etchers to paint murals for the Ladies'

Reception Room. Gabrielle Clements's mural, *Harvest*, was for sale for $1,500, and Margaret Lesley Bush-Brown's *Spring* was offered for $1,000. Cassatt, who was represented in the Keppel Collection by four drypoints, painted a mural, *Modern Woman*, to decorate the Woman's Building. The organizers of the art department for the 1895 Cotton States Exposition in Atlanta placed Blanche Dillaye's etchings in a separate section titled "Works of Art by Women," which also included paintings by Anna Lea Merritt and Emily Sartain. Other women were integrated in the list of works in the main art department.

Some of the artists who participated in the *Women Etchers of America* exhibition expressed opinions about the status of women artists and about exhibiting women's art separately. Cassatt wrote to her dealer, Paul Durand-Ruel, in the late 1890s that she did not want to be included in "amateur" women artists' exhibitions in America:

> I have just received a letter from a lady secretary of the Ladies Art League, telling me that you promised her a choice of my pictures belonging to you to show in the exhibition that these ladies are going to have, subject to my consent. I refuse absolutely and I believe that you will not profit at all in showing my work in this exhibition. I know that my works have been sent even to the most amateur exhibitions of women artists in America. I doubt that this practice will do me any good, nor you. I would have thought that for selling, there would have been more opportunity last year in London.[64]

Cassatt, who had often had to defend her desire to become an artist, believed that women should have equal professional opportunities. But despite pleas from Mrs. Bertha Palmer, President of the Board of Lady Managers for the Woman's Building at the Columbian, that she accept an appointment as one of two women members of the International Board of Juries, Cassatt refused.[65] An opponent of the jury system, Cassatt probably declined to serve in the belief that the abolishment of juries would eliminate an impediment to professional women artists. Cassatt did not participate actively in the women's movement until 1915, when she helped organize a fund-raising exhibition in New York, *Suffrage Loan Exhibition of Old Masters and Works by Edgar Degas and Mary Cassatt.*

I do not know whether Cassatt meant the reference to "amateur" women's exhibitions in her letter to Paul Durand-Ruel to include the *Women Etchers of America* exhibition held ten years earlier or whether she considered the exhibitions at the Ohio Valley Centennial and the Woman's Building at the Columbian to be amateur. Did she also react negatively when Durand-Ruel lent her paintings to the 1894, 1896, and 1899 exhibitions of the Woman's Art Club of New York, of which she was not a member?[66] Cassatt saw much of the mixed criticism written in America about her work and must have observed how difficult it was for a woman and a modernist to get a fair review, a problem which could be increased if all the exhibitors were women.

When Anna Lea Merritt submitted her etchings to the *Women Etchers of America* exhibition and agreed to paint a mural for the vestibule of the Woman's Building at the Columbian Exposition, she apparently did not protest that women were being exhibited separately in both cases. A member of

Mary Cassatt, photograph, The Art Institute of Chicago.

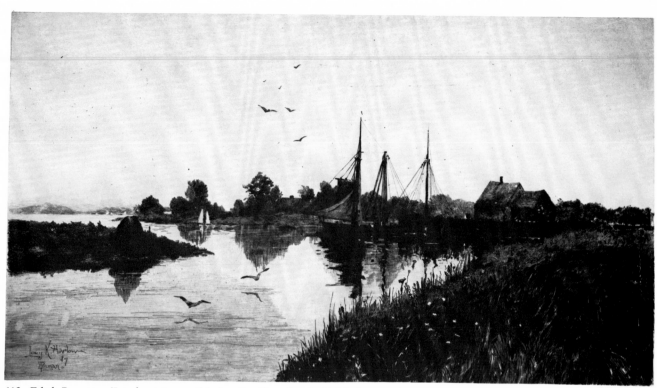

113. Edith Penman, [*Landscape*], possibly *Loading Up*, after L. K. Harlow

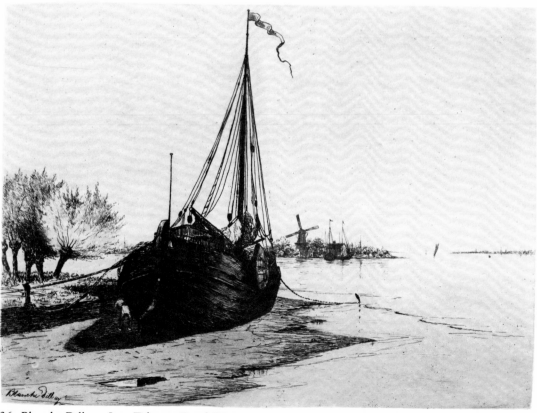

36. Blanche Dillaye, *Low Tide on a Dutch River*

96. Mary Nimmo Moran, *Point Isabel, Coast of Florida*

The Plastic Club, a group of Philadelphia women artists, she participated in their separate exhibitions during the first few years of the twentieth century. Yet, in 1900, in her "A Letter to Artists: Especially Women Artists" for *Lippincott's Monthly Magazine*, she wrote against separate exhibitions for women artists:

> Recent attempts to make separate exhibitions of women's work were in opposition to the views of the artists concerned, who knew that it would lower their standard and risk the place they already occupied. What we so strongly desire is a place in the large field: the kind ladies who wish to distinguish us as women would unthinkingly work us harm.[67]

Merritt complained in her memoirs that because women were restricted in their travel in the late 1860s her studies of art had been inhibited: "How I longed to be a man, freed from the tiresome conventions of young ladyhood."[68]

Women did receive some professional acknowledgement. In 1893 Frank Linstow White wrote that art had become a "recognized profession" for women and praised the quality of their work.

> Hardly more than a decade has passed since women artists of real ability and with serious purposes ceased to be a rarity. The flower- and still-life painting lady of amateurish tendencies has been always with us, but the energetic, hopeful female art student abreast with the most advanced theories, and differing from her male fellow workers neither by her choice of subjects nor her manner of execution, is, as a class, essentially a product of to-day.[69]

Twenty years after the 1887-88 *Women Etchers of America* exhibitions, Frank Weitenkampf, keeper of prints for the New York Public Library and one of the few early curators who took an interest in women artists, wrote on women etchers for *Scribner's Monthly*:

> The woman etcher of serious achievement is in the main and essentially a product of the late nineteenth century. She is not numerously represented, this type of artist who happens to be a woman, with which fact her art has not *per se* anything to do, and who makes no appeal on the score of sex nor by choice of sentimental subjects or manner. There are a few striking and particularly noteworthy examples of this quasi-sexless attitude, and a somewhat larger number who come in a good second. All of which does not imply that few women have etched. On the contrary, the list is long and extends far back in time.[70]

Nineteenth-century women who made etchings produced work of great excellence, and by the 1880s many of them were supporting themselves and their families as professional artists. As Weitenkampf and other writers have noted, their etchings cannot be distinguished from men's in quality, style, or subject matter. Yet their work has been neglected or treated separately from the mainstream of the nineteenth-century Etching Revival by historians, critics, and collectors primarily because they were women.

Notes

[1]"American Women Etchers; Exhibition of Their Work at the Museum of Fine Arts," *Boston Transcript*, November 4, 1887, p. 3, col. 5.

[2]The Women's Pavilion at the U.S. Centennial Exposition in 1876 was the first separate, comprehensive exhibition of women's work in America. See Judith Paine, "The Women's Pavilion of 1876," *Feminist Art Journal* 4 (Winter 1975-76): 5-12.

[3]Frances M. Benson, "The Moran Family," *The Quarterly Illustrator* 1 (April, May, June 1893): 81. For the history of the development of the idea of "women's proper sphere" see Barbara Welter, "The Cult of True Womanhood: 1820-1860," *American Quarterly* 18 (Summer 1966): 151-75; and Kathryn Kish Sklar, *Catharine Beecher: A Study in American Domesticity* (New Haven: Yale University Press, 1973). Gerda Lerner, in "The Lady and the Mill Girl," *American Studies* 10 (Spring 1969): 5-15, describes how this concept of women was applied to white middle- and upper-class women; the women who became printmakers were from various levels of the middle class. For the relationship between the ideology of "women's proper sphere" and the emergence of art as a profession for women, see Phyllis Peet, "The Emergence of American Women Printmakers in the Late Nineteenth Century" (Ph.D. diss., University of California, Los Angeles, 1987), chaps. 1 and 2.

[4]Blanche Dillaye, "Women Etchers," *Philadelphia Press*, November 27, 1895, Women's Edition, 17. For the history of the Etching Revival in the United States, see Rona Schneider, "The American Etching Revival. Its French Sources and Early Years," *The American Art Journal* 14 (Autumn 1982): 40-65; Maureen C. O'Brien and Patricia C. F. Mandel, *The American Painter-Etcher Movement* (Southampton, N.Y.: Parrish Art Museum, 1984); Francine Tyler, *American Etchings of the Nineteenth Century* (New York: Dover Publications, 1984); and Thomas P. Bruhn, *American Etching: The 1880s; January 21-March 10, 1985* (Storrs, Conn.: William Benton Museum of Art, University of Connecticut, 1985).

[5]Dillaye, "Women Etchers," 17.

[6]Ibid.

[7]"The Fine Arts: Women Etchers at the Union League," *The Critic* 12 (April 21, 1888): 195.

[8]M[ariana] G[riswold] van Rensselaer, Introduction to *Catalogue of The Works of the Women Etchers of America. April Twelfth to Twenty-first*, by the Union League Club, New York (New York: Union League Club, 1888), 3-4.

[9]Ibid., 3. While Cynthia D. Kinnard in her essay "Mariana Griswold van Rensselaer (1851-1934): America's First Professional Woman Art Critic," in *Women As Interpreters of the Visual Arts, 1820-1979*, ed. Claire Richter Sherman with Adele M. Holcomb (Westport, Conn.: Greenwood Press, 1981), 181-205, does not mention van Rensselaer's essay for the *Catalogue of The Works of the Women Etchers of America*, she does describe much of her work and concludes that van Rensselaer was "decidedly not a feminist. . . . van Rensselaer believed it was woman's role to influence and to educate, and it was this goal she pursued through her art criticism . . . ," p. 200.

[10]Sylvester R. Koehler, Introduction to *Exhibition of the Work of the Women Etchers of America, Nov. 1 to Dec. 31, 1887*, by the Museum of Fine Arts, Boston, Print Department (Boston: Alfred Mudge & Son for the Museum, 1887), 4.

[11]They include Margaret Lesley Bush-Brown, Katherine Levin Farrell, Margaret M. Taylor Fox, Edith Loring Peirce Getchell, Mary Cummings Brown Hatch, Lillian Bayard Taylor Kiliani, Blanche McManus Mansfield (b. 1870), Anna Lea Merritt, Martha Scudder Twachtman, and May Electa Ferris Smith.

[12]Sylvester R. Koehler, "Catalogue of the Contributions of the Section of Graphic Arts to the Ohio Valley Centennial Exposition, Cincinnati, 1888," in U.S. National Museum, *Proceedings* 10 (Washington, D.C.: Smithsonian Institution, 1888), 725.

[13]Ellen Day Hale to Koehler, Boston, December 6, 1888, Koehler Papers, D185, Archives of American Art, Smithsonian Institution.

[14]Ellen Day Hale to Koehler, Boston, December 18, 1888, Koehler Papers, D185, AAA, SI.

[15]Four men and two women attended the class at the National Academy. Smillie selected advanced students for his Art Students' League class. When they met he found he had an even larger majority of women students than he had planned for and wrote in his diary: "To Art Students' League Etching Class where I found my old enemy, 'the young woman,' out in force–nine young women and *two* young men. It makes me 'tired.' However, I was as patient as I knew how to be & did as well as I knew how." See James D. Smillie, Diary, March 21, 1894, James D. Smillie Papers, 2852, AAA, SI. Michael Schantz is working on a dissertation on Smillie.

[16]Dillaye, "Women Etchers," 17. Dillaye had shown her first print, *Salt Marsh*, which she etched in 1882, in the 1882-83 exhibition of the Philadelphia Society of Etchers. All the members of the Philadelphia Society were men, but etchings by Dillaye, Emily Moran, Mary Nimmo Moran, and H. Frances Osborne were included in the Society's exhibition. The 1884 Paris and London exhibits included Dillaye's *Marsh at Ocean City* (catalogue no. 37) and Peirce Getchell's *The Road to the Beach, at Nonquitt* (catalogue no. 53). They and Clements also exhibited several prints each with the New York Etching Club that year.

[17]Because of social and institutional restrictions on women's participation in professional organizations, camaraderie among women was especially important for artists. Through women's organizations and friendships artists exchanged information, made professional contacts, and provided support and encouragement for one another. In 1870 Margaret Lesley (Bush-Brown) and Phoebe Davis Natt had been fellow students at the Philadelphia School of Design for Women. Also studying with this group of six at the Pennsylvania Academy were etchers Margaret Lesley (Bush-Brown), Mary Franklin, May Electa Ferris (Smith), and Katherine Levin (Farrell). For a description of women artists' groups see Julie Graham, "American Women Artists' Groups: 1867-1930," *Woman's Art Journal* 1 (Spring/Summer 1980): 7-12.

[18]Hale, Dixwell, and Boott had been students of William Morris Hunt (1824-1879) and Helen M. Knowlton (1832-1918) in Boston in the 1870s. Boott and Dixwell were with Frank Duveneck (1848-1919) and Otto Bacher (1856-1909) in Florence, where Bacher taught Dixwell to etch early in 1880, the same year he and Whistler influenced Duveneck to etch in Venice. Bacher took his portable etching press from Munich to Florence and then to Venice. I have found no evidence that Boott experimented with etching.

[19]Ellen Day Hale to Margaret Lesley (Bush-Brown), Chartres, August 6/13, 1885, Bush-Brown Family Papers, Box 12, Sophia Smith Collection, Smith College, Northampton, Massachusetts. For a description of Hale see Martha J. Hoppin, "Women Artists in Boston, 1870-1900: The Pupils of William Morris Hunt," *The American Art Journal* 13 (Winter 1981): 37-42. Eric Denker is working on a catalogue of her prints to accompany an exhibition he is organizing for the National Museum of Women in the Arts, Washington, D.C. Peter Hastings

Falk is working on a biography of Hale.

[20]Hale to Lesley (Bush-Brown), Chartres, August 6/13, 1885, Bush-Brown Family Papers, Box 12, SSC, SC.

[21]Ellen Day Hale to Emily P. and Edward Everett Hale, Chartres, August 29, 1885, Hale Family Papers, Box 45, SSC, SC.

[22]Phebe [Phoebe] D. Natt, "Paris Art-Schools," Lippincott's Monthly Magazine 27 (March 1881): 272-73.

[23]Ellen Day Hale to Miss Curtis, Boston, May 14, 1887, Hale Family Papers, Box 45, SSC, SC; Marie Adelaide Belloc (Lowndes), "Lady Artists in Paris," Murray's Magazine 8 (September 1890): 377; and "The Art Student in Paris," The Art Amateur 27 (June 1892): 10. Belloc explained that the rationalization for this was that since the Ecole des Beaux Arts offered free training to men, the private academies had to be competitive in order to attract men students, but they could charge women any price because women were not admitted to the Ecole des Beaux Arts and had nowhere else to go. In 1886 Julian operated nine studios, five for men and four for women. In 1890 there were seventeen, seven of which were for women. Lucy H. Hooper, "Art Schools of Paris," Cosmopolitan Magazine 13 (November 1892): 60, reported that there were over 1,000 students, of whom 300 to 400 were women. Katharine DeForest, "Art Student Life in Paris," Harper's Bazar 33 (July 7, 1900): 631, reported that men paid 25 francs and women paid 60 francs a month for a half day. For more information see Christine Havice, "In a Class By Herself: 19th Century Images of the Woman Artist as Student," Woman's Art Journal 2 (Spring/Summer 1981): 35-40; and Jo Ann Wein, "The Parisian Training of American Women Artists," Woman's Art Journal 2 (Spring/Summer 1981): 41-44.

[24][Copley Society, Boston], The Art Student in Paris (Boston: Boston Art Students' Association, 1887), 23.

[25]Louisa May Alcott encouraged the work of her sister, May Alcott, when she gave her $1,000 from her profits on Work, A Story of Experience (Boston: Roberts Brothers, 1872), her novel about women's problems in earning a living, so that May could go to London to study art.

[26]Margaret Bertha Wright, "Art Student Life in Paris," The Art Amateur 3 (September 1880): 70.

[27]Margaret Bertha Wright, "Eleanor and Kathleen Greatorex," The Art Amateur 13 (September 1885): 69.

[28]Eliza Greatorex made her first experiments in etching in 1868; her etching The Pass of St. Gothard, which she probably copied from one of her drawings made in Europe, was included in the 1868 National Academy of Design exhibition. She apparently did not touch an etching needle again until 1874, when she decided to reproduce in etching her drawings for the new edition she was planning of her New York portfolio, Old New York, from the Battery to Bloomingdale; Etchings by Eliza Greatorex (New York: G. P. Putnam's, 1875). The published book contained collotypes described as "etched reproductions by H. Thacher." To Greatorex at this time collotype and etching both simply represented methods to make multiple copies of her art. She did not yet consider etching a special means of expression. She exhibited etchings and a cliché verre, Bits of Nuremberg, at the 1875 National Academy of Design exhibition. She may have been influenced to experiment with cliché verre during one of her trips to Paris, or Bits of Nuremberg may have actually been executed in collotype, a process which also combines drawing and photography.

[29]We know Under the Lamp was in the exhibit because of an annotation in the copy of the New York version of the catalogue in the New York Public Library. I want to thank Nancy Mowll Mathews and Madeleine Fidell Beaufort for discussing with me which of Samuel P. Avery's Cassatt prints may have been in the Women Etchers of America exhibitions.

[30]"The Fine Arts: Women Etchers at the Union League," 195.

[31]Frank Linstow White, "Our Women in Art," The Independent 44 (August 25, 1892): 7.

[32]Mary Cassatt to Paul Durand-Ruel, Cap d'Antibes, [February 17, 1892], coll. Durand-Ruel & Cie, Paris, published in Nancy Mowll Mathews, ed., Cassatt and Her Circle; Selected Letters (New York: Abbeville Press, 1984), 227-28.

[33]Mary Cassatt to Joseph Durand-Ruel, Cap d'Antibes, February 18, [1892], coll. Durand-Ruel & Cie, Paris, published in Mathews, 228. In 1893 the Musée du Luxembourg purchased a set of her color prints. Nancy Mathews and Barbara Shapiro are working on an exhibition and catalogue of Cassatt's color prints for the National Gallery of Art, Washington, D.C.

[34][Anna Lea Merritt], Love Locked Out; The Memoirs of Anna Lea Merritt with a Checklist of Her Works, ed. Galina Gorokhoff (Boston: Museum of Fine Arts, [1983]), 119-20.

[35]Sylvester R. Koehler, "The Works of the American Etchers. VIII—Anna Lea Merritt," American Art Review 1, pt. 1 (1880): 230.

[36]She printed impressions of this in black and white and in color à la poupée. There is no other evidence that she worked in color during the nineteenth century. Since her etching plates remained in her hands, I think she may have made the color impression in the 1920s when she and Clements were experimenting with color.

[37]Ellen Day Hale to Margaret Lesley (Bush-Brown), Chartres, August 31, 1885, Bush-Brown Family Papers, Box 12, SSC, SC.

[38]Dillaye, "Women Etchers," 17.

[39]Martha Scudder to Koehler, Cincinnati, December 20, 1880, Koehler Papers, D190, AAA, SI.

[40]Blanche Dillaye, "Etching" (quoting from her lecture), in The Congress of Women Held in the Woman's Building, World's Columbian Exposition, Chicago, U.S.A., 1893 (Chicago and Philadelphia: S. I. Bell & Co., 1894), 644.

[41]"The Fine Arts: Women Etchers at the Union League," 195.

[42]J. R. W. Hitchcock, Etching in America, . . . (New York: White, Stokes, & Allen, 1886), 85.

[43]"The Fine Arts: The Water-Colorists and the Etchers," The Critic 7 (February 5, 1887): 69. Her teacher, Stephen Parrish, translated drawings from nature into etchings back in his studio—a practice of many American landscape painters who were committed to depicting the out-of-doors in its natural light. Whistler, who often did the same, felt the practice did not prevent the final etching from being regarded as made "from nature."

[44]Sylvester R. Koehler, ed., Gems of American Etchers (Cassell & Co., 1885), n. pag.

[45]Ibid. It is doubtful that Koehler was the author of this essay. I have read nothing else by him which would suggest that he held this view of women's role in art.

[46]Will Jenkins, "Modern Etching and Engraving in America," in Modern Etchings and Engravings; Special Summer Number of "The Studio," ed. Charles Holme (London, Paris, New York: "The Studio," 1902), 83.

[47]Nancy Hale, The Life in the Studio (Boston and Toronto: Little, Brown & Co., 1957), 111-12. Clements's descriptions of process are

preserved in the Graphic Arts Division, National Museum of American History, Smithsonian Institution.

[48]Mary Nimmo Moran, handwritten "Autobiographical Sketch," undated (incomplete), and Ruth B. Moran, handwritten "Draft for Biographical Sketch of Mary Nimmo Moran," 4, Thomas Moran Biographical Collection, East Hampton Free Library, East Hampton, New York. For a description of Moran's printmaking career, see Bruhn, 27-72; Anne Morand, *Prints of Nature; Poetic Etchings of Mary Nimmo Moran; September 7-December 2, 1984* (Tulsa: Thomas Gilcrease Institute of American History and Art, 1984); and Marilyn G. Francis, "Mary Nimmo Moran: Painter-Etcher," *Woman's Art Journal* 4 (Fall 1983/Winter 1984): 14-19.

[49]Mary Nimmo Moran, Newark, n.d., Richard Watson Gilder Papers, Manuscript Division, New York Public Library. The letter was probably written in the summer of 1879 to Mrs. Helena De Kay Gilder (1848-1916), activist-artist and wife of Scribner and Century editor Richard Watson Gilder (referred to as "Watsy" in the letter). Mary Moran made etchings in Easton, Pennsylvania, in 1879 and 1881. There is a print by her dated 1879, *East Hampton Barrens*, which according to tradition was done from nature. However, one author has suggested that it perhaps was made from sketches from the year before since there is no record that the Morans went to East Hampton in 1879. Mary went to Easton in the summer of 1879 while Thomas was on a trip west. It is possible she also went to East Hampton while he was away. She does not mention Thomas in this Gilder letter, so he perhaps was away from home when she wrote it. The letter probably describes her 1879 trips to Easton during his absence; she made her first etchings there. If 1879 is the correct date for the letter, the trip to East Hampton mentioned in it helps to support the tradition that *East Hampton Barrens* was done from nature. In June 1881, the Morans moved from Newark into New York, which also helps to confirm an 1879 date for the letter.

[50]Anna Lea Merritt, "A Letter to Artists: Especially Women Artists," *Lippincott's Monthly Magazine* 65 (March 1900): 467.

[51]Thomas Moran to Mary Moran, Kanab, August 13, 1873, Thomas Moran Biographical Collection, EHFL.

[52]Mary Nimmo Moran, "Autobiographical Sketch."

[53]Ruth B. Moran, "Draft for Biographical Sketch of Mary Nimmo Moran," 4.

[54]L[eslie] W. Miller, "An Art for Enthusiasts," *Our Continent* 3 (January 31, 1883): 139.

[55]Sylvester R. Koehler, "The Works of the American Etchers. XX–Mrs. M. Nimmo Moran," *American Art Review* 2, pt. 1 (1881): 31.

[56]"Etchings at Klackner's," *The Critic* 14 (March 16, 1889): 135.

[57]"Fine Arts," *New York Daily Herald*, April 26, 1881, in "Scrapbook," Thomas Moran Biographical Collection, EHFL.

[58]M[ariana] G[riswold] van Rensselaer, "American Etchers," *The Century Magazine* 25 (February 1883): 494.

[59]Ibid.

[60]Elizabeth Luther Cary, "The Morning of American Etching," *Parnassus* 4 (March 1932): 5.

[61]Morris T. Everett, "The Etchings of Mrs. Mary Nimmo Moran," *Brush and Pencil* 8 (April 1901): 4.

[62]Anna Lea Merritt to Koehler, Philadelphia, December 3, 1879, Koehler Papers, D188, AAA, SI.

[63]William B. Despard to Koehler, New York, January 8, 1881, Koehler Papers, D184, AAA, SI. In this letter Despard forwards to Koehler for the *American Art Review* the bill for the plate of *The Pond, Cernay-la-ville* (without quoting the price).

[64]Mary Cassatt to Paul Durand-Ruel, Mesnil-Beaufresne, June 22, [ca. 1898], coll. Durand-Ruel & Cie, Paris, published in Mathews, 266-67.

[65]See Bertha Palmer to Mary Cassatt, Chicago, December 15, 1892, and January 31, 1893, coll. Chicago Historical Society, reproduced in Mathews, 242, 245-46.

[66]Ellen Day Hale and Blanche Dillaye were members of the Woman's Art Club of New York. Exhibitors in their annual shows included Margaret Lesley Bush-Brown and Edith Penman.

[67]Merritt, "A Letter to Artists: Especially Women Artists," 467.

[68][Merritt], *Love Locked Out; . . .* , 56.

[69]Frank Linstow White, "Younger American Women in Art," *Frank Leslie's Popular Monthly* 33 (June 1892): 538.

[70]Frank Weitenkampf, "Some Women Etchers," *Scribner's Monthly* 46 (December 1909): 731. In 1901 Weitenkampf wrote the *Catalogue of a Collection of Engravings, Etchings and Lithographs By Women* for the exhibition of the Koenen collection of works of European women printmakers which Samuel P. Avery had purchased and given to the New York Public Library.

CHECKLIST OF THE EXHIBITION

Listed in alphabetical order by artist, with selected nineteenth century exhibitions. Asterisk (*) indicates that work is illustrated.

1. Margaret White Lesley Bush-Brown, 1857-1944
 Autumn Leaves, ca. 1885
 Etching on wove paper, 3⅛ x 4⅝ inches
 Signed in pencil l.r.
 Lent by the Miriam and Ira D. Wallach Division of Art, Prints and Photographs, The New York Public Library, Astor Lenox and Tilden Foundations, MEYG
 Exhibited: Boston Art Club, 1886; Union League Club, N.Y. (as *In A Wood*), 1888(?)

2. Margaret White Lesley Bush-Brown, 1857-1944
 Fishing, 1885
 Etching on Japan, 12 x 7⅛ inches
 Signed and dated in plate l.l.
 Lent by the Sophia Smith Collection, Smith College
 Exhibited: New York Etching Club, 1886

3. Margaret White Lesley Bush-Brown, 1857-1944
 A Market in Normandy, ca. 1884
 Etching and drypoint on laid paper, 13⅞ x 8¾ inches
 Signed in pencil l.r.; signed in plate l.r.
 Lent by the Miriam and Ira D. Wallach Division of Art, Prints and Photographs, The New York Public Library, Astor Lenox and Tilden Foundations, MEYG
 Exhibited: Union League Club, N.Y., 1888

4. Margaret White Lesley Bush-Brown, 1857-1944
 A Mid-Summer Day Dream, ca. 1885 *
 Etching and drypoint on laid paper, 8⅝ x 11⅛ inches
 Signed, titled, and dated in plate l.l.; remarque of young woman asleep l.r. margin
 Lent by the Miriam and Ira D. Wallach Division of Art, Prints and Photographs, The New York Public Library, Astor Lenox and Tilden Foundations, MEYG
 Exhibited: New York Etching Club, 1886; Union League Club, 1888

5. Margaret White Lesley Bush-Brown, 1857-1944
 Portrait of Ellen Day Hale, 1883
 Etching on Japan, 9 x 6⅞ inches
 Signed and dated in plate u.l.
 Lent by the Sophia Smith Collection, Smith College
 Exhibited: New York Etching Club, 1884

6. Louise Prescott Canby, active 1874-1903
 A Road at Colora, 1885
 Etching on wove paper, from portfolio *Etched Sketches*, 5¼ x 9¾ inches
 Signed in plate l.r.
 Lent by the Pennsylvania Academy of the Fine Arts, Philadelphia
 Shown at the High Museum of Art and The Woodmere Art Museum only
 Exhibited: Museum of Fine Arts, Boston, 1887; Union League Club, N.Y., 1888; New York Etching Club, 1888

7. Louise Prescott Canby, active 1874-1903
 A Summer Afternoon, 1885
 Etching on wove paper, from portfolio *Etched Sketches*, 3⅞ x 7 inches
 Signed in plate l.r.
 Lent by the Pennsylvania Academy of the Fine Arts, Philadelphia
 Shown at the Hudson River Museum of Westchester and the National Museum of American History, Smithsonian Institution, only
 Exhibited: Museum of Fine Arts, Boston, 1887; Union League Club, N.Y., 1888

8. Mary Stevenson Cassatt, 1844-1926
 The Bonnet, ca. 1891 (B137) *
 Drypoint on laid paper, 2nd state, 7¼ x 5⁷⁄₁₆ inches
 Signed in pencil l.r. "épreuve d'essai/Mary Cassatt"; Watermark u.l. in reverse parallel to l. edge
 High Museum of Art, purchase with funds from the Lawrence and Alfred Fox Foundation for the Ralph K. Uhry Collection, 57.42
 Exhibited: Galerie Durand-Ruel, Paris, 1893; Galerie Durand-Ruel, N.Y., 1895

9. Mary Stevenson Cassatt, 1844-1926
 Katherine Cassatt, 1880 (B37)
 Drypoint on laid paper, 5½ x 3⅞ inches
 Signed in pencil l.l.
 Lent by the Library of Congress
 Shown at the High Museum of Art and Hudson River Museum only
 Exhibited: Museum of Fine Arts, Boston, 1887; Union League Club, N.Y., 1888

10. Mary Stevenson Cassatt, 1844-1926
 Gathering Fruit, 1893 (B157)
 Drypoint and aquatint in colors on laid paper, 5th state, 16¾ x 11¾ inches
 Signed in pencil l.r.
 Lent by the Library of Congress
 Shown at the High Museum of Art only
 Exhibited: Galerie Durand-Ruel, Paris, 1893; Galerie Durand-Ruel, N.Y., 1895

11. Mary Stevenson Cassatt, 1844-1926
The Letter, 1891 (B146)
Drypoint, soft-ground etching, and aquatint in colors on laid paper, 3rd state, no. 4 in set of 10, printed in an edition of 25; 13⅝ x 8¹⁵⁄₁₆ inches
Signed in pencil with note "Imprimée par l'artiste et M. Leroy" l.r.
Lent by the Library of Congress
Shown at the High Museum of Art only
Exhibited: Galerie Durand-Ruel, Paris, 1891, 1893; Frederick Keppel Gallery, N.Y., 1891; Galerie Durand-Ruel, N.Y., 1895

12. Mary Stevenson Cassatt, 1844-1926
Mlle. Luguet Seated on a Couch, ca. 1880 (B49)
Soft-ground etching and aquatint on laid paper, 2nd state, 8½ x 5½ inches
Signed in pencil l.l.
Lent by the Library of Congress
Shown at the High Museum of Art and Hudson River Museum only
Exhibited: Possibly with Impressionists, Paris, 1880, as *Portrait d'enfant*; Museum of Fine Arts, Boston, 1887; Union League Club, N.Y., 1888; Galerie Durand-Ruel, Paris, 1893

13. Mary Stevenson Cassatt, 1844-1926
Maternal Caress, 1891 (B150)
Drypoint, soft-ground etching, and aquatint in colors on laid paper, 3rd state, no. 8 in set of 10, printed in an edition of 25; 14½ x 10½ inches
Signed in pencil with note "Imprimée par l'artiste et M. Leroy" l.r.
Lent by the Library of Congress
Shown at the High Museum of Art only
Exhibited: Galerie Durand-Ruel, Paris, 1891, 1893; Frederick Keppel Gallery, N.Y., 1891; Galerie Durand-Ruel, N.Y., 1895, 1915

14. Mary Stevenson Cassatt, 1844-1926
Under the Lamp (*Two Women at a Lamp*), ca. 1880 (B748) *
Pencil, 8 x 8½ inches
Signed in pencil l.l.
Anonymous Loan

15. Mary Stevenson Cassatt, 1844-1926
Under the Lamp (*Two Women at a Lamp*), ca. 1880 (B71) *
Soft-ground etching and aquatint on laid paper, 7¾ x 8¹¹⁄₁₆ inches
Signed in pencil l.l.; "état" in pencil l.r.
Lent by the Miriam and Ira D. Wallach Division of Art, Prints and Photographs, The New York Public Library, Astor Lenox and Tilden Foundations, MEZAP
Exhibited: Possibly with Impressionists, Paris, 1880, as *Le soir*; Museum of Fine Arts, Boston, 1887; Union League Club, N.Y., 1888; Galerie Durand-Ruel, Paris, 1893

16. Mary Stevenson Cassatt, 1844-1926
The Visitor, ca. 1880-81 (B34)
Soft-ground etching, aquatint, drypoint, and fabric texture, on laid paper, 4th state, 15⅝ x 12³⁄₁₆ inches

Lent by the Library of Congress
Shown at the High Museum of Art only
Exhibited: Galerie Durand-Ruel, Paris, 1893

17. Gabrielle DeVaux Clements, 1858-1948
The Birches, 1936
Aquatint in colors on Japanese vellum, 11⅞ x 7⅛ inches
Signed in pencil l.r.; "Sc & Imp" in pencil l.l.
Lent by the Division of Graphic Arts, National Museum of American History, Smithsonian Institution, 17164

18. Gabrielle DeVaux Clements, 1858-1948
Bishop Berkeley's Seat, 1887
Etching on laid paper, from *Newport; Six Etchings by Miss G. D. Clements and Miss E. D. Hale* (Boston: L. Prang & Co.), 3⅜ x 5 inches
Titled in plate l.r.; signed in plate l.l.
Lent by Rona Schneider

19. Gabrielle DeVaux Clements, 1858-1948
Ft. Dumpling and Beavertail Light, 1887
Etching on laid paper, from *Newport; Six Etchings by Miss G. D. Clements and Miss E. D. Hale* (Boston: L. Prang & Co.), 2½ x 4½ inches
Signed in plate l.r.; titled in plate l.l.
Lent by Rona Schneider

20. Gabrielle DeVaux Clements, 1858-1948
In the Harbor, Newport, 1887
Etching on laid paper, from *Newport; Six Etchings by Miss G. D. Clements and Miss E. D. Hale* (Boston: L. Prang & Co.), 3 x 6 inches
Titled in plate l.r.; signed in plate l.l.
Lent by Rona Schneider

21. Gabrielle DeVaux Clements, 1858-1948
Long Wharf–Newport, 1887
Etching on laid paper, from *Newport; Six Etchings by Miss G. D. Clements and Miss E. D. Hale* (Boston: L. Prang & Co.), 2½ x 4⅛ inches
Titled and signed in plate l.l.
Lent by Rona Schneider

22. Gabrielle DeVaux Clements, 1858-1948
The Mill Race, 1884; published in 1889 by Christian Klackner, N.Y.
Etching on Japan, 13¾ x 7½ inches
Signed and dated in plate l.l.
Lent by the Library of Congress
Shown at the High Museum of Art and Hudson River Museum only
Exhibited: New York Etching Club, 1885; Museum of Fine Arts, Boston, 1887; Union League Club, N.Y., 1888

23. Gabrielle DeVaux Clements, 1858-1948
An Old House, Elm Street, Newport, 1887
Etching, from *Newport; Six Etchings by Miss G. D. Clements and Miss E. D. Hale* (Boston: L. Prang & Co.), 2⁹⁄₁₆ x 4¹⁄₁₆ inches
Lent by Rona Schneider

24. Gabrielle DeVaux Clements, 1858-1948
The Old Moat, Chartres, 1885*
Etching on wove paper, 11 x 8 inches
Signed and dated in plate l.l.; signed in pencil l.r.
Lent by the Museum of Fine Arts, Boston, Museum purchase, 1888, M5088
Exhibited: New York Etching Club, 1886; Museum of Fine Arts, Boston, 1887; Union League Club, N.Y., 1888; Pennsylvania Academy of the Fine Arts, Philadelphia, 1888; World's Columbian Exposition, Chicago, Pennsylvania Building, Ladies' Parlor, 1893

25. Gabrielle DeVaux Clements, 1858-1948
A Pond by the Sea (By the Shore), 1883
Etching on laid paper, 6½ x 11⅝ inches
Signed in plate l.l.; "XIX" in plate l.l.
Lent by Rona Schneider
Exhibited: Museum of Fine Arts, Boston, 1887; Union League Club, N.Y., 1888

26. Gabrielle DeVaux Clements, 1858-1948
The Ravine, Tryon, North Carolina, 1918
Copperplate with etching and aquatint, 8⅝ x 4¾ inches
Lent by the Division of Graphic Arts, National Museum of American History, Smithsonian Institution, 10732

27. Gabrielle DeVaux Clements, 1858-1948
The Ravine, Tryon, North Carolina, 1918
Etching and aquatint on Japanese vellum, 8⅝ x 4¾ inches
Inscribed across bottom: "Clear wiped proof on plate paper for experiment in pencil for height of mountain in back-ground."
Lent by the Division of Graphic Arts, National Museum of American History, Smithsonian Institution, 10733

28. Gabrielle DeVaux Clements, 1858-1948
The Ravine, Tryon, North Carolina, 1918
Etching and aquatint with pencil on Japanese vellum, 8⅝ x 4¾ inches
Inscribed across bottom: "Proof on plate paper worked in pencil to determine effect of aqua-tint."
Lent by the Division of Graphic Arts, National Museum of American History, Smithsonian Institution, 10734

29. Gabrielle DeVaux Clements, 1858-1948
The Ravine, Tryon, North Carolina, 1918
Etching and aquatint in colors on Japanese vellum, 8⅝ x 4¾ inches
Signed in pencil l.r.
Lent by the Division of Graphic Arts, National Museum of American History, Smithsonian Institution, 10736

30. Gabrielle DeVaux Clements, 1858-1948
The Ravine, Tryon, North Carolina, 1918
Etching and aquatint in colors on Japanese vellum, 8⅝ x 4¾ inches

Signed in pencil l.r.; "No. 5" in pencil l.l.
Lent by the Division of Graphic Arts, National Museum of American History, Smithsonian Institution, 13107

31. Gabrielle DeVaux Clements, 1858-1948
The Ravine, Tryon, North Carolina, 1918
Etching and aquatint in colors on Japanese vellum, 8⅝ x 4¾ inches
Lent by the Division of Graphic Arts, National Museum of American History, Smithsonian Institution, 13108

32. Gabrielle DeVaux Clements, 1858-1948
The Return, Gloucester, Massachusetts, ca. 1887*
Etching on Japanese vellum, 7¼ x 6½ inches
Signed in pencil l.r.
Lent by the Library of Congress
Shown at the High Museum of Art only

33. Gabrielle DeVaux Clements, 1858-1948
Up the Steps, Mont St. Michel, 1885*
Etching on wove paper, 8⅜ x 3³⁄₁₆ inches
Signed and dated in plate l.l.; signed in pencil l.r.
Lent by Rona Schneider
Exhibited: New York Etching Club, 1886; Museum of Fine Arts, Boston, 1887; Union League Club, N.Y., 1888; Pennsylvania Academy of the Fine Arts, Philadelphia, 1888; World's Columbian Exposition, Chicago, Woman's Building, 1893

34. Blanche Dillaye, 1851-1931
Fishing Weirs, Bay of Fundy, ca. 1889*
Etching on wove paper, 6⅜ x 12⅞ inches
Signed in plate l.l.; signed in pencil l.r.
Lent by the Syracuse University Art Collection, 63.717
Exhibited: New York Etching Club, 1891; World's Columbian Exposition, Chicago, Pennsylvania Building, Ladies' Parlor, 1893

35. Blanche Dillaye, 1851-1931
A French Roadway, 1886
Etching and drypoint on Japan, 12⁹⁄₁₆ x 8⅛ inches
Signed and dated in plate l.l.; signed in pencil l.r.
Lent by the Miriam and Ira D. Wallach Division of Art, Prints and Photographs, The New York Public Library, Astor Lenox and Tilden Foundations
Exhibited: Cotton States and International Exposition, Atlanta, 1895

36. Blanche Dillaye, 1851-1931
Low Tide on a Dutch River, 1887*
Etching on Japan, 8⅜ x 11⅜ inches
Signed and dated in plate l.l.; signed in pencil l.r.
Lent by the Miriam and Ira D. Wallach Division of Art, Prints and Photographs, The New York Public Library, Astor Lenox and Tilden Foundations, MEYG
Exhibited: Museum of Fine Arts, Boston, 1887; Union League Club, N.Y., 1888; New York Etching Club, 1888; World's Columbian Exposition, Pennsylvania Building, Corridor, 1893

37. Blanche Dillaye, 1851-1931
Marsh at Ocean City, 1883
Etching and drypoint on Japan, 5⅞ x 11⅝ inches
Signed in plate l.l.; signed in pencil l.r.
Lent by the Miriam and Ira D. Wallach Division of Art,
Prints and Photographs, The New York Public Library,
Astor Lenox and Tilden Foundations, MEYG
Exhibited: Paris Salon, 1884; Royal Society of Painter-
Etchers, London, 1884; New York Etching Club, 1884;
Museum of Fine Arts, Boston, 1887; Union League Club,
N.Y., 1888; World's Columbian Exposition, Chicago, Penn-
sylvania Building, Ladies' Parlor, 1893

38. Blanche Dillaye, 1851-1931
Mist on the Cornish Coast, ca. 1891 *
Etching on Japan, 10⅝ x 17 inches
Signed in plate l.l.; signed in pencil l.r.
Lent by the Miriam and Ira D. Wallach Division of Art,
Prints and Photographs, The New York Public Library,
Astor Lenox and Tilden Foundations, MEYG+
Exhibited: New York Etching Club, 1892; World's Columbian
Exposition, Chicago, Woman's Building and Pennsylvania
Building, Ladies' Parlor, 1893; Cotton States and Interna-
tional Exposition, Atlanta, 1895

39. Blanche Dillaye, 1851-1931
An Upland Path, ca. 1890
Etching and drypoint on Japan, 6¾ x 9¾ inches
Signed in plate l.l.; signed in pencil l.r.
Lent by the Miriam and Ira D. Wallach Division of Art,
Prints and Photographs, The New York Public Library,
Astor Lenox and Tilden Foundations, MEYG+
Exhibited: New York Etching Club, 1891

40. Blanche Dillaye, 1851-1931
A Winding Stream, n.d.
Etching and drypoint on wove paper, 7 x 10⅜ inches
Signed in plate l.l.
Lent by Rona Schneider

41. Florence May Esté, 1860-1926
A Duck Pond, ca. 1885-86 *
Etching on wove paper, 8½ x 13⅝ inches
Signed in plate l.l.
Lent by the Library of Congress
Shown at the High Museum of Art and Hudson River
Museum only
Exhibited: New York Etching Club, 1887

42. Katherine Levin Farrell, 1857-1951
South Dartmouth Wharf, 1886 *
Etching on Japanese vellum, 7¹³⁄₁₆ x 14¹³⁄₁₆ inches
Signed in pencil l.r.; titled in pencil l.l.
Lent by the Pennsylvania Academy of the Fine Arts,
Philadelphia, John S. Phillips Collection, 1876.9.344
Shown at the High Museum of Art and The Woodmere
Art Museum only
Exhibited: New York Etching Club, 1887; Museum of Fine
Arts, Boston, 1887; Union League Club, N.Y., 1888; World's
Columbian Exposition, Chicago, Woman's Building and
Pennsylvania Building, Ladies' Parlor, 1893

43. Margaret M. Taylor Fox, 1857-active to 1941
The Cove, ca. 1891 *
Etching, chine collé (on gray paper), 13⅜ x 19¾ inches
Signed in plate l.l.; signed in pencil l.r.
Lent by the Division of Graphic Arts, National
Museum of American History, Smithsonian Institu-
tion, 5490

44. Margaret M. Taylor Fox, 1857-active to 1941
A November Morning, ca. 1891
Etching, chine collé (on taupe paper), 4⅞ x 7¾ inches
Signed in plate l.l.; signed in pencil l.r.
Lent by the Division of Graphic Arts, National
Museum of American History, Smithsonian Institu-
tion, 5489

45. Margaret M. Taylor Fox, 1857-active to 1941
The Pasture Land, 1884
Etching on wove paper, 7 x 10¾ inches
Signed in plate l.r.; blind stamp of Philadelphia Art
Union
Lent by the Division of Graphic Arts, National
Museum of American History, Smithsonian Institu-
tion, 19223
Exhibited: Museum of Fine Arts, Boston, 1887; Union League
Club, N.Y., 1888

46. Margaret M. Taylor Fox, 1857-active to 1941
Shark River, N.J., 1885
Etching on wove paper, from portfolio *Etched Sketches*,
4 x 9¾ inches
Signed in plate l.r.
Lent by the Pennsylvania Academy of the Fine Arts,
Philadelphia
Shown at the High Museum of Art and The Woodmere
Art Museum only
Exhibited: New York Etching Club, 1887; Museum of Fine
Arts, Boston, 1887; Union League Club, N.Y., 1888; Cotton
States and International Exposition, Atlanta, Woman's
Building, 1895

47. Margaret M. Taylor Fox, 1857-active 1941
Winter, 1890
Etching, chine collé (on taupe paper), 5⅜ x 7⅞ inches
Signed in plate l.l.; signed in pencil l.r.
Lent by the Division of Graphic Arts, National
Museum of American History, Smithsonian Institu-
tion, 5488
Exhibited: New York Etching Club, 1891; World's Columbian
Exposition, Woman's Building, 1893; Cotton States and
International Exposition, Atlanta, Woman's Building, 1895

48. Edith Loring Peirce Getchell, 1855-1940
Canal, Dordrecht, 1884
Etching on Japan, 12 x 8¹⁄₁₆ inches
Signed in plate l.l.; signed in pencil l.r.
Lent by Rona Schneider
Exhibited: New York Etching Club, 1885; Museum of Fine
Arts, Boston, 1887; Union League Club, N.Y., 1888; World's
Columbian Exposition, Chicago, Pennsylvania Building,
Ladies' Parlor, 1893

49. Edith Loring Peirce Getchell, 1855-1940
Desolation, after Ross Turner, 1887
Etching on Japan, 7⅛ x 10⅛ inches
Signed in plate l.r.; "Ross Turner" in plate l.l.; signed in pencil l.r.
Lent by the Museum of Fine Arts, Boston, Museum purchase, 1888, M5101
Exhibited: Museum of Fine Arts, Boston, 1887; Union League Club, N.Y., 1888; New York Etching Club, 1888; World's Columbian Exposition, Pennsylvania Building, Corridor, 1893

50. Edith Loring Peirce Getchell, 1855-1940
Impatient Pussy Willows, 1902
Etching on laid paper, 8½ x 12 inches
Signed in plate l.l.; signed in pencil l.r.
Lent by the Worcester Art Museum, 1909.3

51. Edith Loring Peirce Getchell, 1855-1940
[*Landscape with river and boat*], n.d.
Etching and drypoint on laid paper, 7⅜ x 10¼ inches
Signed in plate l.l.; signed in pencil l.r.
Lent by the Worcester Art Museum, 1909.5

52. Edith Loring Peirce Getchell, 1855-1940
Premonition of Storm, n.d. *
Etching on Japanese vellum, 6 x 8⅞ inches
Signed in plate l.l.; titled and "$10" in pencil l.l.
Lent by the Worcester Art Museum, 1909.25

53. Edith Loring Peirce Getchell, 1855-1940
Road to the Beach, Nonquit, Massachusetts, 1883
Etching on wove paper, 5¾ x 17¾ inches
Signed in plate l.l.; "3" in plate l.r.; signed in pencil l.r.
Lent by Rona Schneider
Exhibited: Paris Salon, 1884; Boston Art Club, 1884; New York Etching Club, 1884; Royal Society of Painter-Etchers, London, 1884; Museum of Fine Arts, Boston, 1887; Union League Club, N.Y., 1888; Galerie Durand-Ruel, Paris, 1889; World's Columbian Exposition, Chicago, Woman's Building, 1893

54. Edith Loring Peirce Getchell, 1855-1940
Solitude (Peck's Beach, New Jersey), 1884 *
Etching on Japan, undescribed 2nd state with "Solitude" erased, 5¾ x 8⅝ inches
Signed in plate l.r.
High Museum of Art, purchase with Stratton Industries Fund, 1984.103
Exhibited: Museum of Fine Arts, Boston, 1887; Union League Club, N.Y., 1888; World's Columbian Exposition, Chicago, Pennsylvania Building, Ladies' Parlor, 1893

55. Edith Loring Peirce Getchell, 1855-1940
A Windswept Road, n.d.
Etching on laid paper, 7⁷/₁₆ x 10¹⁵/₁₆ inches
Signed in plate l.r.; signed in pencil l.r.
Lent by the National Museum of American Art, Smithsonian Institution, gift of Chicago Society of Etchers, 1935.13.106

56. Eliza Pratt Greatorex, 1819-1897
Bay of Naples, Italy, 1887

Etching, chine collé, 6⅜ x 13¾ inches
Lent by the Library of Congress
Shown at the High Museum of Art and Hudson River Museum only

57. Eliza Pratt Greatorex, 1819-1897
Castle Garden, New York (The Battery–from no. 1 Broadway), 1880, after a drawing for *Old New York, from The Battery to Bloomingdale*, New York: G. P. Putnam's Sons, 1878
Etching on Japan, 4⅜ x 8 inches
Signed and dated in plate l.l.
Lent by Rona Schneider
Exhibited: Either a former state of this etching or a different plate of same subject was exhibited at the Brooklyn Art Association and Louisville Industrial Exposition, 1875

58. Eliza Pratt Greatorex, 1819-1897
Chevreuse, 1881 *
Etching on laid paper, 5⅜ x 3⅞ inches
Signed in plate l.l.; title and "artist's proof" in pencil l.l. margin
Lent by the Museum of Fine Arts, Boston, gift of Sylvester Rosa Koehler, 1898, K1237
Exhibited: Museum of Fine Arts, Boston, 1881, 1887; Union League Club, N.Y., 1888

59. Eliza Pratt Greatorex, 1819-1897
Church of Ober-Ammergau, 1880
Etching on laid paper, 4⅝ x 3⅛ inches
Signed and dated in plate l.l.; title and "artist's proof" in pencil l.l. margin
Lent by the Museum of Fine Arts, Boston, gift of Sylvester Rosa Koehler, 1898, K1241
Exhibited: Museum of Fine Arts, Boston, 1881

60. Eliza Pratt Greatorex, 1819-1897
A House on the Hudson, Washington Heights, 1884
Etching, chine collé, 4¼ x 6¼ inches
Lent by the Library of Congress
Shown at the High Museum of Art and Hudson River Museum only
Exhibited: Museum of Fine Arts, Boston, 1887; Union League Club, N.Y., 1888

61. Eliza Pratt Greatorex, 1819-1897
Near the Theatre, Ober-Ammergau, 1880
Etching on laid paper, 6¼ x 4¾ inches
Signed in plate l.l.; "Oberammergau" in plate l.r.; title and "artist's proof" in pencil l.l. margin
Lent by the Museum of Fine Arts, Boston, gift of Sylvester Rosa Koehler, 1898, K1239
Exhibited: Museum of Fine Arts, Boston, 1881

62. Eliza Pratt Greatorex, 1819-1897
The Pond, Cernay-la-Ville, 1880, from the *American Art Review*, II, pt. 2, 1881
Etching on Japanese vellum, 4⅜ x 6⅞ inches
Signed and dated in plate l.l.
High Museum of Art, purchase with Stratton Industries Fund, 1986.15
Exhibited: Museum of Fine Arts, Boston, 1881, 1887; Union League Club, N.Y., 1888

63. Eliza Pratt Greatorex, 1819-1897
Rome, Italy, 1887*
Etching, chine collé, 8 x 4⅝ inches
Lent by the Library of Congress
Shown at the High Museum of Art only

64. Eliza Pratt Greatorex, 1819-1897
View of Florence from Maiano, Italy, 1886
Etching, chine collé, 6⅜ x 13¾ inches
Lent by the Library of Congress
Shown at the High Museum of Art only
Exhibited: Museum of Fine Arts, Boston, 1887; Union League
Club, N.Y., 1888

65. Ellen Day Hale, 1855-1940
The Green Calash (*The Old Calash*, *The Great Calash*),
1925, after a painting of 1904 by the artist
Soft-ground etching and aquatint in colors on Japanese
vellum, 11⅝ x 6¾ inches
Signed and dated in plate l.r.; signed in pencil l.r.
Lent by Eric Denker and Wendy Livingston

66. Ellen Day Hale, 1855-1940
The Marketplace, Dives, Normandy, 1881
Charcoal on laid ("Lalanne") paper, 16⅞ x 11⅛ inches
Inscribed and dated in charcoal l.l. "Dives/August 14"
Lent by the Boston Athenaeum, A50

67. Ellen Day Hale, 1855-1940
Megiddo, from Nazareth, 1930
Soft-ground etching on Japanese vellum, 8½ x 11⅞
inches
Signed and dated in plate l.r.; signed in pencil l.r.
Lent by the Boston Athenaeum, A5

68. Ellen Day Hale, 1855-1940
Megiddo, from Nazareth, 1930
Pencil on blue laid ("Ingres") paper, 12⅜ x 19¼ inches
Lent by the Boston Athenaeum, A37

69. Ellen Day Hale, 1855-1940
Milk Wagon, Cairo (*Milk Delivery, Cairo*), 1930*
Soft-ground etching and aquatint in colors on Japan,
7⅞ x 9½ inches
Signed and dated in plate l.l.; signed in pencil l.r.
Lent by Eric Denker and Wendy Livingston

70. Ellen Day Hale, 1855-1940
Newport from the South, 1887*
Etching on laid paper, from *Newport; Six Etchings by
Miss G. D. Clements and Miss E. D. Hale* (Boston: L.
Prang & Co.), 2⅞ x 6 inches
Titled and signed in plate l.r.
Lent by Rona Schneider

71. Ellen Day Hale, 1855-1940
Porte Guillaume, Chartres, 1885*
Etching on wove paper, 5½ x 3¹⁵/₁₆ inches
Signed in plate l.r.; signed in pencil l.r.
Lent by Eric Denker and Wendy Livingston
Exhibited: New York Etching Club, 1886 (as *The King's Gate,
Chartres*); Boston Art Club, 1886; Museum of Fine Arts,
Boston, 1887; Union League Club, N.Y., 1888

72. Ellen Day Hale, 1855-1940
The Willow Whistle, 1888*
Albumen photograph, 7¼ x 4⁷/₁₆ inches
Lent by Peter Hastings Falk

73. Ellen Day Hale, 1855-1940
The Willow Whistle, 1888*
Pencil, 15½ x 8⅝ inches
Lent by Eric Denker and Wendy Livingston

74a. Ellen Day Hale, 1855-1940
The Willow Whistle, 1888*
Etching and drypoint on Japanese vellum, 15½ x 8⅝
inches
Signed and dated in plate u.r.; signed in pencil l.r.;
printed in u.l. margin "Copyright by E. D. Hale,
Boston, Mass. 1889"
Lent by the Pennsylvania Academy of the Fine Arts,
Philadelphia, Henry D. Gilpin Fund, 1982.7.2
Shown at the High Museum of Art and The Woodmere
Art Museum only

74b. Ellen Day Hale, 1855-1940
The Willow Whistle, 1888
Etching and drypoint on Japanese vellum, 15½ x 8⅝
inches
Signed and dated in plate u.r.; printed in u.l. margin
"Copyright by E. D. Hale, Boston, Mass. 1889"
Lent by the Philadelphia Museum of Art, gift of Samuel
B. Sturgis, 73.268.30
Shown at the Hudson River Museum of Westchester
and the National Museum of American History,
Smithsonian Institution, only

75. Ellen Day Hale, 1855-1940
A Woman of Normandy, 1889 (plate etched), ca.
1920-30 (color imprint pulled)*
Drypoint in colors on Japan, 6⅝ x 4¾ inches
Initialed and dated in plate u.l.; signed in pencil l.l.
Lent by the Boston Athenaeum, A51

76. Mary Cummings Brown Hatch, active 1880s-1920s
The Old Church Graveyard, 1921
Etching on wove paper, 7⅞ x 10¾ inches
Signed in pencil l.r.
Lent by The Cleveland Museum of Art, gift of Mrs.
Mary C. Hatch, 22.77
Shown at the High Museum of Art only

77. Mary Cummings Brown Hatch, active 1880s-1920s
A Suggestion, 1883
Etching on Japanese vellum, 3⅜ x 4¾ inches
Signed in pencil l.r.
Lent by the Museum of Fine Arts, Boston, Museum
purchase, 1888, M5087
Exhibited: Museum of Fine Arts, Boston, 1887; Union
League Club, N.Y., 1888

78. Gertrude Rummel Hurlbut, active 1880s-d. 1909
Near East Hampton, L. I., 1880*
Etching on Japan, 9¾ x 6¾ inches
Initialed and dated in plate l.r.

Lent by The Parrish Art Museum, Southampton, N.Y., Dunnigan Collection, 76.1.328
Exhibited: New York Etching Club, 1882

79. Mary Louise McLaughlin, 1847-1939
Beeches in Burnet Woods, 1883 *
Etching on laid paper, 7⁹/₁₆ x 10½ inches
Signed and dated in plate l.r.; titled in pencil l.c.; signed in pencil l.l.
Lent by the Cincinnati Art Museum, gift of Theodore A. Longstroth, 1986.80
Exhibited: Museum of Fine Arts, Boston, 1887; Union League Club, N.Y., 1888

80. Mary Louise McLaughlin, 1847-1939
Head of a Girl, 1884 *
Etching and drypoint on Japan, 6³/₁₆ x 5⅞ inches
Signed and dated in plate u.r.; signed in pencil lower margin "To Frederick Keppel, from his friend George McLaughlin, Cincinnati"
Lent by the Miriam and Ira D. Wallach Division of Art, Prints and Photographs, The New York Public Library, Astor Lenox and Tilden Foundations, MEYG
Exhibited: Perhaps *Head of a Girl* in Museum of Fine Arts, Boston, 1892; World's Columbian Exposition, Chicago, Woman's Building, 1893

81. Mary Louise McLaughlin, 1847-1939
Sunset, n.d.
Color monotype on laid paper, 8¹/₁₆ x 9⅞ inches
Signed with monogram within image l.l.; signed in ink l.r.
Lent by the Library of Congress
Shown at the High Museum of Art and Hudson River Museum only

82. Anne Massey Lea Merritt, 1844-1930
Eve (Eve Repentant), 1887, after a painting of 1885 by the artist *
Etching on Japanese vellum, 13⅛ x 19 inches
Signed in pencil l.l.; remarque of fowl l.r.; inscribed u.l. "Copyright 1887 by C. Klackner, 17 E. 17th St., N.Y."
Lent by the Museum of Fine Arts, Boston, gift of Sylvester Rosa Koehler, 1898, K4088
Exhibited: Royal Society of Painter-Etchers, London, 1887; Museum of Fine Arts, Boston, 1887; Union League Club, N.Y., 1888

83. Anna Massey Lea Merritt, 1844-1930
Portrait of Louis Agassiz, 1879, after an 1861 photograph
Etching on Japan, 7⅝ x 4½ inches
Signed and dated in plate l.r.; titled in plate l.c.; signed in pencil l.l.
Lent by the Miriam and Ira D. Wallach Division of Art, Prints and Photographs, The New York Public Library, Astor Lenox and Tilden Foundations, MEYG
Exhibited: Museum of Fine Arts, Boston, 1881, 1887; Union League Club, N.Y., 1888

84. Anna Massey Lea Merritt, 1844-1930
Portrait of Sir Gilbert Scott 1879, after a drawing by George Richmond
Etching on wove paper, 1st state, 7¼ x 4⅞ inches
Signed in ink l.r.; titled in ink l.l.; "After a drawing by George Richmond" in pencil l.l.
Lent by the Museum of Fine Arts, Boston, gift of Sylvester Rosa Koehler, 1898, K1609
Exhibited: Boston Art Club, 1880; Museum of Fine Arts, Boston, 1881, 1887; Union League Club, N.Y., 1888

85. Anna Massey Lea Merritt, 1844-1930
St. Cecilia (St. Cecilia Asleep), 1887, after a painting of 1886 by the artist
Etching on Japanese vellum, 24⁵/₁₆ x 13⅞ inches
Inscribed in plate l.r. "Anna Lea Merritt pixit et aq ft olure 36"; u.l. "Copyright 1887 C. Klackner, 17 E. 17th Street, New York"; remarques of three putti u.l., wreath and palm frond l.c.
Lent by The Parrish Art Museum, Southampton, N.Y., Dunnigan Collection, 1976.1.366
Exhibited: Royal Society of Painter-Etchers, London, 1887; Museum of Fine Arts, Boston, 1887; Union League Club, N.Y., 1888

86. Emily Kelley Moran, 1850-1900
Belmont on the Schuylkill, 1876
Etching on Japan, 4⅛ x 8 inches
Signed in plate u.r.; signed in pencil l.r.
Lent by the National Museum of American Art, Smithsonian Institution, transfer from Smithsonian Institution, National Museum of American History, Division of Graphic Arts, 1973.122.40
Exhibited: Museum of the Fine Arts, Boston, 1881; Philadelphia Society of Etchers, 1882-83; Museum of Fine Arts, Boston, 1887; Union League Club, N.Y., 1888

87. Emily Kelley Moran, 1850-1900
The Ford (On the Neschamony), 1886
Etching on Japan, 2nd state, 9 x 16 inches
Signed in pencil l.r.
Lent by the Division of Graphic Arts, National Museum of American History, Smithsonian Institution, 181
Exhibited: Museum of Fine Arts, Boston, 1887; Union League Club, N.Y., 1888

88. Emily Kelley Moran, 1850-1900
Long Beach, York Harbor, Maine, 1883 *
Etching on tissue, 2nd state, 7½ x 12⅛ inches
Signed in pencil l.r.; "No. 9" in pencil l.l.
Lent by the Division of Graphic Arts, National Museum of American History, Smithsonian Institution, 179
Exhibited: Philadelphia Society of Etchers, 1882-83; New York Etching Club, 1883; Museum of Fine Arts, Boston, 1887; Union League Club, N.Y., 1888; World's Columbian Exposition, Chicago, Woman's Building, 1893

89. Emily Kelley Moran, 1850-1900
On the Schuylkill, 1877
Etching, chine collé, 4 x 4½ inches
Signed in plate u.l.; signed in pencil l.r.; "173" in pencil l.r.
Lent by the National Museum of American Art, Smithsonian Institution, transfer from Smithsonian Institution, National Museum of American History, Division of Graphic Arts, 1973.122.41
Exhibited: Museum of Fine Arts, Boston, 1881; Philadelphia Society of Etchers, 1882-83; Museum of Fine Arts, Boston, 1887; Union League Club, N.Y., 1888

90. Emily Kelley Moran, 1850-1900
The Schuylkill, Columbia Bridge, 1876
Etching on Japan, 3⅝ x 6⅞ inches
Signed and dated in plate u.l.; signed in pencil l.r.; "174" in pencil l.r.
Lent by the National Museum of American Art, Smithsonian Institution, transfer from Smithsonian Institution, National Museum of American History, Division of Graphic Arts, 1973.122.42
Exhibited: Museum of Fine Arts, Boston, 1881; Philadelphia Society of Etchers, 1882-83; Museum of Fine Arts, Boston, 1887; Union League Club, N.Y., 1888

91. Mary Nimmo Moran, 1842-1899
Evening, East Hampton, 1881 (K21)
Etching on Japan, 1st state, 7¹⁵/₁₆ x 4½ inches
Signed and dated in plate l.l.; signed in pencil l.r.
Lent by the Division of Graphic Arts, National Museum of American History, Smithsonian Institution, 14773.1
Exhibited: New York Etching Club, 1882

92. Mary Nimmo Moran, 1842-1899
Evening, East Hampton, 1881 (K21)
Etching on Japanese vellum, 2nd state, 7¹⁵/₁₆ x 4½ inches
Signed and dated in plate l.l.; signed in pencil l.c.
Lent by the Division of Graphic Arts, National Museum of American History, Smithsonian Institution, 14773.2
Exhibited: Philadelphia Society of Etchers, 1882-83; Art Institute of Chicago, 1885; Museum of Fine Arts, Boston, 1887 (state not identified); Union League Club, N.Y., 1888; Klackner's, N.Y., 1889; World's Columbian Exposition, Chicago, Department of Fine Arts, 1893

93. Mary Nimmo Moran, 1842-1899
Gardiner's Bay, Long Island, seen from Fresh Pond, 1884 (K34)
Etching on Japanese vellum, 7½ x 11 inches
Signed and dated in plate l.l.
High Museum of Art, gift of Mr. and Mrs. D. K. Young in honor of Elise Cherie Rector, 1985.293
Exhibited: Museum of Fine Arts, Boston, 1887; Union League Club, N.Y., 1888; Klackner's, N.Y., 1889

94. Mary Nimmo Moran, 1842-1899
The Haunt of the Muskrat, East Hampton, 1884 (K38)*
Etching on Japan, 4⅝ x 11⅜ inches

Signed and dated in plate l.r.; signed in pencil l.l.
Lent by the National Museum of American Art, Smithsonian Institution, transfer from Smithsonian Institution, National Museum of American History, Division of Graphic Arts, 1973.122.55
Exhibited: New York Etching Club, 1885; Museum of Fine Arts, Boston, 1887; Union League Club, N.Y., 1888; Klackner's, N.Y., 1889; World's Columbian Exposition, Chicago, Department of Fine Arts, 1893

95. Mary Nimmo Moran, 1842-1899
Hook Pond, East Hampton, Long Island (Salt Water Ponds), 1884 (K37)
Etching on Japan, 9¾ x 11⁵/₁₆ inches
Signed and dated in plate l.r.; signed in pencil l.l.
Lent by the National Museum of American Art, Smithsonian Institution, transfer from Smithsonian Institution, National Museum of American History, Division of Graphic Arts, 1973.122.61
Exhibited: New York Etching Club, 1885; Museum of Fine Arts, Boston, 1887; Union League Club, N.Y., 1888; Klackner's, N.Y., 1889

96. Mary Nimmo Moran, 1842-1899
Point Isabel, Coast of Florida, 1887 (K52)*
Etching on wove paper, 10 x 19¼ inches
Signed and dated in plate l.l.; signed in pencil l.l.; in pencil "a.p. $15," blind stamp: "published 88 by J. D. Waring N.Y., copywrited by M. N. Moran 88," for the Society of American Etchers
Lent by Roger Genser, The Prints and the Pauper
Exhibited: Museum of Fine Arts, Boston, 1887; Union League Club, N.Y., 1888; New York Etching Club, 1888; Klackner's, N.Y., 1889; World's Columbian Exposition, Chicago, Department of Fine Arts, 1893

97. Mary Nimmo Moran, 1842-1899
Solitude, 1880, from *American Art Review*, II, pt. 1, 1881 (K9)
Etching and sandpaper, chine collé, 5½ x 7⅜ inches
Initialed and dated in plate l.r.
High Museum of Art, gift of Mr. and Mrs. Barry Blumberg, 1985.294
Exhibited: Royal Society of Painter-Etchers, London, 1881; Museum of Fine Arts, Boston, 1881; Boston Art Club, 1881; Massachusetts Charitable Mechanic Association, 1881; Philadelphia Society of Etchers, 1882-1883; Art Institute of Chicago, 1885; Museum of Fine Arts, Boston, 1887; Union League Club, N.Y., 1888; Klackner's, N.Y., 1889

98. Mary Nimmo Moran, 1842-1899
Summer, Suffolk County, New York (Summer, East Hampton), 1883 (small version of K30)
Etching on fairly heavy laid paper, from the *Catalogue of the New York Etching Club Exhibition*, 5¾ x 3¾ inches
Initialed in plate l.r.
High Museum of Art, purchase with Stratton Industries Fund, 1986.26.4
Exhibited: New York Etching Club, 1884; Museum of Fine Arts, Boston, 1887; Union League Club, N.Y., 1888; Klackner's, N.Y., 1889; World's Columbian Exposition, Chicago, Woman's Building and Department of Fine Arts, 1893

99. Mary Nimmo Moran, 1842-1899
Swamp Grasses–East Hampton (Meadowland), 1884 (K39)
Etching on Japan, 4¾ x 11½ inches
Signed and dated in plate l.r.; signed in pencil l.c.
Lent by the National Museum of American Art, Smithsonian Institution, transfer from Smithsonian Institution, National Museum of American History, Division of Graphic Arts, 1973.122.58
Exhibited: New York Etching Club, 1885 (as study of *Salt Meadow Weeds*); Museum of Fine Arts, Boston, 1887; Union League Club, N.Y., 1888; Klackner's, N.Y., 1889

100. Mary Nimmo Moran, 1842-1899
'Tween the Gloaming and the Mirk When the Kye Come Hame, 1883 (K29)*
Etching, roulette, sandpaper, scotchstone on wove paper, 7⅜ x 11¼ inches
Signed and dated in plate l.l.
High Museum of Art, purchase with Stratton Industries Fund, 1982.46
Exhibited: New York Etching Club, 1884; Museum of Fine Arts, Boston, 1887; Union League Club, N.Y., 1888; Klackner's, N.Y., 1889; World's Columbian Exposition, Chicago, Department of Fine Arts, 1893

101. Mary Nimmo Moran, 1842-1899
Twilight (An East Hampton Scene), 1880 (K10A)*
Etching, roulette, sandpaper, scotchstone on laid paper, 3 x 5¼ inches
Signed in plate l.r.
High Museum of Art, purchase with Stratton Industries Fund, 1985.125
Exhibited: Royal Society of Painter-Etchers, London, 1881; Museum of Fine Arts, Boston, 1881; Boston Art Club, 1881; New York Etching Club, 1882; Philadelphia Society of Etchers, 1882-83; Museum of Fine Arts, Boston, 1887; Union League Club, N.Y., 1888; Klackner's, N.Y., 1889; Museum of Fine Arts, Boston, 1892; World's Columbian Expostition, Chicago, Department of Fine Arts, 1893; Museum of Fine Arts, Boston, 1893, 1894

102. Ellen Oakford, active 1880s-1890s
The Campus, Yale College, 1888
Etching on Japanese vellum, 9⅞ x 15 inches
Monogram and date in plate l.l.; "Copyright 1888 by C. Klackner, 53 East 17th Street, New York" u.l.; signed in pencil l.l.; remarque of fence l.r.
Lent by Rona Schneider
Exhibited: New York Etching Club, 1889

103. Harriet Frances Osborne, 1846-1913
Custom House from Derby Wharf, from *Old Salem Etchings by H. Frances Osborne*, ca. 1885
Etching on wove paper, 2¼ x 3½ inches
Lent by the Essex Institute, 120,728

104. Harriet Frances Osborne, 1846-1913
Doorway on Federal Street, from *Old Salem Etchings by H. Frances Osborne*, ca. 1885
Etching on wove paper, 2¼ x 3½ inches
Lent by the Essex Institute, 120,728

105. Harriet Frances Osborne, 1846-1913
House of Seven Gables, from *Old Salem Etchings by H. Frances Osborne*, ca. 1885
Etching on wove paper, 2¼ x 3½ inches
Lent by the Essex Institute, 120,728

106. Harriet Frances Osborne, 1846-1913
Junipers, Salem Neck, from *Old Salem Etchings by H. Frances Osborne*, ca. 1885
Etching on wove paper, 2¼ x 3½ inches
Lent by the Essex Institute

107. Harriet Frances Osborne, 1846-1913
Marblehead Neck, 1880
Etching on laid paper, 2⅞ x 5⅞ inches
Initialed in plate l.l.
Lent by the Museum of Fine Arts, Boston, gift of the etcher, 1880, M357
Exhibited: Museum of Fine Arts, Boston, 1881, 1887; Union League Club, N.Y., 1888

108. Harriet Frances Osborne, 1846-1913
Marblehead Neck, 1880
Etching on laid paper, 4⁷⁄₁₆ x 6⅝ inches
Inscription on verso: "Miss H. Frances Osborne December 15, 1880. Drawn on the plate at the lecture on etching in Salem, and bitten in and printed by me before the audience.; This, however, is not one of the impressions I printed. K."
Lent by the Museum of Fine Arts, Boston, gift of Sylvester Rosa Koehler, 1898, K1662
Exhibited: Museum of Fine Arts, Boston, 1887; Union League Club, N.Y., 1888

109. Harriet Frances Osborne, 1846-1913
Webb's Wharf, from *Old Salem Etchings by H. Frances Osborne*, ca. 1885
Etching on wove paper, 2¼ x 3½ inches
Lent by the Essex Institute, 120,728

110. Edith Penman, 1860-1929
[*Landscape*], possibly *At Cedar Bridge, Bronx River*, ca. 1888
Etching on wove paper, 4¼ x 2¾ inches
Signed in plate l.r.; signed in pencil l.r.
Lent by The Parrish Art Museum, Southampton, N.Y., Dunnigan Collection, 1976.1.124

111. Edith Penman, 1860-1929
[*Landscape*], possibly *College Orchard, St. John's College*, ca. 1888
Etching on Japanese vellum, 3³⁄₁₆ x 4⅞ inches
Signed in plate l.r.; signed in pencil l.r.
Lent by The Parrish Art Museum, Southampton, N.Y., Dunnigan Collection, 1976.1.123

112. Edith Penman, 1860-1929
[*Landscape*], possibly *Corn Cribs, Bathgate Farm, Fordham, New York*, ca. 1888
Etching on wove paper, 2¾ x 4¼ inches
Signed in plate l.r.; signed in pencil l.r.
Lent by The Parrish Art Museum, Southampton, N.Y., Dunnigan Collection, 1976.1.125

113. Edith Penman, 1860-1929
[Landscape], possibly Loading Up, after L. K. Harlow,
1887*
Etching on Japanese vellum, 13⅞ x 21¼ inches
Signed in plate l.l. "Louis K. Harlow, E. Penman '87";
"Copyright 1888 by C. Klackner, 53 East 17th Street,
New York" u.l.
Lent by The Parrish Art Museum, Southampton, N.Y.,
Dunnigan Collection, 1976.1.113
Exhibited: Union League Club, N.Y., 1888 (Loading Up)

114. Edith Penman, 1860-1929
[Moorings], 1890*
Etching on wove paper, 6¾ inches in diameter
Signed in pencil l.r. of c.; u.c. around pl.l. is
"Copyright C. Klackner, N.Y., 1890"
Lent by Rona Schneider

115. Martha Scudder Twachtman, 1861-1936
A Dordrecht Canal, 1881*
Etching on Japan, 4⅞ x 7 inches
Lent by the Museum of Fine Arts, Boston, Museum
purchase, 1888, M5096
Exhibited: Museum of Fine Arts, Boston, 1887; Union League
Club, N.Y., 1888

116. Martha Scudder Twachtman, 1861-1936
A Ruin on Mill Creek, Cincinnati, 1880*
Etching on chine collé, 4 x 5⅛ inches
Lent by the Museum of Fine Arts, Boston, Museum
purchase, 1888, M5095
Exhibited: Perhaps one of two Landscapes in Museum of Fine
Arts, Boston, 1881; Museum of Fine Arts, Boston, 1887;
Union League Club, N.Y., 1888

117. Martha Scudder Twachtman, 1861-1936
A View of the Meuse, 1881
Etching on Japan, 3¾ x 2⅝ inches
Lent by the Museum of Fine Arts, Boston, Museum
purchase, 1888, M5097
Exhibited: Museum of Fine Arts, Boston, 1887; Union
League Club, N.Y., 1888

BIOGRAPHIES OF THE ARTISTS

Artists who participated in the *Woman Etchers of America* exhibition, New York, 1888

KEY TO REFERENCES:

Falk, Peter Hastings, ed. *Who Was Who in American Art*. Madison, Conn.: Sound View Press, 1985.

Koehler, Sylvester R. *The United States Art Directory and Year Book*. 2 vols. 1, New York, London, and Paris: Cassell, Petter, Galpin & Co., 1882; 2, New York, London, and Paris: Cassell & Co., 1884.

Petteys, Chris, comp. *Dictionary of Women Artists: An International Dictionary of Women Artists born before 1900*. With the assistance of Hazel Gustow, Ferris Olin, and Verna Ritchie. Boston: G. K. Hall, 1985.

Ulehla, Karen Evans, comp. and ed. *The Society of Arts and Crafts, Boston, Exhibition Record, 1897-1927*. Boston: Boston Public Library, 1981.

LUCIA GRAY SWETT ALEXANDER: b. Boston, Mass. April 2, 1814; d. Florence, Italy, 1916. Writer, etcher.

In the Boston *Women Etchers of America* Sylvester Koehler included an etching, *Vision of Virgin and Child*, which was listed in the catalogue for the New York version of the show as by Mrs. F. Alexander. The etching had been donated by George W. Wales to the Boston Museum in time to be exhibited but too late to be entered in the Boston catalogue. The Museum's record book indicates that Mrs. Alexander made the etching after a drawing by her daughter, Francesca Alexander. Mrs. Alexander was the daughter of a well-to-do, devout Protestant family. She married self-taught Boston portrait painter Francis Alexander; their daughter Francesca (Esther Frances) was born in 1837. In 1853 the family moved to Florence, Italy. In 1882, two years after Francis's death, John Ruskin visited the Alexanders in Florence, bought Francesca's drawings and illuminated manuscripts, and took it upon himself to popularize her work. The 1876 U.S. Centennial Exposition in Philadelphia included four works by Francesca: an oil painting, *Madonna*, two pen-and ink drawings, and, in the section of "Drawings, Etchings, Etc." without its medium identified, *A Prayer*, which was owned by Wales. Mrs. Alexander produced two books. For the first, she compiled and translated stories of the saints and martyrs of the Church from medieval sources. It was published in 1905 as *Il Libro D'Oro* in Boston and *The Golden Book* in London. She also compiled a selection of fifty of Ruskin's letters to her daughter which were published with memoirs of her family in 1931.

REFERENCES: "Accession Records" and "List of Exhibitions," Archives, Museum of Fine Arts, Boston, Mass.; Artist Files, Fine Arts Division, Boston Public Library, Boston, Mass.; Constance Grosvenor Alexander, *Francesca Alexander, A Hidden Servant; Memories Gathered by One Who Loved Her Dearly*, Cambridge, Mass., Harvard University Press, 1927; Lucia Gray Swett, *John Ruskin's Letters to Francesca and Memoirs of the Alexanders*, Boston, Lothrop, Lee & Shepard, 1931; Van Wyck Brooks, *The Dream of Arcadia: American Writers and Artists in Italy, 1760-1915*, New York, E. P. Dutton & Co., 1958; Paul R. Baker, "Francesca Alexander," in *Notable American Women: 1607-1950 . . .*, I, Cambridge, Mass., The Belknap Press of Harvard University Press, 1971, pp. 34-35; Jeffrey Alan Gallery, *Francesca Alexander, 1837-1917; April 7 to April 30, 1983*, New York, Jeffrey Alan Gallery, 1983; Petteys.

MARGARET WHITE LESLEY BUSH-BROWN: b. Philadelphia, Pa., May 19, 1857; d. Ambler, Pa., November 17, 1944. Painter, pastelist, etcher, miniature painter, muralist.

J. Peter Lesley, the artist's father, was Professor of Geology and Mining Engineering at the University of Pennsylvania in Philadelphia. Margaret occasionally worked for him making geological models. Her mother, Susan Lyman Lesley, a writer and social reformer, was very supportive of Margaret's desire to become an artist. Margaret Lesley's name appears on the student register of the Pennsylvania Academy in 1869 and apparently she began to draw from the antique casts before she was told she was too young to do so. She then briefly took classes at the Philadelphia School of Design for Women. From the fall of 1876, after she returned from a trip to Europe with her parents, until 1880 she studied with Christian Schussele and Thomas Eakins at the Pennsylvania Academy. Lesley traveled to Paris in 1880 to study in the studio of Emile-Auguste Carolus-Duran. She also studied with Tony Robert-Fleury, Jules Lefebvre, and Gustave Boulanger at the Académie Julian. She joined Ellen Day Hale and Helen Knowlton in the summer of 1881 to travel and sketch in Belgium and the French provinces. In 1882 she returned to Philadelphia and took classes at the Pennsylvania Academy for a few months, then went back to Paris. She attended the Pennsylvania Academy again in 1884. In Philadelphia in October 1883, Gabrielle Clements taught her to etch.

After a courtship during which she insisted that her future husband, sculptor Henry Kirke Bush-Brown, respect her desire to work as an artist, she married on April 7, 1886, and moved to her husband's home in Newburgh, New York, along the Hudson River. She continued to exhibit her prints for the next few years but did not make new etchings. The Bush-Browns spent 1888-90 in France and Italy, where their daughter and first son were born. After returning to the United States, they continued to work in Newburgh and New York City until 1910, when they moved to Washington, D.C. Margaret often made drawings for Henry's sculpture.

Margaret exhibited at the Pennsylvania Academy, in the Paris Salon, with the Massachusetts Charitable Mechanic Association, the Boston Art Club, the St. Botolph Club, the Charcoal Club of Baltimore, the National Academy of Design, the Woman's Art Club of New York, in the 1901 Pan-American Exposition in Buffalo, the 1901-02 South Carolina Inter-State and West Indian Exposition in Charleston, the Panama-Pacific Exposition in San Francisco, and painted a mural, *Spring*, for the Ladies' Reception Room of the Pennsylvania State Building at the 1893 Columbian Exposition. She

and Henry had a joint exhibition at the Salmagundi Club in 1898, and in 1924 the Atlanta Art Association exhibited works by Margaret, Henry, and their daughter, Lydia.

In 1911 the Corcoran Gallery sponsored a solo exhibition of thirty-two of Margaret's paintings and in 1923 Doll & Richards Gallery, Boston, hung a solo exhibit of her portrait drawings. Bush-Brown's etchings were exhibited at the Boston Art Club, the New York Etching Club, the Art Institute of Chicago, the Salmagundi Club, and the National Arts Club. In the New York *Women Etchers of America* she showed five etchings. She was a member of the Woman's Art Club, the National Association of Women Painters and Sculptors, Arts Club of Washington, National Society of Miniature Painters, Philadelphia Arts Club, Society of Washington Artists, Washington Water Color Club, Washington Society of Mural Painters, National Arts Club, New York, and the National Alliance of Unitarian Women. She gave a lecture, "Address Before New York Unitarian Club on The Relations of Women to the Artistic Professions" in 1901. In the twentieth century she made regular trips to the mid-west in search of portrait commissions. Her daughter, Lydia Bush-Brown Head, became a well-known designer, her son James, a landscape architect, and her son Harold was a professor of architecture at the Georgia Institute of Technology in Atlanta.

REFERENCES: Bush-Brown Family Papers, Sophia Smith Collection, Smith College, Northampton, Mass.; Koehler; Corcoran Gallery of Art, *Exhibition of Portraits and Pictures by Mrs. Henry K. Bush-Brown*, Washington, D.C., Corcoran Gallery of Art, 1911; Doll & Richards Gallery, *Portrait Drawings by M. Lesley Bush-Brown*, Boston, Doll & Richards, 1923; "Margaret Lesley Bush-Brown [Obituary]," *The New York Times*, November 18, 1944, p. 13; Falk; Petteys.

LOUISE PRESCOTT CANBY: active 1874-1903. Painter, Etcher.

While a student of the Philadelphia School of Design for Women, Canby learned to etch from Peter Moran in 1884. She used the school, which she had entered in 1874, as a base to execute etching commissions for the next few years. With three other students she produced the portfolio *Etched Sketches* in 1885 (see Fox). Twelve of her landscape etchings, including those from the portfolio, were exhibited with the *Women Etchers of America* in Boston and two additional scenes were added to the New York version of the show. She traveled and etched in Europe in 1887. The New York Etching Club included her work in its 1888, 1891, and 1892 exhibitions. In 1893 her etchings were exhibited at the Columbian Exposition in the Fine Arts Building, the Ladies' Parlor of the Pennsylvania State Building, and the Woman's Building. She exhibited as a member with The Plastic Club in Philadelphia in 1903.

REFERENCES: "Records" and "Scrapbook," Philadelphia School of Design for Women Collection, Archives, Moore College of Art, Philadelphia, Pa.; Petteys.

MARY STEVENSON CASSATT: b. Allegheny City, Pa., May 22, 1844; d. Mesnil-Beaufresne, France, June 14, 1926. Painter, pastelist, etcher, muralist.

Cassatt's well-educated, socially prominent parents, Katherine Kelso Johnston Cassatt and Robert Simpson Cassatt, a Pittsburgh investment banker, took their children–Mary, her sister, and three brothers –to live in Europe from 1850 to 1855. Soon after the family returned to America they established a home in Philadelphia. Mary Cassatt studied art at the Pennsylvania Academy from 1860 to 1862, then intermittently until 1865. In late 1865 or early 1866 she traveled to Paris and studied with Charles Chaplin and Jean-Léon Gérôme.

During 1867 to 1870 she moved among several villages in France to study with Edouard Frére, Paul Soyer, and Thomas Couture. After a tour of Italy she took classes in Rome with Charles Bellay in 1870 before she went home to Pennsylvania. In December 1871, she returned to Italy with her friend, engraver Emily Sartain. They settled in Parma, where Cassatt studied painting with Carlo Raimondi, head of the academy's engraving school. During the next two years she traveled in Spain, Belgium, and Holland, copying old master paintings, before settling in Paris in 1874. After a trip home in 1875, Cassatt did not visit the United States again until 1898.

Cassatt exhibited in the Paris Salon several times between 1868 and 1876, and in 1877 committed herself to the Impressionist group, showing with them for the first time in 1879. She also exhibited her paintings in the American section of the 1878 Exposition Universelle and at the Pennsylvania Academy, the National Academy of Design, and with the Society of American Artists.

Using subjects from contemporary life, most often family and friends, Cassatt began to etch seriously in 1879. She exhibited etchings with the Impressionists in 1880, the Société des Peintres-Graveurs in 1889 and 1890, and in an exhibit which included Edith Loring Peirce Getchell and other American etchers at the Galerie Durand-Ruel, Paris, in 1889. At Durand-Ruel's two years later she showed the innovative color aquatints and drypoints which she had made after having seen an exhibit of Japanese woodblock prints. Cassatt's etchings were first shown in the United States in the *Women Etchers of America* exhibitions of 1887 and 1888. Also in 1888 a selection of her etchings and drypoints was included in Cincinnati's Ohio Valley Centennial Exposition. In 1891 Frederick Keppel exhibited her black and white etchings and color aquatints in New York. The Galerie Durand-Ruel, which had included her paintings in its 1886 Impressionist exhibition in New York, produced a major retrospective of her work in all media in 1893 in Paris and a smaller version in New York two years later. Only one of her prints was exhibited with the New York Etching Club, in their second from the last exhibition in 1893. Her etchings were exhibited at the Boston Museum of Fine Arts and the Women's Art Club, New York, in 1892, and in the Woman's Building of the 1893 Columbian Exposition, for which she also produced a mural, *Modern Woman*. Cassatt's etchings were also exhibited at the 1901 Pan American Exposition in Buffalo, Albert Roullier's Galleries, Chicago, Frederick Keppel's Gallery and the Walpole Galleries in New York, with the Brooklyn Society of Etchers, and in the 1928 *Exposition de la Gravure Moderne Américaine* at the Bibliothèque Nationale, Paris. In support of women's right to vote, her work was included in the 1915 *Suffrage Loan Exhibition of Old Masters and Works by Edgar Degas and Mary Cassatt* in New York.

REFERENCES: Mary Cassatt Papers, Archives of American Art, Smithsonian Institution, Washington, D.C.; Mary Cassatt Papers, Archives, Pennsylvania Academy of the Fine Arts, Philadelphia, Pa.; Koehler; Galerie Durand-Ruel, *Exposition de Tableaux, Pastels et gravures par Mlle. Mary Cassatt*, Paris, Galerie Durand-Ruel, 1891; "Various Exhibitions," *The Art Amateur*, 25, November 1891, p. 131; New York Public Library, Art and Prints Division, *A Handbook of the Samuel P. Avery Collection of Prints and Art Books in the New York Public Library*, New York, New York Public Library, 1901; Achille Segard, *Mary Cassatt, un Peintre des enfants et des mères*, Paris, Librairie Paul Ollendorf, 1913; Christian Brinton, "Concerning Miss Cassatt and Certain Etchings," *International Studio*, 27, February 1916, pp. i-vii; Frank Weitenkampf, "The Drypoints of Mary Cassatt," *The Print Collector's Quarterly*, VI, December 1916, pp. 397-409; Albert Roullier Art Gallery, *American Exhibition of Original Etchings & Dry-points by Mary Cassatt. October 5 to October 24, 1925*, Chicago, Albert Roullier Art Gallery, 1925; Frank Weitenkampf, "Mary Cassatt, Print-maker," *New York Public Library Bulletin*, 30,

December 1926, pp. 858-59; Bibliothèque Nationale, *Exposition de la Gravure Moderne Américaine, June-July, 1928*, Paris, Bibliothèque Nationale, 1928; Baltimore Museum of Art, *Mary Cassatt, January 7-February 10, 1936,* Baltimore, Baltimore Museum of Art, 1936; Adelyn Breeskin, "The Graphic Works of Mary Cassatt," *Prints,* December 1936, pp. 63-70; Sue Fuller, "Mary Cassatt's Use of Soft-Ground Etching," *Magazine of Art,* 43, February 1950, pp. 54-57; Francis E. Hyslop, Jr., "Berthe Morisot and Mary Cassatt," *College Art Journal,* 13 Spring 1954, pp. 179-84; Frederick A. Sweet, *Miss Mary Cassatt, Impressionist from Philadelphia,* Norman, University of Oklahoma Press, 1966; Nancy Hale, *Mary Cassatt, a Biography of the Great American Painter,* Garden City, N.Y., Doubleday & Co., 1975; Susan Fillin Yeh, "Mary Cassatt's Images of Women," *College Art Journal,* 35, Summer 1976, pp. 359-63; Lillian M. C. Randall, ed., *The Diary of George A. Lucas: An American Art Agent in Paris 1857-1901,* Princeton, Princeton University Press, 1978; Barbara Stern Shapiro, *Mary Cassatt at Home* (exhibition catalogue), Boston, Museum of Fine Arts, 1978; Adelyn Breeskin, *Mary Cassatt; A Catalogue Raisonné of the Graphic Work,* Washington, D.C., Smithsonian Institution Press, 1979; Madeline Fidell-Beaufort, Herbert L. Kleinfield, and Jeanne K. Welcher, eds., *Samuel Putnam Avery, 1822-1904, The Diaries, 1871-1882, of Samuel Putnam Avery, Art Dealer,* New York, Arno Press, 1979; Nancy Mowll Mathews, *Mary Cassatt and Edgar Degas; October 15-December 15, 1981,* San Jose, Calif., San Jose Museum of Art, 1981; Nancy Mowll Mathews, ed., *Cassatt and her Circle: Selected Letters,* New York, Abbeville Press, 1984; Suzanne G. Lindsay, *Mary Cassatt and Philadelphia, February 17-April 14, 1985,* Philadelphia, Philadelphia Museum of Art, 1985; Petteys; Nancy Mowll Mathews, *Mary Cassatt,* The Library of American Art Series, New York, Harry N. Abrams, 1987.

GABRIELLE DE VAUX CLEMENTS: b. Philadelphia, Pa., September 11, 1858; d. Rockport, Mass., March 23, 1948. Painter, muralist, etcher, teacher.

In etching Clements specialized in landscapes, seascapes, architectural and city views. She made etchings based on her travels in the United States, France, Algiers, and Palestine. From about 1918 until the late 1930s she and Ellen Day Hale experimented with color, basing their work on the method of French etcher René Ligeron. Clements was the daughter of Dr. Richard Clements of Philadelphia and Gabrielle DeVaux of South Carolina, descendent of General Francis "Swamp Fox" Marion, hero of the American Revolution. She studied lithography with Charles Page at the Philadelphia School of Design for Women in 1875, and executed scientific drawings and lithographs for Cornell University while she studied for her B.S. degree, which she received in 1880. Clements studied with Thomas Eakins from 1880 to 1883 at the Pennsylvania Academy, where she won the Toppan Prize for the best painting by a student. She learned to etch from Stephen Parrish in Philadelphia in 1883. She went to Paris to study at the Académie Julian with Tony Robert-Fleury and William A. Bouguereau in 1884-85. In 1895 she joined the faculty of Baltimore's Bryn Mawr School, a school for girls established by Martha Carey Thomas and Mary E. Garrett, where she taught art for many years.

Between 1896 and 1931 she was commissioned by the Bendann Galleries to etch a series of nine views of Baltimore. Clements painted murals in five churches in the Washington, D.C.-Maryland area, one in Detroit, *Harvest* for the Ladies' Reception Room of the Pennsylvania State Building at the Columbian Exposition in Chicago, and two murals in Philadelphia—one for The New Century Club building and the other for the music room of Mrs. Horace Brock. She made a few etchings based on her mural designs. Several of her etchings were published by Christian Klackner, *A Tramp* was pub-

lished in J. R. W. Hitchcock's *Some Modern Etchings,* and her *Portrait of Edmondo de Amicis* was the frontispiece for *Spain and the Spaniards.* Clements exhibited paintings and etchings at the Pennsylvania Academy, the National Academy of Design, with the Philadelphia Society of Artists, the New York Etching Club, the Boston Art Club, the Association of Canadian Etchers, the Boston Art Students' Association, the Boston Water Color Club, and the Massachusetts Charitable Mechanic Association. She entered twenty-one etchings in the *Women Etchers of America* show.

Clements participated in major expositions, including the 1888 Ohio Valley Centennial, 1893 World's Columbian in Chicago, 1895 Cotton States and International Exposition in Atlanta, 1901 Inter-State and West Indian Exposition in Charleston, 1904 Louisiana Purchase Exposition in St. Louis, and Philadelphia's 1926 Sesqui-Centennial International Exposition. In the twentieth century she exhibited with the Chicago Society of Etchers, the Society of American Etchers, Baltimore Charcoal Club, the Society of Washington Artists, the National Art Club, at the U.S. National Museum (now the National Museum of American History), Smithsonian Institution, the Library of Congress, Goodspeed's in Boston, and the J. B. Speed Art Museum in Louisville, Kentucky. Living and working in Rockport on Cape Ann near Gloucester, Massachusetts, with Ellen Day Hale during the summers, she exhibited with the Rockport Art Association, the Folly Cove Etchers, and the North Shore Arts Association. She taught Hale and Margaret Lesley Bush-Brown to etch, and in the early twentieth century in their Rockport studio she and Hale worked on color etching and aquatint with several younger artists, including Margaret Yeaton Hoyt (her former painting and drawing student), Lesley Jackson (whom she taught to etch), Theresa F. Bernstein, and William Meyerowitz (see Hale).

REFERENCES: Gabrielle DeVaux Clements Papers, Archives of American Art, Smithsonian Institution, Washington, D.C.; Department of Manuscripts and University Archives, Cornell University, Ithaca, N.Y.; Prints and Photographs Division, Museum and Library of Maryland History, Baltimore, Md.; Artist Files, Graphic Arts Division, National Museum of American History, Smithsonian Institution, Washington, D.C.; Archives, Pennsylvania Academy of the Fine Arts, Philadelphia, Pa.; Bush-Brown Family Papers and Hale Family Papers, Sophia Smith Collection, Smith College, Northampton, Mass.; Koehler; J. R. W. Hitchcock, *Some Modern Etchings,* New York, White, Stokes, and Allen, 1884; *Spain and the Spaniards,* New York, G. P. Putnam's Sons, 1885; "The Cape Ann Quarries," *Harper's Monthly* 70, March 1885, p. 557; C. Klackner Gallery, *Klackner's American Etchings,* New York, C. Klackner, 1888; Goodspeed's Bookshop, *Exhibiton and Sale of Etchings and Soft-ground Aquatints in Color of French, Italian and American Subjects by Ellen Day Hale and Gabrielle DeV. Clements, . . . January 14, . . . January 26, 1924,* Boston, Goodspeed's, 1924; "Gabrielle de Vaux Clements, . . . ; Chancel Decorations for the Mission Chapel of St. Paul, Baltimore," *Art Digest* 8, October 15, 1933, p. 11; J. B. Speed Memorial Museum, *Exhibition of Etchings in Color by Ellen Day Hale, Gabrielle DeVeaux Clements, Lesley Jackson, Margaret Yeaton Hoyt, Theresa F. Bernstein, and William Meyerowitz, November 30 to December 30, 1935,* Louisville, Ky., J. B. Speed Memorial Museum, 1935; "Gabrielle D. Clements [Obituary]," *The New York Times,* March 28, 1948, p. 2; Ulehla; Falk; Petteys.

SARAH COLE: b. Bolton-le-Moor, Lancashire, England, 1805; d. Catskill, N.Y., 1857. Painter, etcher.

Under Cole's name in the New York version of the *Women Etchers of America* was the entry "proofs of plates etched in 1844." However, etcher John Falconer, who owned Cole's plates, never supplied the

four etchings which were intended for the show, and none of her plates and etchings has been found. Cole, who lived in Catskill, New York, was the youngest sister of landscape painter Thomas Cole. Their parents, James and Mary Cole, had brought their family to Philadelphia in 1818. Sarah moved with her parents to Steubenville, Ohio, where her father set up a wallpaper manufacturing business. She, like Thomas, probably assisted her father in designing and engraving the blocks to print the paper. By 1823 the family had moved to New York, and Thomas Cole joined them after a few months' study at the Pennsylvania Academy in Philadelphia. Sarah accompanied Thomas on sketching trips and he undoubtedly taught her to paint. Asher B. Durand showed her the techniques of etching. She etched at least one plate after a painting by her brother. Sarah exhibited at the National Academy of Design, at the Maryland Historical Society, and with the American Art Union.

REFERENCE: Petteys.

GEORGIANA A. DAVIS: b. New York, N.Y., ca. 1852; d. 1901. Painter, illustrator, etcher.

Davis studied at the Cooper Union School of Design for Women in New York for several years in the early 1860s. Later in her career she took classes at the Art Students' League. Known primarily as an illustrator, she worked for *Aldine, Frank Leslie's Illustrated Weekly*, and the Salvation Army's *War Cry*, and designed covers as well as illustrations for McLoughlin Bros., publishers of children's books. Working on Stephen Parrish's etching press, Davis and Phoebe Natt collaborated on an etching, *Miserere Nobis*, after a drawing by Davis, in 1886. Natt exhibited the etching under her name in the *Eighth Annual Black and White Exhibition* of the Salmagundi Club that year. They exhibited it together in *Women Etchers of America*. Davis exhibited with the National Academy of Design, the American Society of Water Color Painters, the Women's Pavilion of the U.S. Centennial Exposition in 1876, and as a member of the Boston Art Club in the 1890s. She is reported to have made etchings of genre and Western subjects, but none has been found.

REFERENCES: Cooper Collection, Cooper Union, New York, N.Y.; *The Quarterly Illustrator*, 2 (January-March and October-December 1894), pp. 74, 454; Lorado Taft, *Artists and Illustrators of the Old West, 1850-1900*, New York, Bonanza Books, 1953, pp. 151, 338; Judy Larson, *Enchanted Images; American Children's Illustration, 1850-1925*, Santa Barbara, Calif., Santa Barbara Museum of Art, 1980, pp. 60, 64; Falk; Petteys.

ANNIE BLANCHE DILLAYE: b. Syracuse, N.Y., September 4, 1851; d. Philadelphia, Pa., December 20, 1931. Painter, etcher, illustrator, poster designer, jeweler, silversmith, teacher, writer.

Dillaye specialized in seascape, landscape, and architectural etchings of views in the United States, England, Europe, and Canada. She also made etchings after paintings by other artists. A daughter of Stephen D. Dillaye and Charlotte B. Malcolm, she attended private schools—Miss Bonney's and Miss Dillaye's School for Young Ladies (later renamed the Ogontz School for Young Ladies) in Philadelphia. She studied art with Thomas Eakins at the Pennsylvania Academy from late 1877 to 1882 and then learned to etch from Stephen Parrish in Philadelphia in 1883. Traveling abroad during 1885-87, she studied in Paris with Eduardo-Leon Garrido. Dillaye sometimes took students on sketching trips to Europe. An art-activist all her life, she was President of the Philadelphia Water Color Club and the Fellowship of the Pennsylvania Academy, and a founder and President of the Plastic Club, Philadelphia. She was also a member of the Philadelphia

Society of Etchers (founded in 1928), the Black and White Club, Association of Women Painters and Sculptors (New York), the American Women's Art Association (Paris), the Philadelphia, New York, and Chicago water color clubs, and the Daedalus Arts and Crafts Guild of Philadelphia. Dillaye was employed by the Pennsylvania Academy in the mid-1890s to direct its art education program. In the twentieth century she spent winters in Coconut Grove, near Miami, Florida, where she owned a grapefruit farm.

Dillaye exhibited often at the Pennsylvania Academy and the Boston Art Club, in the Paris Salon five times, with the Philadelphia Society of Artists, the Philadelphia Society of Etchers, the Royal Society of Painter-Etchers, London, and the New York Etching Club. In 1886 the Williams & Everett Gallery in Boston held a special exhibition of Edith Loring Peirce Getchell's and Dillaye's etchings.

In the twentieth century, she exhibited regularly with the Plastic Club, which held a solo exhibition of her etchings and "auto-lithographs" (none of which has been located) in 1902 and a comprehensive show of her paintings and prints in 1927, the American Art Society, the Philadelphia Art Week Association, the Woman's Art Club of New York, the Philadelphia Art Alliance, the Brooklyn Society of Etchers, the new Philadelphia Society of Etchers, and at the Syracuse Museum of Art. Dillaye also exhibited at many expositions, including the 1888 Ohio Valley Centennial, in the Woman's Building and the Ladies' Parlor of the Pennsylvania Building at the 1893 Columbian in Chicago, the 1895 Cotton States and International in Atlanta, the 1901 Pan-American at Buffalo, the 1903 Exposition Universelle (Lorient, France), the 1904 Louisiana Purchase in St. Louis, the 1913 National Conservation Exposition in Knoxville, the 1915 Panama-Pacific in San Francisco, and Philadelphia's 1926 Sesqui-Centennial. Dillaye won several medals for her etchings and paintings. In the early 1880s she and Joseph Pennell were commissioned by the Historical Society of Pennsylvania to etch sixteen plates for *Views on the Old Germantown Road*, which was published in the 1884 *Pennsylvania Magazine of History* and as a limited edition portfolio. In the *Women Etchers of America* exhibitions she entered forty etchings.

REFERENCES: Koehler; Howard M. Jenkins, "The Welsh Settlement at Gwynedd," *Pennsylvania Magazine of History and Biography* 8, 1884, op. p. 179, p. 180; "Another Exhibition of Etchings by Peirce and Dillaye at Williams & Everett's Gallery on Boylston Street," *The Art Interchange* 32, January 16, 1886, p. 16; Blanche Dillaye, "Etching," *The Congress of Women, Held in the Woman's Building, World's Columbian Exposition, Chicago, U.S.A., 1893*, Chicago and Philadelphia, S. I. Bell & Co., 1894; Dillaye, "Women Etchers," *Philadelphia Press*, November 27, 1895, Women's Edition, p. 17; "The Plastic Club of Philadelphia," *Harper's Bazaar* 30, July 14, 1897, p. 619; The Plastic Club, *A Catalogue of Etchings, Pencil Sketches and Auto-Lithographs by Blanche Dillaye, April 4-16, 1902*, Philadelphia, The Morris Press, 1902; Philadelphia Art Alliance, *Memorial Exhibition of Watercolors and Etchings by Blanche Dillaye*, Philadelphia, Philadelphia Art Alliance, 1932; "Pioneer Woman Etcher," *The Art Digest*, 6, January 1, 1932, p. 12; "Blanche Dillaye [Obituary]," *The New York Times*, December 21, 1931, p. 21; Ulehla; Falk; Petteys.

ANNA PARKER DIXWELL: b. Jamaica Plain, Mass., June 5, 1847; d. Paris, France, April 21, 1885. Painter, etcher.

Anna Dixwell was one of four children of Boston banker and art patron John J. Dixwell and Elizabeth Boardman Bowditch. Her father was a collector and a supporter of the New England School of Design for Women. Anna Dixwell's painting subjects included city and rural architectural views, landscapes, floral arrangements, and still-lifes. In her etching she specialized in landscapes of America and European

architectural views. A student of Dr. William Rimmer, William Morris Hunt, and Helen Knowlton in Boston around 1873-74, she studied in the winter of 1874-75 in Paris under Emile-Auguste Carolus-Duran. For the next year and a half she traveled in Europe. From 1876 to 1880 she lived in both Boston and New York, where she frequented the Art Students' League. She was also on the Committee of Design for the School of Art Needlework at the Boston Museum of Fine Arts. Again in Europe traveling with artist Elizabeth Boott (who married Frank Duveneck in 1886), she studied etching with Otto H. Bacher in early 1880 in Florence and may have joined Duveneck, Bacher, and the group of "Duveneck Boys" in Venice, where Bacher and James Abbott McNeill Whistler influenced Duveneck to etch. The following year, 1881, Dixwell traveled in Italy and Spain. When she returned to Boston in 1882, she studied with Emil Carlsen. On her third trip to Paris, in 1885, she was accepted at the Académie Julian and studied with William Adolphe Bouguereau and Tony Robert-Fleury until she died less then two months later.

Dixwell had established a strong exhibition record before she left for Paris. Her paintings and etchings were included in exhibits of the National Academy of Design, the New York Etching Club, the Salmagundi Club, the Pennsylvania Academy of the Fine Arts, the Philadelphia Society of Artists, the Boston Art Club, the Massachusetts Charitable Mechanic Association, the New England Manufacturers' and Mechanics' Institute, the 1883 Cincinnati Industrial Exposition, the 1883 Internationalen Kunst-Ausstellung, Munich, and in the Boston Museum of Fine Arts 1883 *Contemporaneous American Art*. Dixwell and Boott exhibited their paintings and charcoals in 1882 at the J. Eastman Chase and the Williams & Everett galleries in Boston. In 1884 she had a solo exhibition of thirty paintings and eleven works in "black and white" at the J. Eastman Chase Gallery. Eight of her etchings were included in the *Women Etchers of America*, but none has yet been located.

REFERENCES: Koehler; J. Eastman Chase's Gallery, *Exhibition of Paintings by Elizabeth Boott and Anna P. Dixwell, . . . November 17 to December 1, 1882*, Boston, J. Eastman Chase's Gallery, 1882; J. Eastman Chase's Gallery, *Exhibition of Pictures by Anna P. Dixwell, From February 20 to March 6, 1884, . . .* Boston, J. Eastman Chase's Gallery, 1884; Falk; Petteys.

FLORENCE ESTE: b. Cincinnati, Ohio, 1860; d. Paris, France, 1926. Painter, pastelist, etcher.

After touring France with her mother and Emily Sartain in the summer of 1874, Esté worked in Sartain's Paris studio and studied with Tony Robert-Fleury while living at Del Sarte's boarding house. Influenced by Sartain, Esté entered the Pennsylvania Academy in 1876 and studied with Thomas Eakins. Except for 1877-78, she continued to work at the Academy until 1882 with fellow students and future etchers Gabrielle Clements, Blanche Dillaye, Phoebe D. Natt, Margaret Lesley (Bush-Brown), Margaret Levin (Farrell), Mary Franklin, and Joseph Pennell. Etchers Stephen Parrish and Stephen Ferris were enrolled in the men's life class. In 1884 Esté joined Parrish's etching students, Dillaye, Natt, Clements, and Elizabeth Bonsall, as tenants in his studio while he was in Europe. She soon learned to etch on Parrish's press. In 1886-87 she took William Sartain's portrait class at the Philadelphia School of Design for Women, where Emily Sartain was the new principal. Esté moved permanently to Paris in 1888 and lived for a time in the same building as her friend Cecilia Beaux, who was enrolled at Julian's. During her later years in Paris she studied with Alexandre Nozal and at the Académie Colarossi with Raphael Collin.

Esté exhibited with the Brooklyn Art Association, the Boston Art Club, the American Watercolor Society, the Salmagundi Club, The New York Etching Club, and at the Pennsylvania Academy of the Fine Arts. Three of Esté's etchings were included in the New York version of the *Women Etchers of America*, and in 1893 her etchings were exhibited in the Ladies' Parlor of the Pennsylvania Building at the World's Columbian Exposition and in the Paris Salon. Beginning in 1894 she exhibited regularly with the Salon de la Société Nationale des Beaux-Arts (known as the Salon de la Société des Artistes Français in 1894) in Paris; she an Associate Member in 1902. She was an honorary member of the Philadelphia Water Color Club. Three of her paintings were exhibited in the Plastic Club's 1923 *Exhibition of Eminent Women Painters*, and in 1925 she won a Pennsylvania Academy prize for one of her watercolor paintings.

REFERENCES: Cecilia Beaux Papers, Archives of American Art, Smithsonian Institution, Washington, D.C.; Sartain Papers, Archives, Moore College of Art, Philadelphia, Pa.; Koehler; Falk; Petteys.

KATHERINE LEVIN FARRELL: b. Philadelphia, Pa., March 15, 1857; d. 1951. Painter, etcher.

Levin Farrell's oil and watercolor paintings were mostly landscapes of Pennsylvania and the New England coast and floral subjects. In etching she specialized in portraits after Hugo Kauffmann and Paul Thumann as well as landscapes. A 1879 graduate of the Philadelphia School of Design for Women, where she had studied with Peter Moran and Stephen Ferris, she also was a pupil of Thomas Eakins at the Philadelphia Academy of the Fine Arts from 1880 to 1887. Levin Farrell studied at various times with William Sartain, Fred Wagner, Henry Breckenridge, and Earle Horter. She also studied at the Philadelphia Museum School of Art, the Drexel Institute from 1903 to 1905, and with Emil Bisttram in Taos, New Mexico, after the mid-1930s. She exhibited at the Philadelphia School of Design for Women, the Philadelphia Academy of the Fine Arts, the New England Manufacturers' and Mechanics' Institute, the National Academy of Design, the Philadelphia Society of Artists, the Brooklyn Art Association, the Boston Art Club, and the New York Etching Club. Sixteen of her etchings were exhibited in the *Women Etchers of America* exhibitions.

Within two or three years after the women etchers shows she married Theodore P. Farrell, and with the exception of the 1893 World's Columbian Exposition, where her etchings and oil paintings were exhibited in the Ladies' Parlor of the Pennsylvania Building and in the Woman's Building, she did not exhibit again until 1897, when she became a regular exhibitor with the Art Club of Philadelphia. In 1898 she was a founding member of the Plastic Club; she exhibited with them in their black and white and color exhibitions for many years. In the twentieth century she also exhibited with the American Art Society, the Philadelphia Art Alliance, which held a solo exhibition of her work in 1938, the Philadelphia Art Week Association, and the Philadelphia Society of Etchers. She was awarded the Plastic Club's silver and gold medals, the 1903-04 John R. Drexel and Anthony J. Drexel Prize for Watercolor, and the 1934 prize in Gimbel's Philadelphia Women's Achievement Competition. She was also a member of the Fellowship of the Pennsylvania Academy. Her etchings were published in J. R. W. Hitchcock's deluxe portfolios, *Some Modern Etchings* and *Recent American Etchings*, and in *Masterpieces of German Art*.

REFERENCES: Koehler; J. R. W. Hitchcock, *Some Modern Etchings*, New York, White, Stokes, & Allen, 1884; Hitchcock, *Recent American Etchings*, New York, White, Stokes, & Allen, 1885; *Masterpieces of German Art*, Philadelphia, Gebbie & Co., 1885; Falk; Petteys.

MARGARET M. TAYLOR FOX: b. Philadelphia, Pa., July 26, 1857; active to 1941. Painter, illustrator, etcher, teacher.

Taylor (Fox), who studied from November 1887 to March 1889 at the Pennsylvania Academy, where she was a painting student of Thomas Anshutz, learned etching from Peter Moran at the Philadelphia School of Design for Women. Having entered the School in 1880, she graduated in 1883 but continued to take classes until the fall semester of 1892-93, when she married Dr. George L. Fox and moved to the Washington, D.C.-Maryland area, where she continued to work. She received the James L. Claghorn Gold Medal for the best original illustrations at the School of Design in 1885. Taylor (Fox) was commissioned to produce etchings by the Philadelphia Art Union in 1884, by the J. B. Lippincott Company to illustrate deluxe editions of *English Poems* and Oliver Goldsmith's *The Deserted Village* and *The Traveller*, and by H. L. Everett to illustrate *Historic Churches of America: Their Romance and Their History*. She, Louise Prescott Canby, Catherine E. Dallett (b. 1861), and Anna R. Garrett (active 1880-1933), all landscape students of Peter Moran, collaborated in the portfolio *Etched Sketches* in 1885.

Taylor (Fox) exhibited sixteen etchings, nine of which were landscapes, in *Women Etchers of America*. Her etchings also were exhibited with the New York Etching Club, in the Fine Arts and Woman's Buildings and in the Ladies' Parlor of the Pennsylvania Building at the Columbian Exposition in Chicago in 1893, as well as in the Woman's Building of Atlanta's Cotton States and International Exposition in 1895. In the twentieth century she exhibited with the National Arts Club.

REFERENCES: School Records and Scrapbook, Philadelphia School of Design for Women Collection, Archives, Moore College of Art, Philadelphia, Pa.; Oliver Goldsmith, *The Deserted Village*, Philadelphia, J. B. Lippincott Co., 1888; Goldsmith, *The Traveller*, Philadelphia, J. B. Lippincott Co., 1889; *Historic Churches of America; Their Romance and Their History*, Philadelphia, H. L. Everett, 1890; *English Poems*, Philadelphia, J. B. Lippincott Co., 1891; Falk; Petteys.

MARY JETT FRANKLIN: b. Athens, Ga., February 25, 1842; d. Athens, Ga., February 12, 1928. Painter, etcher, teacher.

The daughter of Leonidas and Myrtis Thomas Franklin of Athens, Georgia, Mary Franklin was a portrait and genre painter. On October 4, 1860, a Mary Franklin registered in the Pennsylvania Academy's Antique Class, but there is no further record under this name until the 1870s. In 1877 she entered the Academy's Life Class, where she continued to study with Thomas Eakins until April 1880. She learned to etch from Stephen Ferris around 1880. Franklin lived in New York in 1881 and in 1888 was living in Mount Carroll, Illinois. She moved to Paris in the late 1890s, where she studied at the Académie Colarossi and with Louis Deschamps, Jean Geoffrey, Raphael Collin, Henri Morriset, and Caro del Viey. After many years in France she returned to Athens, Georgia, and continued to execute portrait commissions.

Franklin exhibited at the Pennsylvania Academy between 1877 and 1896, with the National Academy of Design, in the 1897 Tennessee Centennial and International Exposition in Nashville, and in the Salon des Artistes Indépendants in the early twentieth century. She exhibited the three titles (two genre scenes and a portrait) with the New York Etching Club in 1882 that she showed with the *Women Etchers of America* six years later in the New York version of the show. None of her etchings has been found. She was awarded a Medal of Honor at the Paris Academy of Fine Arts Exhibition in 1917.

REFERENCES: Mary Franklin Papers, Special Collections, University of Georgia Libraries, Athens, Ga.; Koehler; Falk; Petteys.

EDITH LORING PEIRCE GETCHELL: b. Bristol, Pa., January 25, 1855; d. Worcester, Mass., September 18, 1940. Painter, etcher, textile designer.

Getchell specialized in etching. Using watercolor to make preliminary sketches, she often emphasized tonal qualities in her etched landscapes of Holland and the United States. She studied art with Peter Moran at the Philadelphia School of Design for Women in 1874-77 and then returned to Bristol, Pennsylvania, for three years to work as a designer at Livingston Mills. During two winters in New York in the early 1880s she studied with William Sartain and R. Swain Gifford. She moved to Philadelphia, opened a studio, and attended Thomas Eakins's class at the Pennsylvania Academy in 1883-84. She also studied etching with Stephen Parrish in his Philadelphia studio in 1883-84 before she left for a tour of Europe. After her marriage in April 1885, she moved to Worcester, Massachusetts. She was a member of the Philadelphia Society of Artists, the Philadelphia Sketch Club, the New York Etching Club (she and Mary Nimmo Moran were the only women members), and in the twentieth century, the Chicago and California Societies of Etchers.

Peirce Getchell's etchings were selected several times for publication by Frederick Keppel and the Philadelphia Art Union. The New York Etching Club's deluxe portfolio, *Twenty Original American Etchings*, included her *Solitude*. The publisher, Cassell & Co., used the etchings from that publication later in *Gems of the American Etchers*. W. K. Vickery of San Francisco commissioned several etchings from her after William Keith and Mary Curtis Richardson in 1886, and Robert M. Lindsay of Philadelphia commissioned her to make etchings after a series of paintings by Ross Turner in 1887. Her etching *A Souvenir, Old South Church* was published in the 1888 New York Etching Club catalogue, and *Path to the Wreck* was one of two original etchings used to illustrate the Union League Club version of the *Women Etchers of America* catalogue that year.

Getchell exhibited at the Philadelphia School of Design for Women, the Philadelphia Society of Artists, the Pennsylvania Academy, the National Academy of Design, and the American Water Color Society. Her etchings were shown in the Paris Salon, with the Pennsylvania Academy and Boston Museum of Fine Arts, with the Royal Society of Painter-Etchers in London, the Philadelphia Society of Artists, the Boston Art Club, and the New York Etching Club. She entered fifty-eight etchings in the *Women Etchers of America*. The Williams & Everett Gallery in Boston exhibited etchings by Getchell and Blanche Dillaye in 1886, and the Galerie Durand-Ruel in Paris included her work in its 1889 show of etchings by Mary Cassatt, Otto Bacher, Stephen Parrish, and other American etchers. Getchell's etchings were among those Sylvester Koehler sent to the 1888 Ohio Valley Centennial. In the 1893 Columbian Exposition in Chicago she exhibited etchings in the Fine Arts and Woman's Buildings, and the Ladies' Parlor of the Pennsylvania Building. In the twentieth century her work was exhibited in the 1904 Louisiana Purchase Exposition in St. Louis and the 1915 Panama-Pacific Exposition in San Francisco, by the Boston Water Color Club and the Chicago and California Societies of Etchers, and at Albert Roullier's Art Galleries. The Worcester Art Museum held a solo exhibition of Getchell's etchings in 1908 and included her etchings in its 1912 *Exhibition of American Etchings*.

REFERENCES: Koehler; "Another Exhibition of Etchings by Peirce and Dillaye at Williams & Everett's Gallery on Boylston Street," *The Art Interchange* 32, January 16, 1886, p. 16; Sylvester R. Koehler, ed., New York Etching Club, *Twenty Original American Etchings*, New York, Cassell & Co., 1885; Koehler, ed., *Gems of American Etchers*, New York, Cassell & Co., 1885; Frederick Keppel & Co., *Illustrated Catalogue of Etchings by American Artists. For Sale by Frederick Keppel*

& Co, New York, DeVinne Press, 1908; Worcester Art Museum, *Exhibition of Etchings by Edith Loring Getchell, December 5 to December 14, Nineteen hundred and eight*, Worcester, Mass., Worcester Art Museum, 1908; "Edith Loring Getchell [Obituary]," *The New York Times*, September 19, 1940, p. 23; Falk; Petteys.

ELEANOR ELIZABETH GREATOREX: b. New York, N.Y., May 26, 1854; d. Paris, France, 1897. Painter, etcher, illustrator, muralist, pottery decorator, teacher.

Her mother, artist Eliza Greatorex (see biography), began to train Eleanor and her sister Kathleen Honora Greatorex (1851-1913) in the early 1860s, while they were living in Cornwall-on-the-Hudson, New York. The sisters studied at the National Academy of Design in 1869-70 and later at the Art Students' League. They accompanied their mother to Europe for the first time in 1870. Making Munich their base each winter, Eleanor and Kathleen studied German and music the first year, and painting with Carl Otto in the winter of 1871-72. They also copied old master paintings in the Pinakothek. The Greatorexes spent the summers working from nature in Nuremberg, Switzerland, and Italy, where Eleanor and Kathleen studied in Rome. When they returned to New York in the fall of 1872, Eleanor and Kathleen gave private lessons to art students. In 1878 the Greatorexes returned to Paris. The sisters studied with Emile-Auguste Carolus-Duran and Jean-Jacques Henner in 1879 and with Arthur Melville in 1880 after a trip to England. Early in 1881 the three Greatorexes were sketching in Algiers when Eleanor became ill. In August 1881, they returned to New York because of her illness. In 1882 they opened a studio and set up a class for professional artists. Eliza, who had exhibited an etching on glass in 1875 at the National Academy of Design, taught Eleanor and Kathleen the process (cliché verre) in 1883. The sisters produced wall and ceiling murals for the Ladies' Reception Room of the Dakota Apartment Building overlooking Central Park in 1884.

Eleanor illustrated Matilda Despard's translation of Heinrich Hoffmann-Donner's *Prince Greenwood and Pearl-of-Price, . . .* (Washington, D.C.: N. Peters, 1874) and worked for *Godey's Magazine* in the 1890s. In her paintings, she specialized in figure and flower subjects. She exhibited paintings at the National Academy of Design, with the Brooklyn Art Association, the Boston Art Club, the Salmagundi Club, the American Water Color Society, the Philadelphia Society of Artists, the Chicago Inter-State Industrial Exposition in 1883, the 1876 U.S. Centennial Exposition, and the Exposition Universelle in Paris in 1889. In the exhibition of *The Private Collection of Thomas B. Clarke of New York* at the American Art Gallery, New York, in 1883-84, hers was the only art by a woman. Her etchings were included in the 1881 Philadelphia Society of Artists' show. In the *Women Etchers of America* and the New York Etching Club exhibitions in 1888 she showed three Italian scenes—Titian's house in Pieve di Cadore, Titian's kitchen, and a fountain in the Ampezzo Pass. None of her etchings has been located. Eleanor Greatorex was a member of the American Water Color Society.

REFERENCES: Koehler; Candace Wheeler, "American Flower-Painters," New England Manufacturers' & Mechanics' Institute, *Catalogue of the Art Department*, Boston, New England Manufacturers' & Mechanics' Institute, 1883; M. B. W. [Margaret Bertha Wright], "Eleanor and Kathleen Greatorex," *The Art Amateur* 13, September 1885, pp. 69-70; "The Year's Art as Received in the Quarterly Illustrator," *The Quarterly Illustrator* I, January-March 1893, pp. 26, 107, 115, 117, 201, 285; Falk; Petteys.

ELIZA PRATT GREATOREX: b. Manor Hamilton, Ireland, December 25, 1819; d. Paris, France, February 9, 1897. Painter, illustrator, etcher, teacher.

Greatorex was the daughter of the Rev. James Calcott Pratt, a Methodist minister, who brought his family from Ireland to New York in 1840. Her sister, Matilda Pratt Despard, wrote a novel about their childhood, *Kilrogan Cottage*. In 1849 Eliza married musician Henry Wellington Greatorex and between 1851 and 1854 they had two daughters and a son. Eliza, who had begun to paint in Ireland, studied with William W. Wotherspoon in New York from 1854 to 1856. In 1856-57 the family traveled in England and Ireland, where she practiced her sketching. After her husband's death in 1858 she opened a studio on Broadway in New York. Within a few years she moved to the building on Fifth Avenue where James Hart and James D. Smillie also had studios. She studied painting with William and James Hart and probably received advice in etching from Smillie, as did her daughter Kathleen Honora (1851-1913) in 1874. (Kathleen, who did not exhibit in the *Women Etchers of America*, showed an etching at the National Academy of Design in 1875.) Eliza taught art in her studio and at Miss Henrietta Haines School for many years. She had made three trips to Europe by 1870 (including one in 1862 to study in Paris with Emile Charles Lambinet), when she and her daughters, Kathleen and Elizabeth Eleanor (see biography) went to Germany and France to study and sketch the landscape. In Munich, Eliza took private classes with Karl von Piloty and copied old master paintings in the gallery of the Pinakothek.

After returning to the United States, she and her three children traveled by train to Colorado, where her son, Thomas, who had been working for the U.S. government in Washington, D.C., settled (and died in 1881). The pen and ink drawings which she had made in Ober-Ammergau, Nuremberg, and Colorado were reproduced in collotype (heliotype) to illustrate her travel journals. Greatorex produced several collotype-illustrated portfolios of her pen and ink drawings of historic New York scenes, the most well known of which is *Old New York, from the Battery to Bloomingdale; . . .* of 1875. Interested in the reproductive capabilities of etching in the mid-1870s because she was looking for a means to reproduce her drawings for the New York portfolios, Greatorex made etchings after her drawings of New York and Ober-Ammergau in 1874-75. For her etchings such as *Castle Garden (The Battery, from No. 1 Broadway)*, she either made new plates or reworked the earlier plates in the 1880s, after she had studied etching in Paris with Charles Henri Toussaint in 1879. At that time, while she and her daughters were living abroad from 1878 to August 1881, she also sought advice from Maxime Lalanne. She traveled to England, Germany, and Italy, and spent several months in Algiers, making etchings during most of her tour. One of her etchings was accepted in the 1881 Paris Salon. Her etchings were exhibited with the New York Etching Club as part of the Salmagundi Club's show in 1880 and in the 1881 Boston Museum of Fine Arts' *Exhibition of American Etchings*. Sylvester Koehler published *The Pond, Cernay-la-ville* in the *American Art Review*.

In early 1882, she again set up her New York studio, where she and her daughters conducted art classes, and she etched scenes of contemporary New York City. They also taught in their summer home at Cragsmoor, New York. In 1886 they moved back to Paris. During the next two years Eliza made a series of etchings in Europe. She exhibited again in the Paris Salon in 1889, 1890, and 1894. She had exhibited at the National Academy of Design in New York from 1855 to 1884 and was elected an Associate in 1869. She was a member of the Artists' Fund Society, and an honorary member of the Ladies' Art Association and Sorosis. She also exhibited with the Washington Art Association, Brooklyn Art Association, the American Water Color

Society, the Boston Art Club, the Philadelphia Society of Artists, the Society of American Artists, at the Boston Athenaeum, the Pennsylvania Academy, the Chicago Inter-State Industrial Exposition of 1876, and the Exposition Universelle in 1878 and 1889. She exhibited her drawings of Colorado at the Brooklyn Art Association in 1873 and those of New York in the Women's Pavilion of the 1876 Centennial Exposition. Her etchings were also exhibited at the National Academy of Design, the Boston Museum of Fine Arts, with the American Water Color Society, the Brooklyn Art Association, the Philadelphia Society of Artists, the Salmagundi Club, the New York Etching Club, at the Louisville Industrial Expositions of 1875 and 1877, the Ohio Valley Industrial Exposition in 1888, and the Brooklyn Woman's Club in 1890.

REFERENCES: Eliza Greatorex Papers, Manuscript Division, New York Public Library, New York, N.Y.; Dreer Collection of Painters and Engravers, Historical Society of Pennsylvania, Philadelphia, Pa.; Mrs. [Elizabeth Fries Lummis] Ellet, *Women Artists in All Ages and Countries*, N.Y., Harpeer & Brothers, 1859, p. 316; "Sketchings; Domestic Art Gossip; Washington Art Gossip," *The Crayon* VII, March 1860, p. 84; Henry Greatorex, *Love me! Words by Eliza. Music by H. W. Greatorex*, Richmond, Va., Geo. Dunn, and Columbia, S.C., Julian A. Selby, ca. 1863; Eliza Greatorex, *Rock Enon Springs, Virginia* [Washington, D.C.?, Pratt?, n.d.]; Greatorex, *Relics of Manhattan; A Series of Photographs, from pen and ink sketches taken on the spot, . . . illustrating historic scenes and buildings in and around this city . . .*, [.N.Y.?, n.p., 1869]; Greatorex, *Die Heimath von Ober-Ammergau*, Ober-Ammergau, [1871?]; Greatorex, *The Homes of Ober-Ammergau; A Series of Twenty Etchings in heliotype, from the original Pen-and-Ink Drawings, . . .*, Munich, Jos. Albert, 1872; Greatorex, *Landmarks of Old New York. Reproductions from pen and ink drawings*, N.Y., Henry K. Van Siclen, n.d.; "Mrs. Greatorex", *Rocky Mountain News*, July 1, 1873, p. 4; "Mrs. Greatorex", *Colorado Springs Gazette*, July 19, 1873, p. 2; *Colorado Springs Gazette*, August 23, 1873, p. 2; "Greatorex," *Rocky Mountain News*, August 27, 1873, p. 4; *Colorado Springs Gazette*, September 6, 1873, p. 4; Greatorex, *Summer Etchings in Colorado*, intro. Grace Greenwood, N.Y., G. P. Putnam's Sons, 1873; Greatorex, *Old New York from the Battery to Bloomingdale; Etchings by Eliza Greatorex. The Etchings are produced by H. Thatcher from the Original Pen-Drawings of the Artist*, text by M[atilda] Despard, N. Y., G. P. Putnam's Sons, 1875; Greatorex, *Souvenir of 1876; Reproductions from pen and ink drawings* [Philadelphia?, n.p., 1876]; Matilda [Pratt] Despard, *Kilrogan Cottage*, N.Y., Harper & Brothers, 1878; Greatorex, *Catalogue Sale of Private Collection of Paintings, old engravings, old china, studio properties, and furniture*, N.Y., Eliza Greatorex, 1878; Sylvester R. Koehler, "The Works of the American Etchers. XXII. Mrs. Eliza Greatorex," *American Art Review* 2, pt. 2, 1881, p. 12; Koehler; "Obituary," *The New York Daily Tribune*, February 11, 1897, p. 11; "Obituary," *Boston Transcript*, February 11, 1897, p. 7; Gilbert McClurg, *Brush and Pencil in Early Colorado Springs*, Colorado Springs, Colo., [n.p.], 1924; National Academy of Design, *Our Heritage: A Selection from the Permanent Collection of the National Academy; . . .*, N.Y., National Academy of Design, 1942; Cragsmoor Free Library, *A Century of Women Artists in Cragsmoor*, Cragsmoor, N.Y., Cragsmoor Free Library, 1979; Arvada Center for the Arts and Humanities, *Colorado Women in the Arts*, Arvada, Colo., Arvada Center, 1979; Chris Petteys, "Colorado's First Women Artists," *Denver Post, Empire Magazine*, May 6, 1979, p. 37; Falk; Petteys.

ELLEN DAY HALE: b. Worcester, Mass., February 11, 1855; d. Brookline, Mass., February 11, 1940. Painter, etcher, muralist, photographer, writer, teacher.

In printmaking Hale experimented with style, techniques, and color. Her subjects, which she found in Massachusetts as well as in her trips to California and South Carolina, Europe, Algiers, and the Middle East, included architectural views, landscapes, figures, and portraits. Hale was a member of the prominent Beecher-Hale family, the eldest child and only daughter of Emily Baldwin Perkins Hale (granddaughter of Lyman Beecher) and author, orator, and clergyman Edward Everett Hale (grandnephew of Nathan Hale), the grandniece of author Harriet Beecher Stowe and educator and author Catherine Beecher, and the niece of artist and author Susan Hale, who probably gave Ellen her first art lessons. Her mother encouraged Hale and her seven brothers, including artist Philip Lesley Hale, to draw while they were growing up. Her father, who had experimented with daguerreotype, probably taught her photography. She was fluent in six languages. In Boston, she studied art with Dr. William Rimmer in 1873 and with William Morris Hunt and Helen Knowlton from 1874 to 1879. Hale opened her own portrait studio in 1877. She assisted Knowlton and Rimmer, took private students, and began teaching at private grammar schools. She occasionally attended classes in Philadelphia at the Pennsylvania Academy while she was visiting her cousin, Margaret Lesley (Bush-Brown).

In April 1881, Hale went to Europe with Knowlton, and in Paris she took Emmanuel Frémiet's drawing class at the Jardin des Plantes, then studied briefly at the Académie Colarossi with Louis-Joseph-Raphael Collin and Gustave-Claude-Etienne Courtois before she joined the private class for women taught by Emile-Auguste Carolus-Duran and Jean-Jacques Henner. She went to Europe with her father and aunt, Susan Hale, in 1882. Ellen Hale entered the Académie Julian that fall and studied there for several months. On a return trip to France in 1885 she again attended Julian's and received instruction from Rodolphe Julian, William Adolphe Bouguereau, and Tony Robert-Fleury. While on a sketching tour of France in 1885 Gabrielle Clements taught her to etch.

Hale exhibited in the Paris Salon in 1883 and 1885. She had begun to exhibit in the mid-1870s and maintained an ambitious exhibition record throughout her life. Her work appeared in the U.S. Centennial Exposition in 1876, at London's Royal Academy in 1882, at the Pennsylvania Academy and the Boston Art Club (where she participated in a special show with Susan Hale, Helen M. Knowlton, and Laura Combs Hills in 1878), in special exhibitions at the Boston Museum of Fine Arts, at the Massachusetts Charitable Mechanic Association, the St. Botolph Club, the Copley Society, the Guild of Boston Artists, the American Society of Painters in Water Colors, the 1885 North, Central, and South American Exposition at New Orleans, the 1888 Ohio Valley Centennial, in the Fine Arts and Woman's Buildings at the 1893 Columbian Exposition, the New York Etching Club, the Salmagundi Club, the National Academy of Design, the Art Institute of Chicago, the Corcoran Gallery, the U.S. National Museum (now the National Museum of American History), Smithsonian Institution, the J. B. Speed Art Museum in Louisville, Kentucky, and the Worcester Art Museum. Hale exhibited three etchings of France in *Women Etchers of America*.

In the twentieth century she exhibited with many art organizations, including the North Shore Arts Association of Gloucester, the Folly Cove Etchers, the Rockport Art Association, the Society of Washington Artists, the Washington Watercolor Club, the Charcoal Club of Baltimore, the Chicago Society of Etchers, and the National Arts Club. In Boston Hale's work was also exhibited at Lewis J. Bird & Company, the Williams & Everett Gallery, the Gallery on the Moors, and Goodspeed's. In the early 1890s Hale spent almost two years in California, where she made a series of etchings of the Missions and taught Eleanor Hunter Nordhoff to etch. When her father was appointed Chaplain of the United States Senate in 1904, Hale moved

to Washington, D.C., to act as his hostess. She remained there until his death in 1909. During World War I Hale and Clements spent winters in Charleston, South Carolina, where they taught a new generation of artists to etch, including Alice Ravenel Huger Smith, who established an etching club in Charleston, and Elizabeth O'Neill Verner. Hale, Clements, and several other artists experimented with French etcher René Ligeron's method of color aquatint in Hale's Rockport studio in the 1920s and 1930s (see Clements).

REFERENCES: Ellen Day Hale Papers and Philip Lesley Hale Papers, Archives of American Art, Smithsonian Institution, Washington, D.C.; Bush-Brown Family Papers and Hale Family Papers, Sophia Smith Collection, Smith College, Northampton, Mass.; The Boston Art Club, *Paintings in Oil and Watercolors by Miss Susan Hale, Miss H. M. Knowlton, and Miss Ellen Day Hale*, Boston, The Boston Art Club, 1878; Koehler; Greta, "Art in Boston: . . . Ellen Hale's Work," *The Art Amateur* XVI, January 1887, p. 28; Ellen Day Hale, *History of Art; A Study of the Lives of Leonardo, Michelangelo, Raphael, Titian, and Albert Dürer*, Chicago, Charles H. Kerr & Company, and Boston, George H. Ellis, 1888; Caroline Penniman Atkinson, ed., *Letters of Susan Hale*, Boston, Marshall Jones Company, 1919; Goodspeed's Bookshop, *Exhibiton and Sale of Etchings and Soft-ground Aquatints in Color of French, Italian and American Subjects by Ellen Day Hale and Gabrielle DeV. Clements, . . . January 14, . . . January 26, 1924*, Boston, Goodspeed's Bookshop, 1924; J. B. Speed Memorial Museum, *Exhibition of Etchings in Color by Ellen Day Hale, Gabrielle DeVeaux Clements, Lesley Jackson, Margaret Yeaton Hoyt, Theresa F. Bernstein, and William Meyerowitz, November 30 to December 30, 1935*, Louisville, Ky., J. B. Speed Memorial Museum, 1935; Nancy Hale, *A New England Girlhood*, Boston, Little, Brown and Co., 1936; Nancy Hale, *The Life in the Studio*, Boston, Little, Brown and Co., 1969; Alanna Chesebro, *Ellen Day Hale, 1855-1940. October 17-November 14, 1981*, New York, Richard York Gallery, 1981; Falk; Petteys.

MARY CUMMINGS BROWN HATCH: active 1881-1920s. Etcher.

A resident of Newark, New Jersey, Brown Hatch etched landscapes, architecture, and coastal scenes of New Jersey, Long Island, and upstate New York. Twelve of her prints, etched between 1881 and 1887, were exhibited with the *Women Etchers of America* in 1887-88. The Boston Museum of Fine Arts purchased *A Suggestion* from the exhibition. Previously she had exhibited with the Salmagundi Club in 1881, the Pennsylvania Academy of the Fine Arts in 1883, and the New York Etching Club in 1882 (as Brown) and 1887 (as Hatch). She donated a 1921 etching to the Cleveland Museum of Art, but no other record of her or her work has been found in Ohio.

REFERENCES: Koehler; Petteys.

GERTRUDE RUMMEL HURLBUT: b. Germany; d. Geneva, Switzerland, November 30, 1909. Painter, etcher.

Married and living in New York City, Hurlbut exhibited landscape etchings in 1882 with the New York Etching Club and the Boston Art Club. She entered five etchings in the New York version of the *Women Etchers of America* in 1888. She is listed in dictionaries of artists as a portrait and miniature painter.

REFERENCES: Koehler; Falk; Petteys.

LILIAN BAYARD TAYLOR KILIANI: active 1880s. Etcher.

On December 1, 1881, James D. Smillie recorded in his diary that Taylor visited him in his studio in New York and he showed her how to sharpen etching points. Two of her portrait etchings after Rembrandt and Van Dyke paintings were exhibited in the 1886 New York Etching Club show. Also in 1886, one of her etchings was exhibited in the Salmagundi Club's black and white exhibition. She was living in Meckelstr' Halle, Germany, in 1888 when her portraits after Rembrandt, Rubens, and Van Dyck were exhibited in the *Women Etchers of America* exhibition at the Union League Club. *The Critic* of April 21, 1888, complimented her "very good" line and "charm of quality." None of her etchings has been found.

REFERENCE: Petteys.

ELEANOR MATLACK: active 1880s-90s. Painter, etcher.

A resident of Philadelphia, Matlack exhibited twenty-nine etchings in the Boston exhibition of the *Women Etchers of America*; she added one and made one substitution in the New York version of the show. The catalogues thus include thirty-one etchings by Matlack made between 1881 and 1888. And there are several additional titles recorded in other exhibition catalogues, but not one etching by her has been found. The titles indicate they were landscape scenes of Pennsylvania, Rhode Island, and England. Matlack exhibited paintings with the Brooklyn Art Association, the Philadelphia Society of Artists, the Boston Art Club, the Salmagundi Club, at the Pennsylvania Academy, and the Massachusetts Charitable Mechanic Association. She entered her etchings in exhibitions at the New England Manufacturers' and Mechanics' Institute, the Boston Art Club, the New York Etching Club five times, the *Special Exhibition of Works of The New York Etching Club, and other Etchings* at the Art Institute of Chicago in 1885, and in the Woman's Building and the Ladies' Parlor of the Pennsylvania Building at the Columbian Exposition in 1893.

REFERENCE: Petteys.

MARY LOUISE MCLAUGHLIN: b. Cincinnati, Ohio, September 29, 1847; d. Cincinnati, January 17, 1939. Painter, sculptor, etcher, monotypist, wood carver, maker of stained glass, metalwork, jewelry, and tapestry, writer.

McLaughlin's father, William, was a successful dry goods merchant. Her brother James was the architect of the Cincinnati Art Museum, and her brother George, an attorney, was a member of the Cincinnati Etching Club. McLaughlin took drawing lessons at a private academy before she entered the McMicken School of Design in Cincinnati, where she was a student from 1873 to 1877. She studied drawing, wood carving, and pottery decoration with Benn Pitman and Marie Eggers. She probably learned to etch in 1877 while she was a pupil of Henry Farny. She may have worked with Otto Bacher, who also may have experimented with etching at that time. Later, McLaughlin studied painting with Frank Duveneck at the Cincinnati Art Academy.

A leader in the Cincinnati art pottery movement and an inventor in the field of pottery decoration, her technique was adopted by the Rookwood Pottery in Cincinnati. Among seven books McLaughlin wrote, two were on pottery decoration, one was on oil painting, and one was on etching—*Etching: A Practical Manual for Amateurs*, published in 1880. She also wrote a series of articles for *The Art Amateur* on china painting.

McLaughlin exhibited oil paintings, pottery, and decorative arts regularly with the Philadelphia Society of Artists, the Boston Art Club, the Cincinnati Industrial Expositions, the New England Manufacturers' and Mechanics' Institution, the Louisville Industrial Expositions, the Society of American Artists, at the Cincinnati Art Museum, the Pennsylvania Academy, and in the Paris Salon. She also exhibited at many world's fairs, including in the Women's Pavil-

ion of the 1876 U.S. Centennial Exposition in Philadelphia, at the Exposition Universelle in Paris in 1878, 1889, and 1900, the 1893 Columbian Exposition, the 1895 Cotton States Exposition in Atlanta, the 1901 Pan American Exposition in Buffalo, and the 1904 Louisiana Purchase Exposition in St. Louis. Her etchings were exhibited at the Boston Museum of Fine Arts, the Ohio Valley Centennial in 1888, and in the Woman's Building at the 1893 Columbian Exposition.

To the *Women Etchers of America* exhibitions she sent eleven prints, four of which were drypoints. In the early twentieth century she continued to etch and also worked in color monotype. Among the many awards she won was an honorable mention at the 1878 Paris Salon. Her professional memberships included the Cincinnati Etching Club, Woman's Art Club of Cincinnati, The Crafters, the Cincinnati Pottery Club, American Ceramic Society, and an honorary membership in the Society of Arts, London.

REFERENCES: Cincinnati Artists' Collection, Cincinnati Art Museum, Cincinnati, Ohio; Mary Louise McLaughlin Papers, Cincinnati Historical Society, Cincinnati, Ohio; Mary Louise McLaughlin, *Etching: A Practical Manual for Amateurs*, Cincinnati, Robert Clarke and Company, 1880; Koehler; Frederick Keppel & Co., New York, *Catalogue of an Exhibition of Paintings in Oil, Water Colors, Wood Carvings, Etchings, Drypoints, Art Pottery and Etched Decoration on Metal; the Work of Miss Mary Louise McLaughlin of Cincinnati*, Cincinnati, Press of William Halsted, 1892; "Work by a Talented Lady," *The New York Times*, October 27, 1892, p. 7; Cincinnati Art Museum, *The Ladies, God Bless 'Em. The Women's Art Movement in Cincinnati in the Nineteenth Century. February 19-April 18, 1976*, Cincinnati, Cincinnati Art Museum, 1976; Cincinnati Art Museum, *The Golden Age: Cincinnati Painters of the Nineteenth Century Represented in the Cincinnati Art Museum, October 6, 1979-January 13, 1980*, Cincinnati, Cincinnati Art Museum, 1979; Ulehla; Falk; Petteys.

ANNA MASSEY LEA MERRITT: b. Philadelphia, Pa., September 13, 1844; d. London, England, April 7, 1930. Painter, muralist, etcher, illustrator, writer.

A member of a prosperous, socially prominent Philadelphia family whose Quaker parents had converted to Unitarianism in her youth, Anna Lea attended Eagleswood School (run by the abolitionists Theodore and Angelina Grimké Weld) in Bryn Mawr, Pennsylvania, from 1858 to 1860, and the Agassiz School in Cambridge, Massachusetts, in 1861. Under private tutors she studied the classics, languages, mathematics, and music. Her father, Joseph Lea, Jr., owned cotton manufacturing and printing factories. He and her mother, Susanna Massey Lea, raised six daughters, two of whom were artists, one a pianist, and one an actress. Anna Lea (Merritt) taught herself to paint from instruction books before her family moved to Europe in 1865. She studied art briefly with Stefano Ussi in Florence, Heinrich Hofmann in Dresden, and in Paris.

Settling permanently in England in 1870, she returned to Philadelphia for several months each year to visit her family and to execute commissions for oil portraits. In London she studied with art critic and restorer Henry Merritt beginning in 1872. She married him in 1877, three months before he died. With technical help from Charles West Cope and Elizabeth Ruth Edwards, Merritt taught herself to etch in 1877 in order to illustrate a book of his art criticism and fiction, *Henry Merritt. Art Criticism and Romance* Most of her etchings in this memorial publication are narrative scenes. She produced a frontispiece portrait for it and for many other books. She made etchings after her own and other artists' paintings. In the *Women Etchers of America* exhibitions the majority of her etchings

were portraits. Three of her portrait etchings were published in *The Etcher* (in 1879, 1880, and 1883). Sylvester Koehler included two in the *American Art Review* and one in *American Etchings; . . . ,* and one was published in *American Artists and Their Works*. Individual etchings by Merritt were published by Christian Klackner, Wunderlich and Co., and Eyre & Spottiswood, England.

Merritt exhibited regularly at the Pennsylvania Academy, with London's Royal Academy, and the Royal Society of British Artists (of which she was a member). She also exhibited at the 1876 U.S. Centennial Exposition (where she won two awards), the Brooklyn Art Association, the Philadelphia Society of Artists, the National Academy of Design, the Boston Museum of Fine Arts, the Boston Art Club, the National Art Club, and as a member of the Plastic Club. Her paintings were exhibited in the 1876 U.S. Centennial Exposition, the 1889 Exposition Universelle in Paris, the Paris Salon, and the American and British painting sections of the Fine Arts Building of the 1893 Columbian Exposition in Chicago, where she also painted panels of *Needlework, Benevolence,* and *Education* for the vestibule of the Woman's Building and won two medals. Other expositions include the 1895 Cotton States Exposition in Atlanta, the 1901 Pan-American Exposition in Buffalo, and the 1915 Panama-Pacific Exposition in San Francisco, in which she included her etchings. She exhibited etchings with the New York Etching Club, the Salmagundi Club, the Boston Art Club, the Massachusetts Charitable Mechanic Association, the Philadelphia Society of Etchers, the Royal Society of Painter-Etchers in London, the Berlin Society of Etchers, the Boston Museum of Fine Arts, the 1888 Ohio Valley Centennial in Cincinnati, the Woman's Building at the 1893 Columbian Exposition, and the St. Louis Louisiana Purchase Exposition. She was an Associate of the Royal Society of Painter-Etchers, London, from 1887 to 1892, and 1905 to 1919.

After moving to Hurstbourne-Tarrant, a village on the Hampshire Downs, in 1891, Merritt wrote a technical article on mural painting, a book about life in a rural community, a book on her garden, and articles on gardening. She illustrated the books on Hampshire Downs and on gardening with her paintings. At this time she also wrote her well-known "A Letter to Artists: Especially Women Artists" for *Lippincott's Monthly Magazine*.

REFERENCES: Anna M. Lea Merritt Papers, Manuscript Division, New York Public Library, New York, N.Y.; Anna Lea Merritt, *Henry Merritt: Art Criticism and Romance, with Recollections and Twenty-three Etchings by Anna Lea Merritt*, London, C. Kegan Paul & Co., 1879; *The Etcher, . . . Original Etched work of Modern Artists*, London, Sampson Low, Marston, Searle, and Rivington, 1879-83; Sylvester R. Koehler, ed., "Portrait of Sir Gilbert Scott," *American Art Review* 1, pt. 1, 1879, opp. p. 228; Koehler, "The Works of the American Etchers. VIII. Anna Lea Merritt," *American Art Review* 1, pt. 1, 1880, pp. 229-30; Koehler; Koehler, ed., *American Etchings; . . . ,* Boston, Estes & Lauriat, 1886; Anna Lea Merritt, "A Talk About Painting," *St. Nicholas* 12, December 1884, pp. 85-92; C. Klackner Gallery, *Klackner's American Etchings*, New York, C. Klackner, 1888; "Mrs. Anna Lea Merritt's Portraits and Pictures," *The Studio*, 2, February 1887, pp. 128-29; "Art Notes: Mrs. Anna Lea Merritt," *The Critic* 7, February 5, 1887, p. 69; "Saint Cecilia, from a Picture Painted by Mrs. Anna Lea Merritt," *The Studio*, 2, June 1887, pp. 217-19; "A Portrait of Oliver Wendell Holmes by Mrs. Anna Lea Merritt," *The Studio*, 3, August 1887, p. 39; "Mrs. Anna Lea Merritt's Portrait of James Russell Lowell," *The Studio*, 3, May 1888, p. 85; Anna Lea Merritt, "A Letter to Artists: Especially Women Artists," *Lippincott's Monthly Magazine* 65, March 1900, pp. 463-69; Merritt," *Writer* 14, 1901, p. 60; Anna Lea Merritt, "Review," *Athenaeum* 1, January 10, 1903, p. 43; Austin Chester, "The Art of Anna Lea Merritt," *Windsor Magazine* 38, November 1913, pp. 605-20; "Mrs.

Anna L. Merritt, Noted Artist, Dies, . . . ," *The New York Times*, April 8, 1930, p. 26; Galina Gorokhoff, ed., *Love Locked Out; The Memoirs of Anna Lea Merritt with A Checklist of Her Works*, Boston, Museum of Fine Arts, [1983]; Falk; Petteys.

EMILY KELLEY MORAN: b. Dublin, Ireland, ca. 1850; d. Philadelphia, Pa., 1900. Painter, etcher.

Her husband, Peter Moran, whom she married in 1867, taught her to etch in about 1875, a few years before he added etching to his course for landscape students at the Philadelphia School of Design for Women. Both Morans etched Barbizon-style landscapes. In 1879 Emily exhibited an etching in the Philadelphia Society of Artists' first annual show. She exhibited five etchings in the Boston Museum of Fine Arts 1881 *Exhibition of American Etchings* and two in the Museum's 1893 etching show. She also exhibited with the Philadelphia Society of Etchers, at the Pennsylvania Academy, the New York Etching Club, the Association of Canadian Etchers, the 1888 Ohio Valley Centennial Exposition in Cincinnati, and in the Woman's Building and the Department of Fine Arts at the Columbian Exposition in 1893.

Moran exhibited fifteen prints in the 1887 Boston version of the *Women Etchers of America* and eighteen in the New York show the next year. One of her etchings, *Long Beach, York Harbor, Maine*, depicting the unloading of a fishing smack at low tide, is reported to have been published in *The Etcher's Folio* (Philadelphia, H. F. Richter Publishing Company, [1900?]), but the copy of the portfolio in the Buffalo and Erie County Public Library contains no plates by women.

REFERENCES: Koehler; Frances M. Benson, "The Moran Family," *The Quarterly Illustrator* 1 (April-June 1893), pp. 81, 84; Petteys.

MARY NIMMO MORAN: b. Strathaven, Scotland, May 16, 1842; d. East Hampton, N.Y., September 25, 1899. Painter, etcher, illustrator, teacher.

Mary Nimmo's mother died when she was very young, and in 1847 her father, Archibald Nimmo, who was probably a weaver, brought Mary and her brother to the U.S. She learned to draw and paint from her husband, prominent landscape painter and etcher Thomas Moran, after they married in 1862. She made her first etching in Easton, Pennsylvania, in 1879, while he was away on a trip. The Morans and their two-year-old son traveled to Europe in June 1866. Their first daughter was born shortly after their return in April 1867. Another daughter was born in 1870. Mary went West with Thomas in 1872, to England, Scotland, and Wales in 1882, to Europe again in 1886, and twice to Florida—once in 1877 when he had a commission from Scribner's and again ten years later. She made etchings on most of her trips, but she specialized in scenes of East Hampton, New York, were they lived much of the year in the 1880s and 1890s.

Mary produced illustrations for the *Illustrated Library of Favorite Song* (New York: Scribner's, 1873) and *The Aldine Almanac*, and she assisted Thomas in his illustration commissions and business affairs. She exhibited her paintings at the National Academy of Design and at the Pennsylvania Academy. She exhibited her etchings with the Pennsylvania Academy three times, the American Water Color Society, the Royal Society of Painter-Etchers in London, and the Boston Museum of Fine Arts. They were included in the New York Etching Club exhibitions from 1882 to 1888. The Club published her etchings in their catalogues in 1882, 1884, 1885, 1888, and 1892. Moran also exhibited in Chicago's Inter-State Industrial Expositions, the Philadelphia Society of Etchers, the Brooklyn Art Association, the Boston Art Club, the Massachusetts Charitable Mechanic Association, the Art Institute of Chicago, the Newton Club, the Ohio

Valley Centennial Exposition of 1888, in the Fine Arts Building (where she won a bronze medal for her etchings) and the Woman's Building at the 1893 Columbian Exposition, the Milwaukee Industrial Exposition, and the Walker Art Gallery, London.

In the early twentieth century Moran's etchings were exhibited at the 1904 Louisiana Purchase Exposition in St. Louis, the 1915 Panama-Pacific Exposition in San Francisco, and the 1926 Philadelphia Sesqui-Centennial International Exposition. Her etchings were published by Christian Klackner, William Whitlock, Frederick Keppel, Fischel, Adler & Schwartz, and J. D. Waring (for the Society of American Etchers, of which she was a member). Klackner sponsored an exhibition and catalogue of Mary and Thomas Moran's etchings in 1889. Sylvester Koehler selected four of her etchings for publication in his deluxe etching portfolios. *Twilight* served as the frontispiece for the New York catalogue of the *Women Etchers of America*. Moran exhibited fifty-four prints with the Boston exhibition of women etchers and added three more for the New York version of the show. She was elected a Member of the New York Etching Club and a Fellow of the Royal Society of Painter-Etchers, London.

REFERENCES: Thomas Moran Biographical Collection, East Hampton Free Library, East Hampton, N.Y.; Thomas Moran Studio Collection, Thomas Gilcrease Institute of American History and Art, Tulsa, Okla.; Sylvester R. Koehler, "The Works of the American Etchers. XX. Mrs. M. Nimmo Moran," *American Art Review* 2, pt. 1, 1881, p. 31; Koehler; Hermann Wunderlich & Co., *Catalogue of Modern Etchings*, New York, Hermann Wunderlich & Co., ca. 1882-84; Koehler, ed., *Original Etchings by American Artists*, New York, Cassell & Co., 1883; Koehler, ed., and New York Etching Club, *Twenty Original American Etchings*, New York, Cassell & Co., 1885; Koehler, ed., *Gems of American Etchers*, New York, Cassell & Co., 1885; William Whitlock, *Illustrated Catalogue of American Etchings*, New York, William Whitlock, 1886; Ortgies & Co., *Catalogue of the Pictures in Oil and Water Colors by Thomas Moran, Sale: February 24, 1886*, New York, Ortgies & Co., 1886; Koehler, ed., *American Etchings; . . .* , Boston, Estes & Lauriat, 1886; C. Klackner Gallery, *Klackner's American Etchings*, New York, C. Klackner, 1888; A. DeMontaigu, "A Pen Picture of Mrs. M. Nimmo Moran," *The Art Stationer* 1, July 1888, 1, pp. 4-6; C. Klackner Gallery, *A Catalogue of the Complete Etched Works of Thomas Moran, N.A. and M. Nimmo Moran, S.P.E.*, New York, C. Klackner, 1889; "Mr. and Mrs. T. Moran, Exhibits at Klackner's," *The New York Times*, March 3, 1889, p. 5; "Etchings at Klackner's," *The Critic* 14, March 16, 1889, p. 135; "Two American Etchers: The Work of Mr. & Mrs. Moran," *New York Daily Tribune*, March 11, 1889, p. 7; Frances M. Benson, "The Moran Family," *Quarterly Illustrator* 1, April-June 1893, pp. 67-84; "Obituary," *East Hampton Star*, September 29, 1899, p. 5; Morris T. Everett, "The Etchings of Mrs. Mary Nimmo Moran," *Brush and Pencil* 8, April 1901, pp. 2-16; Frederick Keppel & Co., *Illustrated Catalogue of Etchings by American Artists. For Sale by Frederick Keppel & Co*, New York, DeVinne Press, 1908; Ruth B. Moran, "Thomas Moran, Mary Nimmo Moran—Painter-Etchers," *Santa Barbara Morning Star*, November 30, 1924, p. 4; "American Etching Indebted to Moran," *The New York Times*, September 19, 1926, pp. 14-15; Guild Hall, *Retrospective Exhibition from the Work of the Tile Club and their Followers*, East Hampton, N.Y., Guild Hall, 1931; Division of Graphic Arts, U.S. National Museum, *Exhibition of Etchings by Mary Nimmo Moran*, text by Jacob Kainen, Washington, D.C., Smithsonian Institution Press, 1950; William Gerdts, "Mary Nimmo Moran," *The Museum News* 15, Spring-Summer 1963, p. 24; Thurman Wilkins, *Thomas Moran, Artist of the Mountains*, Norman, Okla., University of Oklahoma Press, 1966; Amy O. Bassford, ed., *Home-thoughts, From Afar; Letters of Thomas Moran to Mary Nimmo Moran*, introduction by Fritiof Fryxell, East Hampton, N.Y., East Hampton Free Library,

1967; Marilyn G. Francis, "Mary Nimmo Moran: Painter-Etcher," *Woman's Art Journal* 4, Fall 1983/Winter 1984, pp. 14-19; Thomas Gilcrease Institute of American History and Art, *Prints of Nature; Poetic Etchings of Mary Nimmo Moran; September 7-December 2, 1984,* Tulsa, Okla., Thomas Gilcrease Institute, 1984; Falk; Petteys.

ALICE E. MORLEY: b. 1857. Painter, etcher.

Morley studied landscape painting and etching with Peter Moran at the Philadelphia School of Design for Women beginning in 1884. She continued to work and take classes at the school until 1891. The 1887 school *Prospectus* was illustrated with her etching *The Meadow Stream.* First and second states of four of her etchings, including *The Meadow Stream,* all done in 1887, were in the *Women Etchers of America* exhibitions. None of her prints has been located. Morley attended the Life Class at the Pennsylvania Academy in 1888. By the end of the nineteenth century she had moved to Rockford, Illinois.

REFERENCES: School Records and Scrapbook, Philadelphia School of Design for Women Collection, Archives, Moore College of Art, Philadelphia, Pa.; Petteys.

PHEBE (PHOEBE) DAVIS NATT: active 1870-1901. Painter, etcher, writer.

Natt's etchings include landscape, architecture abroad and in America, and scenes from Shakespeare. Henry S. Bliss of Buffalo published at least three of her plates. None of her etchings has been located. She was the daughter of the Rev. George W. Natt and the niece of portrait painter and lithographer Thomas J. Natt, who lived with her family in Philadelphia during part of her childhood and may have taught her to draw. Natt studied at the Philadelphia School of Design for Women in the early 1870s, then with Thomas Eakins at the Pennsylvania Academy from 1876 to 1879. In late 1879 she went to Europe and studied in Paris with Jean Jacques-Henner and Léon Bonnat. She also studied in Florence. She returned to Philadelphia after two years abroad and learned to etch in 1883 from Stephen Parrish.

Natt's paintings were exhibited in the Women's Pavilion of the U.S. Centennial Exposition of 1876, the 1881 Paris Salon, with the Pennsylvania Academy many times beginning in 1881, the National Academy of Design, the Cincinnati Industrial Exposition, the Massachusetts Charitable Mechanic Association, the Philadelphia Society of Artists, the New England Manufacturers' and Mechanics' Institute, the 1886 Southern Exposition in Louisville, the 1887 *American Exhibition* in London, the Boston Art Club, in the Art Club of Philadelphia, the Art Institute of Chicago, and in the Colonial Dames of Massachusetts *Exhibition and Competition of Colonial Pictures* in 1898. She exhibited etchings with the Boston Art Club, the Salmagundi Club, the New York Etching Club, in the 1886 Southern Exposition in Louisville, and the Woman's Building of the Columbian Exposition in 1893, and entered nineteen etchings in the *Women Etchers of America* (see Davis). By the end of the century she had moved to New York.

REFERENCES: Phebe D. Natt, "Paris Art-Schools," *Lippincott's Monthly Magazine* 27, March 1881, pp. 269-76; Koehler; Falk; Petteys.

ELLEN OAKFORD: active 1880s-1890s. Etcher, teacher.

Oakford made her first attempt at etching in 1882, a female head in profile, which she drew directly on the plate from life. Six years later, *The Critic's* reviewer of the *Women Etchers of America* exhibition reported that she was "a young etcher whose ability is receiving due recognition." Thirteen of her etchings had been exhibited at the Boston version of the show in 1887. At the Union League she showed twenty-one etched portraits and landscapes, including one from a

series of views of the Yale campus. She also exhibited in the New York Etching Club exhibitions of 1886 through 1891. Seven of her etchings were included in the 1888 Ohio Valley Centennial Exposition at Cincinnati and two were exhibited in the Woman's Building at the 1893 Columbian Exposition. Christian Klackner published her etchings *Evening in the Fields* in 1887, *Twilight* and *The Yale Campus* in 1888, and *Weld Hall at Harvard* and *A Winter View of the Yale Campus* in 1889. *Twilight* was reproduced in *The Studio* magazine in 1902. At the time of the women etchers exhibitions she lived in New Haven, Connecticut, and taught at least one class for the Ladies' Art Association in New York. By the 1890s she was living in Englewood, New Jersey.

REFERENCES: C. Klackner Gallery, *Klackner's American Etchings,* New York, C. Klackner, 1888; Petteys.

HARRIET FRANCES OSBORNE: b. Peabody, Mass., 1846; d. Salem, Mass., 1913. Painter, etcher, teacher.

At a lecture in Plummer Hall, Salem, on December 15, 1880, in which he explained the process of etching, Sylvester R. Koehler of the Boston Museum of Fine Arts pulled a demonstration impression from Osborne's plate entitled *Marblehead Neck.* Osborne, who worked as an artist in Salem from the 1870s into the early twentieth century, made numerous etchings, including a portfolio set, of late nineteenth-century Salem, from its harbor to its most fashionable street. She also etched many landscapes. Osborne traveled to England in 1886-87 and etched several plates while she was there. Otherwise, her subjects were predominantly views of Massachusetts.

Osborne exhibited twenty-one etchings in both *Women Etchers of America* shows. Her etchings as well as oil paintings were shown at Salem's Essex Institute in 1881 and 1883. Koehler included eight etchings in the 1881 exhibition of American etchings at the Boston Museum. Her etchings were also exhibited with the Boston Art Club, the Philadelphia Society of Etchers, the 1888 Ohio Valley Centennial Exposition, and in the Woman's Building at the 1893 Columbian Exposition. She exhibited oil and watercolor paintings in the Women's Pavilion at the 1876 Centennial Exposition, the 1879 *Exhibition of Contemporary Art* at the Boston Museum, and the Museum's 1880 *Exhibition of Living American Artists.* In 1881 she exhibited with the Massachusetts Charitable Mechanic Association, the Boston Art Students' Association, and the Copley Society of Boston. She also exhibited with the Boston Art Club many times, the Boston Art Students' Association, and at the Jordan Art Gallery in 1896. She was a member of the Boston Art Students' Association and the Boston Art Club. Many of her copper plates are in the collection of the Essex Institute in Salem.

REFERENCES: Bettina A. Norton, *Prints at the Essex Institute,* Essex Institute Museum Booklet Series, Salem, Mass., Essex Institute, 1978, pp. 54-55; Petteys.

ANNE LODGE WILLCOX PARRISH: b. ca. 1850; active 1870s-early 20th century. Portrait painter, etcher, teacher.

Anne Parrish was the second wife of Thomas Clarkson Parrish, a painter, etcher, real estate developer, and Colorado state senator who was the brother of painter and etcher Stephen Parrish. Anne met Thomas in Philadelphia at the Pennsylvania Academy of the Fine Arts, where both were students, and painted a portrait of him. They married and settled in Colorado Springs, where they established a studio in about 1880. Anne soon acquired a reputation as a portrait painter. Thomas, who had learned to etch from Stephen, taught etching to Anne. Four of her etchings were shown in the 1888 version of the *Women Etchers of America* exhibition. Two of her etchings, a

Pennsylvania landscape and *Coal Pickers*, were accepted in the New York Etching Club exhibition in 1888, and her *Portrait of Two Children* was exhibited at the Boston Art Club in 1889. None of her prints has been found. Parrish continued to paint in Colorado Springs for a few years after her husband's death in 1899, but eventually returned to Philadelphia. Their daughter Anne, born in 1888, and son Dillwyn both became artists and writers.

REFERENCES: Gilbert McClurg, *Brush and Pencil in Early Colorado Springs*, Colorado Springs, Colo., n.p., 1924, pp. 5-6; Arvada Center for the Arts and Humanities, *Colorado Women in the Arts*, Arvada, Colo., Arvada Center, 1979; Chris Petteys, "Colorado's First Woman Artists," *Denver Post, Empire Magazine*, May 6, 1979, p. 37; Falk; Petteys.

EDITH PENMAN: b. London, England, 1860; d. New York, N.Y., January 14, 1929. Painter, etcher, potter.

Penman came to the United States as a child and attended Cooper Union School of Design for Women in New York in 1879-80. She probably did not learn to etch until 1887. She specialized in landscape etchings, some of which she was commissioned to do after other artists' paintings, including a few each by Louis K. Harlow and Julian Rix. Christian Klackner published over fifty of her etchings. She exhibited eight landscape etchings in the New York version of the *Women Etchers of America* in 1888. The next year *A January Thaw* after Julian Rix was included in the New York Etching Club exhibition. Her etchings were also shown in the exhibit in the Woman's Building at the 1893 Columbian Exposition. Penman exhibited with the National Academy of Design, the Boston Art Club, the Boston Society of Artists, the Fort Worth Museum of Art, and the Nebraska Art Association. In the second decade of the twentieth century she maintained studios in the Van Dyck Studio Building in New York and at Briarcliff Manor, New York, where she spent the summers. She exhibited frequently with the the Woman's Art Club of New York after 1909 and for years served as Treasurer of the National Association of Women Painters and Sculptors, exhibiting in their exhibitions until 1926.

REFERENCES: C. Klackner Gallery, *Klackner's American Etchings*, New York, C. Klackner, 1888; "The Print Publishers," *The Collector* 1, November 15, 1889, p. 15; "Among the Artists," *American Art News* 3, December 17, 1904, p. 2; "Among the Artists," *American Art News* 4, December 30, 1905, p. 3; "Exhibition of 12 Painters, Women, at the MacDowell Club," *New York Times*, March 8, 1914, p. 18; "Edith Penman [Obituary]," *Art Digest* 3, mid-January 1929, p. 12; Ulehla; Falk; Petteys.

CLARA VIRGINIA RICHARDSON: b. Philadelphia, Pa., April 25, 1855; d. 1933. Painter, etcher, illustrator, teacher.

In September 1881, having been recommended by the Philadelphia Normal School for Girls, Richardson was admitted to the Philadelphia School of Design for Women. A pupil of Peter Moran in etching, Stephen Ferris, Elliott Daingerfield, and Henry B. Snell, she received a William J. Horstmann Scholarship from the School in June 1884, as well as an honorable mention for illustration. The next year, 1885-86, she taught pen and ink drawing for photo-engraving, a new source of work for women artists; she again taught in 1886-87, the year Emily Sartain became the School's principal. Two of Richardson's illustrations were reproduced in the School's 1886 *Prospectus*, one of which was for *Hiawatha*, which served as the frontispiece. Twelve of her etchings, most of which were landscapes, were exhibited with the *Women Etchers of America* exhibitions; none of these has been located. Two etchings were included in the Ladies'

Parlor of the Pennsylvania Building at the 1893 Columbian Exposition. Richardson was not teaching at the Philadelphia School of Design for Women in 1925 when she served on its Executive Board. A member of both the Plastic Club of Philadelphia and the Philadelphia Art Alliance, she exhibited with the Plastic Club from 1911 through 1922. In 1914 and again in 1915 she was the Club's recording secretary. By 1927 she had moved to Portland, Maine.

REFERENCES: School Records and Scrapbook, Archives, Philadelphia School of Design for Women Collection, Archives, Moore College of Art, Philadelphia, Pa.; *Maine Library Bulletin* 13, July-October 1927, p. 21; Falk; Petteys.

MARGARET RUFF: b. Philadelphia, Pa., 1847; active to 1897. Painter, etcher.

Ruff exhibited four etchings of coastal scenes in the New York version of the *Women Etchers of America* in 1888. In her paintings she also depicted coastal subjects as well as still life. None of her work has been located. Ruff studied with Thomas Eakins at the Pennsylvania Academy in the early 1880s, with Charles Müller (who worked in New York in the 1860s but may have moved to Philadelphia), and in Paris. Her paintings were exhibited at the National Academy of Design, the Boston Museum of Fine Arts, the Pennsylvania Academy, the Philadelphia Society of Artists many times, the Boston Art Club, the 1879 Cincinnati Industrial Exposition, the 1886 Southern Exposition in Louisville, and with the Art Club of Philadelphia in the 1890s. Her etchings were included in the 1886 New York Etching Club exhibition, and the 1887 Pennsylvania Academy annual, as well as with the women etchers in 1888.

REFERENCES: Koehler; "Landscapes and Portraits; The Grand Spring Display at the Academy of Fine Arts," *Philadelphia Inquirer*, March 10, 1887, in Scrapbook, Philadelphia School of Design for Women Collection, Archives, Moore College of Art, Philadelphia, Pa.; Petteys.

ANNA (ANNIE) CORNELIA SHAW: b. Troy, N.Y., 1852; d. Chicago, Ill., August 31, 1887. Painter, etcher, teacher.

Shaw etched three plates, and an impression from one of them was exhibited in the Boston version of the *Women Etchers of America* show; impressions of all three were in the New York show the next year. In 1882 she exhibited one etching with the New York Etching Club. She worked primarily as a landscape painter and was elected an associate member of the Chicago Academy of Design (later the Art Institute of Chicago) in 1873; she became a full member in 1876. Shaw studied with Henry Chapman Ford in Chicago from 1868 to 1872, and probably learned to etch from John H. Vanderpoel in 1880 at the Chicago Academy, where she was a teacher. She had studios in New York from 1881 to 1884 and Boston from 1884 to 1885. A solo exhibition and sale held at the Art Institute of Chicago after her death included 241 oil paintings and 50 watercolors. Very few of those works and none of her etchings can be found today.

Shaw exhibited with the Chicago Academy and the Boston Art Club many times, the National Academy of Design, the Pennsylvania Academy of the Fine Arts, the Bohemian Art Club in Chicago, the Salmagundi Club, the American Water Color Society, the Society of American Artists, at the Metropolitan Museum in New York, the Boston Museum of Fine Arts, and with the Providence Art Club. She also showed her work at many expositions, including the 1876 U.S. Centennial, the Chicago Inter-State Industrial in 1876 and from 1881 to 1883, the Massachusetts Charitable Mechanic Association in 1881 and 1884, the New England Manufacturers' and Mechanics' Institute in 1883 and 1884, and the 1883 Cincinnati Industrial Exposition. The Art Institute of Chicago lent one of her paintings to the 1901

Pan-American Exposition in Buffalo.

REFERENCES: Koehler; The Art Institute of Chicago, *Special Exhibition and Sale of Works of Annie C. Shaw, Chicago, December 15, 1887*, Chicago, The Art Institute of Chicago, 1887; "Art Notes," *The Graphic*, February 6, 1892, pp. 99-100; Petteys.

MAY ELECTA FERRIS SMITH, active 1880s-1890s. Etcher.

May Electa Ferris was a member of an artistic family. She experimented with etching and exhibited twice, but apparently that was the extent of her professional activity. Her father, Stephen J. Ferris, one of the first artists in America to take up etching, taught drawing and painting at the Philadelphia School of Design for Women for twenty-one years. Her mother, Elizabeth Moran, the sister of artists Thomas, Peter, John, and Edward, did not practice art but instead handled the management of the family so that her husband and her son, Jean Leon Gerome Ferris, were free to concentrate on their art work. May Electa's father taught art to her older brother, Jean Leon Gerome, who began to etch when he was fourteen years old. Their father undoubtedly taught her to etch also. Ferris (Smith) studied in the Antique Class at the Pennsylvania Academy of the Fine Arts from December 1888 through March 1889. Two of her etchings were exhibited in 1888 in the *Women Etchers of America* exhibition at the Union League Club. In 1893 she exhibited a third etching in the Woman's Building at the Columbian Exposition. She married Noah B. Smith in the 1890s. Her aunts were etchers and painters Emily Kelley Moran and Mary Nimmo Moran.

REFERENCE: Petteys.

MARTHA (MATTIE) SCUDDER TWACHTMAN: b. Avondale, Ohio, 1861; d. Greenwich, Conn., 1936. Painter, etcher.

Martha Scudder was the daughter of Jane Hannah and John Milton Scudder, M.D., an administrator and researcher for the Eclectic Medical Institute in Cincinnati. In 1876 she and her younger half-brother, John King Scudder, who, like three of his brothers, later became a physician, attended the Cincinnati School of Design under the supervision of Thomas S. Noble. She studied in Europe in 1879-80. Martha learned to etch in 1880 with the Cincinnati Etching Club, of which John Henry Twachtman, Mary Louise McLaughlin, Caroline A. Lord, Clara Fletcher, Lewis Henry Meakin, Joseph Henry Sharp, and Henry Farny were members. The *Exhibition of American Etchings* at the Boston Museum of Fine Arts in 1881 included two of her landscape etchings and six by John Henry Twachtman, whom she was soon to marry. After their marriage in the spring of 1881, they traveled to England, Holland, Belgium, Munich, and Venice, carrying etching materials with them so they could draw directly on the plates from nature.

In 1882 the Twachtmans returned to America and Mattie exhibited with the National Academy of Design, the Society of American Artists, the American Water Color Society, the Philadelphia Society of Artists, and in Chicago's Inter-State Industrial Exposition. After their first child was born, Martha's father supported their 1883-85 stay in Paris so John could study at the Académie Julian. When the Twachtmans again returned to America they moved to Chicago while he worked on a cyclorama painting. By 1888 they had settled on a farm near Greenwich, Connecticut, and she devoted herself to raising their five children. John painted and taught at the Art Students' League, Cooper Union, and drew illustrations for *Scribner's Magazine*. Their oldest son, J. Alden Twachtman, became a painter of pastels, oils, and murals. Etchings by Martha and John were exhibited by the New York Etching Club in 1883. He was elected a member in 1884. She exhibited with the New York Etching Club again in 1889 and 1893. In the *Women Etchers of America* she exhibited four landscape etchings—three of Holland and one of Cincinnati. Sylvester Koehler included her work in the etchings he sent to the Ohio Valley Centennial in 1888. The Boston Museum and Koehler each purchased several of her etchings from the women etchers exhibition.

REFERENCES: Artists Files, Art and Music Department, The Public Library of Cincinnati and Hamilton County, Cincinnati, Ohio; *Catalogue of the Eighth Annual Exhibition of the School of Design of the University of Cincinnati. June, 1876*, Cincinnati, University of Cincinnati, 1876; Koehler; Cincinnati Art Museum, *A Retrospective Exhibition, John Henry Twachtman, October 7 to November 30, 1966*, introduction by Mrs. Mary Welsh Baskett, Cincinnati, Cincinnati Art Museum, 1966; Petteys.

BIBLIOGRAPHY

(See also references with artists' biographies.)

Manuscript Sources

Boston Public Library. Fine Arts Division. Artist Files. Boston, Massachusetts.

Koehler, Sylvester Rosa. Papers. Archives of American Art, Smithsonian Institution, Washington, D.C.

Museum of Fine Arts, Boston. Register of Engravings, Woodcuts, Etchings. 3 vols. Boston, Massachusetts.

The New York Public Library. Prints and Photographs Division. Vertical Files and Artist Files. New York, New York.

Pennsylvania Academy of the Fine Arts. Records. Archives, Pennsylvania Academy of the Fine Arts, Philadelphia, Pennsylvania.

Philadelphia School of Design for Women Collection. Archives, Moore College of Art, Philadelphia, Pennsylvania.

The Plastic Club. Papers. Archives of American Art, Smithsonian Institution, Washington, D.C.

Smillie, James David. Papers. Archives of American Art, Smithsonian Institution, Washington, D.C.

U.S. National Museum Papers. Smithsonian Institution Archives, Washington, D.C.

Weitenkampf, Frank. Papers. Archives of American Art, Smithsonian Institution, Washington, D.C.

Zimmerer-McKelvie, Kathy. "Alfred Cadart's two trips to the United States and his impact on the American etchers." Unpublished paper, 1975.

Books

Allen, Lucy Ellis. *Women in Art: A Sketch.* Newton, Mass.: Graphic Press, 1918.

American Artists and Their Works, A Series of Etchings, Photo-etchings, Photogravures, and Engravings, after Designs and Paintings by the most celebrated Artists. 2 vols. Boston: Estes & Lauriat, [ca. 1889-91].

Bacher, Otto H. *With Whistler in Venice.* New York: Century Co., 1908.

Bartlett, Truman H. *The Art Life of William Rimmer.* Boston: James R. Osgood & Co., 1881; rpt. New York: Kennedy Graphics/DaCapo Press, 1970.

Beall, Karen F., comp. *American Prints in the Library of Congress; A Catalogue of the Collection.* Baltimore and London: Johns Hopkins Press for the Library of Congress, 1970.

Beaux, Cecilia. *Background With Figures: Autobiography of Cecilia Beaux.* Boston and New York: Houghton Mifflin Co., 1930.

Beecher, Catherine E., and Harriet Beecher Stowe. *A Treatise on Domestic Economy.* Boston: T. H. Webb & Co., 1841; rpt., intro. Kathryn Kish Sklar, New York: Shocken Books, 1977.

Berg, Barbara J. *The Remembered Gate: Origins of American Feminism; The Woman and the City, 1800-1860.* Oxford, New York, Toronto, and Melbourne: Oxford University Press, 1978.

Berkin, Carol Ruth, and Mary Beth Norton. *Women of America; A History.* Boston: Houghton Mifflin Co., 1979.

Blake, Lillie Devereux. *Woman's Place To-day.* New York: John W. Lovell Co., 1883.

The Board of Lady Managers of the Louisiana Purchase Exposition. *Report to the Louisiana Purchase Exposition Commission.* Cambridge, Mass.: Riverside Press, H. O. Houghton & Co., 1905.

Broude, Norma, and Mary D. Garrard, eds. *Feminism and Art History; Questioning the Litany.* New York: Harper & Row, 1982.

Butler, Josephine E[lizabeth Grey]. *Woman's Work and Woman's Culture. A Series of Essays.* London: Macmillan and Co., 1869.

Carroll, Bernice A., ed. *Liberating Women's History; Theoretical and Critical Essays.* Urbana, Chicago, and London: University of Illinois Press, 1976.

Catalogue of Modern Etchings. New York: Hermann Wunderlich & Co., [ca. 1882-84].

Chicago Academy of Fine Arts. *Circular of the School of Instruction, 1879-1880.* Chicago: Chicago Academy of Fine Arts, 1879.

————. *Prospectus and Catalogue of the Schools of the Chicago Academy of Fine Arts, 1882-1883.* Chicago: Chicago Academy of Fine Arts, 1882.

Child, Lydia Maria (Francis). *The History and Condition of Women.* 2 vols. Boston: John Allen & Co., 1835.

Church, Ella Rodman (MacIlvane). *Money-Making for Ladies.* New York: Harper & Bros., 1882.

Cincinnati Museum Association. *Circular of the Art Academy of Cincinnati. . . .* Cincinnati: C. F. Bradley & Co., 1890-92.

Clark, Eliot Candee. *History of the National Academy of Design, 1825-1953.* New York: Columbia University Press, 1954.

Clement, Clara Erskine (Waters). *Women in the Fine Arts from the Seventh Century B.C. to the Twentieth Century A.D.* Boston and New York: Houghton Mifflin Co., 1904.

Congress of Women, Chicago. *The Congress of Women Held in the Woman's Building, World's Columbian Exposition, Chicago, U.S.A., 1893.* Chicago: S. I. Bell & Co., 1894.

[Copley Society, Boston]. *The Art Student in Paris.* Boston: Boston Art Students' Association, 1887.

Cott, Nancy F. *The Bonds of Womanhood; "Woman's Sphere" in New England, 1780-1835.* New Haven and London: Yale University Press, 1977.

Craik, Mrs. D[inah] M[aria] (Mulock). *A Woman's Thoughts About Women. . . .* New York: Rudd & Carleton, 1859.

Ellet, Mrs. [Elizabeth Fries Lummis]. *Women Artists in all Ages and Countries.* New York: Harper & Bros., 1859.

Elliott, Mrs. Maud (Howe), ed. . . . *Art and Handicraft in the Woman's Building of the World's Columbian Exposition, Chicago, 1893*. . . . Chicago and New York: Rand, McNally & Co., 1894.

The Etcher, . . . Original Etched Work of Modern Artists. London: Sampson Low, Marston, Searle, and Rivington, 1879-83.

Fine, Elsa H. *Women and Art: A History of Women Painters and Sculptors from the Renaissance to the 20th Century.* Montclair, N.J.: Allanheld & Schram; London: Prior, 1978.

Forbes, Mrs. E. A. *A Woman's First Impressions of Europe; Being wayside Sketches made during a short tour in the year 1863.* New York: Derby & Miller Co., 1865.

Fuller, Margaret. *Woman in the Nineteenth Century.* New York: Greeley & McElrath, 1845; rpt., intro. Bernard Rosenthal, New York: W. W. Norton & Co., 1971.

Gesellschaft fur Vervielfaltigende Kunst, Vienna. *Die Vervielfaltigende Kunst der Gegenwart.* Vienna: Gesellschaft fur Vervielfaltigende Kunst, 1887-1903.

Gordon, Michael, ed. *The American Family in Social-Historical Perspective.* New York: St. Martin's Press, 1978.

Gornick, Vivian, and Barbara K. Moran, eds. *Woman in Sexist Society.* New York: Basic Books, 1971.

Graves, Mrs. A. J. *Woman in America; Being an examination into the moral and intellectual condition of American female society.* New York, 1841; rev. ed. New York: Harper & Bros., 1855.

Greer, Germaine. *The Obstacle Race; The Fortunes of Women Painters and Their Work.* New York: Farrar, Straus, and Giroux, 1979.

Hale, Sarah Josepha. *Woman's Record; or, Sketches of all Distinguished Women, from Creation to A.D. 1852.* . . . New York: Harper & Bros., 1853; 3rd ed. New York: Harper & Bros., 1868.

Hamerton, Philip Gilbert. *Etching and Etchers.* London: Macmillan and Co., 1868; Boston: Roberts Bros., 1876.

_____. *Landscape; with original etchings and many illustrations from pictures and drawings.* London: Seeley, 1885.

Hanaford, Phebe Ann (Coffin). *Daughters of America; or, Women of the Century.* Augusta, Maine: True and Co., 1883.

Hart, Charles Henry. "'Some Lessons of Encouragement from the Lives of American Women Artists,' Address by Charles Henry Hart." In Philadelphia School of Design for Women, *Announcement for the School Year, 1906-07,* 14-16. Philadelphia: Philadelphia School of Design for Women, 1906.

Hawthorne, Sophia Amelia Peabody. *Notes in England and Italy.* New York: G. P. Putnam & Son, 1869.

Hellerstein, Erna Olafson, Leslie Parker Hume, and Karen M. Offen, eds. *Victorian Women; A Documentary Account of Women's Lives in Nineteenth-Century England, France, and the United States.* Stanford, Calif.: Stanford University Press, 1981.

Hendricks, Gordon. *The Life and Work of Thomas Eakins.* New York: Grossman, 1974.

Hess, Thomas B., and Elizabeth C. Baker, eds. *Art and Sexual Politics; Women's Liberation, Women Artists, and History.* New York: Macmillan Co., 1973.

Higginson, Thomas Wentworth. *Common Sense About Women.* Boston: Lee and Shephard; New York: Charles T. Dillingham, 1882.

Hind, Arthur M. *A History of Engraving & Etching from the 15th Century to the Year 1914.* Boston: Houghton Mifflin Co., 1923; rpt. New York: Dover Publications, 1963.

Hitchcock, J[ames] R[ipley] W[ellman]. *Etching in America; with lists of American etchers and notable collections of prints.* . . . New York: White, Stokes, & Allen, 1886.

_____. *Recent American Etchings.* New York: White, Stokes, & Allen, 1885.

_____. *Some Modern Etchings.* New York: White, Stokes, & Allen, 1884.

Hodson, James Shirley. *An Historical and Practical Guide to Art Illustration, in Connection with Books, Periodicals, and General Decoration. With Numerous Specimens of the Various Methods.* New York: Scribner & Welford, 1884.

Holme, Charles, ed. *Modern Etchings and Engravings;* Special Summer Number of "The Studio." London, Paris, New York: "The Studio," 1902.

_____. *Modern Etchings, Mezzotints and Dry-points;* Special Summer Number of "The Studio." London, Paris, New York: "The Studio," 1913.

Howitt [Watts], Anna Mary. *An Art Student in Munich.* 2 vols. London: Longman, Brown, Green, and Longmans, 1853; Boston: Ticknor, Reed, and Fields, 1854.

Jaques, Bertha. *Concerning Etchings.* Chicago: By the author, 1912.

Johns, Elizabeth. *Thomas Eakins, The Heroism of Modern Life.* Princeton, N.J.: Princeton University Press, 1983.

Keppel, Frederick. *The Golden Age of Engraving; A Specialist's Story About Fine Prints.* New York: Baker & Taylor Co., 1910.

_____. *Illustrated Catalogue of Etchings and Engravings published by Frederick Keppel & Co.* New York: Frederick Keppel & Co., 1908.

Klackner, Christian. *Klackner's American Etchings.* New York: C. Klackner, 1888.

_____. *Proofs and Prints—Engravings and Etchings: How They Are Made, Their Grades, Qualities and Values and How to Select Them.* New York: Frank S. Field, 1884.

Knauff, Theodore C. *An Experiment in Training for the Useful and the Beautiful; A History.* Philadelphia: Philadelphia School of Design for Women, 1922.

Knowlton, Helen M. *Art-Life of William Morris Hunt.* Boston: Little, Brown & Co., 1899; rpt. New York: Benjamin Blom, 1971.

Koehler, Sylvester Rosa, ed. *American Art Review.* Boston: Estes & Lauriat, 1879-81.

_____. *American Etchings; A Collection of Twenty Original Etchings.* Boston: Estes & Lauriat, 1886.

_____. *Etching: an outline of its technical processes and its history with some remarks on collectors and collecting.* . . . New York, London, Paris, Melbourne: Cassell & Co., 1885.

_____. *Gems of American Etchers.* New York, London, Paris, Melbourne: Cassell & Co., 1885.

_____. *Original Etchings by American Artists.* New York, London, Paris, Melbourne: Cassell & Co., 1883.

_____. *Report on the Section of Graphic Arts in the U.S. National Museum, 1888-89.* Washington D.C.: U.S. Government Printing Office, 1891.

_____. *The United States Art Directory and Year Book.* 2 vols. 1, New York, London, and Paris: Cassell, Petter, Galpin & Co., 1882; 2, New York, London, and Paris: Cassell & Co., 1884.

Koehler, Sylvester Rosa, ed., and New York Etching Club. *Twenty Original American Etchings.* New York, London, Paris, Melbourne: Cassell & Co., 1885.

Korzenik, Diana. *Drawn to Art; A Nineteenth-Century American Dream.* Hanover and London: University Press of New England, 1985.

Kraditor, Aileen S. *The Ideas of the Woman Suffrage Movement, 1890-1920.* New York: Columbia University Press, 1965.

Ladies' Art Association, New York. [*Announcement/Plan of Instruction, 1875-1888.*] New York: Ladies' Art Association, 1875-88.

Lalanne, Maxine. *A Treatise on Etching.* Trans. S. R. Koehler. Boston: Estes & Lauriat, 1880.

Lambert, James H. *The Story of Pennsylvania at the World's Fair, St. Louis, 1904.* Philadelphia: Pennsylvania Commission, 1905.

Larkin, Oliver. *Art and Life in America.* Rev. ed. New York: Holt, Rinehart, and Winston, 1960.

Laver, James. *A History of British and American Etching.* London: Ernest Benn, 1929.

Lerner, Gerda, ed. *The Female Experience: An American Documentary.* American Heritage Series, 90. Indianapolis: Bobbs-Merrill Educational Publishers, 1977.

_____. *The Woman in American History.* Reading, Mass.: Addison-Wesley Publications, 1971.

Leymarie, Jean. *The Graphic Works of the Impressionists.* Trans. Jane Brenton. New York: Harry N. Abrams, 1972.

Livermore, Mary Ashton Rice. *What Shall We Do With Our Daughters?, Superfluous Women, and Other Lectures.* Boston: Lee & Shepard; New York: Charles T. Dillingham, 1883.

Loomis, Lafayette C. *The Index Guide to Travel and Art Study in Europe; A compendium of geographical, historical, and artistic information for the use of Americans.* New York: Charles Scribner's Sons, 1883.

Lynes, Russell. *The Tastemakers.* New York: Harper & Bros., 1954.

Manson, George J. *Work for Women.* New York: G. P. Putnam's Sons, 1883.

Melder, Keith E. *Beginnings of Sisterhood; The American Woman's Rights Movement, 1800-1850.* Studies in the Life of Women, ed. Gerda Lerner. New York: Shocken Books, 1977.

Melot, Michel. *Graphic Art of the Pre-Impressionists.* Trans. Robert Erich Wolf. New York: Harry N. Abrams, 1981.

Meyer, Annie Nathan, ed. *Woman's Work in America.* New York: Henry Holt and Co., 1891.

Mill, John Stuart. *The Subjection of Women.* New York, 1869; rpt. Cambridge, Mass.: M.I.T. Press, 1970.

Moore College of Art, Philadelphia. *Design for Women: A History of the Moore College of Art.* Wynnewood, Pa.: Livingston Publishing Co., 1968.

Mumford, Lewis. *The Brown Decades: A Study of the Arts in America, 1865-1895.* New York: Harcourt, Brace and Co., 1931; rpt. New York: Dover Publications, 1971.

Museum of Fine Arts, Boston. *Art & Commerce: American Prints of the Nineteenth Century; Proceedings of a Conference held in Boston, May 8-10, 1975.* Charlottesville, Va.: University Press of Virginia for the Museum of Fine Arts, Boston, 1978.

National Museum of Women in the Arts, Washington, D.C. *National Museum of Women in the Arts.* Introduction by Alessandra Comini. New York: Harry N. Abrams, 1987.

Newbolt, Sir Francis. *The History of the Royal Society of Painter-Etchers and Engravers, 1880-1930.* London: Print Collectors' Club, 1930.

Nieriker, Mrs. Abigail May (Alcott). *Studying Art Abroad, and How to Do It Cheaply.* Boston: Roberts Bros., 1879.

Parker, Rozsika, and Griselda Pollock. *Old Mistresses; Women, Art and Ideology.* London and Henley-on-Thames: Routledge & Kegan Paul, 1981; rpt. New York: Pantheon Books, 1982.

Penny, Virginia. *The Employments of Women: A Cyclopaedia of Woman's Work.* Boston: Walker, Wise & Co., 1863.

Petersen, Karen, and J. J. Wilson. *Women Artists: Recognition and Reappraisal from the Early Middle Ages to the Twentieth Century.* New York: New York University Press, 1976.

Philadelphia School of Design for Women. *Prospectus [Announcement] for the School Year, 1868. . . .* Philadelphia: Philadelphia School of Design for Women, 1868-1900.

The Plastic Club, Philadelphia. *Annual Report, 1903. . . .* [Philadelphia: The Plastic Club, 1903-14].

Rayne, Mrs. Martha Louise. *What Can a Woman Do; or, Her Position in the Business and Literary World.* Petersburgh, N.Y.: Eagle Publishing Co., [1893].

Rothman, Sheila M. *Woman's Proper Place; A History of Changing Ideals & Practices, 1870 to Present.* New York: Basic Books, 1978.

Rubinstein, Charlotte Streifer. *American Women Artists from Early Indian Times to the Present.* Boston: G. K. Hall & Co., 1982.

Shannon, Martha A. S. *Boston Days of William Morris Hunt.* Boston: Marshall Jones Co., 1923.

Sherman, Claire Richter, with Adele M. Holcomb, ed. *Women as Interpreters of the Visual Arts, 1820-1979.* Westport, Conn.: Greenwood Press, 1981.

Sklar, Kathryn Kish. *Catharine Beecher; A Study in American Domesticity.* New Haven: Yale University Press, 1973.

Smith College, Northampton, Mass. *Catalogue of Smith College. . . .* Northampton: Smith College, 1882-88.

Stein, Roger. *John Ruskin and Aesthetic Thought in America, 1840-1900.* Cambridge, Mass.: Harvard University Press, 1967.

Swett, Lucia Gray. *John Ruskin's Letters to Francesca and Memoirs of the Alexanders.* Boston: Lothrop, Lee & Shepard, 1931.

Syracuse University, Syracuse, N.Y. *Catalogue of Syracuse University. . . .* Syracuse: 1883-91.

Trafton, Adeline. *An American Girl Abroad.* Boston: Lee & Shepard; New York: Lee, Shepard and Dillingham, 1872.

Tufts, Eleanor May. *Our Hidden Heritage; Five centuries of Women Artists.* New York: Paddington Press, 1974.

Tyler, Francine. *American Etchings of the Nineteenth Century.* New York: Dover Publications, 1984.

Van Rensselaer, Mrs. Schuyler (Mariana Griswold). *American Etchers.* New York: Frederick Keppel & Co., 1886.

Warner, Marina. *Queen Victoria's Sketchbook.* New York: Crown, 1979.

Weimann, Jean Madeline. *The Fair Women.* Chicago: Academy Chicago, 1981.

Weitenkampf, Frank. *American Graphic Art.* New York: Macmillan Co., 1912; rev. ed., intro. E. Maurice Bloch, New York: Johnson Reprint Corp., 1970.

Welter, Barbara. *Dimity Convictions: The American Woman in the Nineteenth Century.* Athens: Ohio University Press, 1976.

Wilkinson, Gerald. *Turner on Landscape; The Liber Studiorum.* London, Melbourne, Sydney, Auckland, and Johannesburg: Barrie & Jenkins, 1982.

Willard, Frances, and Mary A. Livermore, eds. *A Woman of the Century; Fourteen hundred seventy biographical sketches accompanied by Portraits of Leading American Women in all Walks of Life.* Buffalo: Charles Wells Moulton, 1893.

Wilton, Andrew. *Turner and the Sublime.* Chicago: University of Chicago Press, 1980.

Woody, Thomas. *The History of Women's Education in the United States.* 2 vols. New York: Science Press, 1929; rev. ed. New York: Octagon Books, 1966.

Wray, Henry Russell. *A Review of Etching in the United States.* Philadelphia: R. C. Penfield, 1893.

Exhibition Catalogues
(Arranged chronologically)

U.S. Centennial Commission, Philadelphia. *Official Catalogue, Department of Art.* Women's Pavilion, 87-102. Philadelphia: John R. Nagle, 1876.

Inter-State Industrial Exposition, Chicago. *Illustrated Catalogue of the Art Hall of the Industrial Exposition of Chicago, 1880.* Chicago: Rand, McNally, 1880.

Salmagundi Sketch Club, New York. *Illustrated Catalogue, . . . Annual Black & White Exhibition . . . , (1880-1890).* New York: [Salmagundi Sketch Club], 1880-90.

Boston Art Club, Boston. *Water Colors & Works in Black & White, Illustrated Catalogue, . . . (1881-1890).* Boston, 1881-90.

Royal Society of Painter-Etchers and Engravers, London. *. . . . Catalogue of the . . . Annual Exhibition. . . .* [London], 1881-1910.

Museum of Fine Arts, Boston. *Exhibition of American Etchings, April 11th to May 9th, 1881.* Essay by S. R. Koehler. Boston: A. Mudge & Son, 1881.

Brooklyn Art Association, Brooklyn. *Spring Exhibition. Catalogue of Paintings, (Water Colors,) and Etchings. March 14 to 25th, 1882.* Brooklyn: Martin, Carpenter & Co., 1882.

Philadelphia Society of Etchers, Philadelphia. *Catalogue, The Philadelphia Society of Etchers, Exhibition, open from December 27, 1882, to 3 February, 1883.* Philadelphia: Sherman & Co., 1882.

New York Etching Club, New York. *Catalogue of the New York Etching Club Exhibition. Illustrated with Etchings by . . . , Held at the National Academy of Design. New York. (1882-1889); A Publication by the New York Etching Club . . . (1891-1893).* New York: E. Wells Sackett & Rankin, 1882-83; New York: The Studio Press, 1884; New York: John C. Rankin, 1885-89; New York: Devinne Press, 1891-94.

Brooklyn Art Association, Brooklyn. *Catalogue of the Brooklyn Art Association, March, 1883.* Brooklyn: Martin, Carpenter & Co., 1883.

Internationalen Kunst-Ausstellung, Munich. *Katalog der Internationalen Kunstausstellung im Königlichen Glaspalaste in München. May 18-23, 1883.* Munich: Verlagsanstalt für Kunst und Wissenschaft, 1883.

The Art Institute, Chicago. *Special Exhibition of works of The New York Etching Club, and other Etchings, March 30, 1885.* Chicago: The Art Institute of Chicago, 1885.

Industrial Exposition, Louisville, Ky. *Illustrated Catalogue of the Art Gallery of the Southern Exposition, Louisville, Kentucky, August 28-October 23, 1886.* Louisville: John P. Morton and Co., 1886.

Museum of Fine Arts, Boston, Print Department. *Exhibition of The Work of the Women Etchers of America, Nov. 1 to Dec. 31, 1887.* Introduction by Sylvester Rosa Koehler. Boston: Alfred Mudge & Son for the Museum, 1887.

Koehler, Sylvester Rosa. "Catalogue of the Contributions of the Section of Graphic Arts to the Ohio Valley Centennial Exposition, Cincinnati, 1888." In U.S. National Museum, *Proceedings* 10, 701-31. Washington, D.C.: Smithsonian Institution, 1888.

The Union League Club, New York. *Catalogue of The Work of the Women Etchers of America, April 12 to 21, 1888.* Introduction by M[ariana] G[riswold] van Rensselaer. New York: The Union League Club, 1888.

Brooklyn Women's Club, Brooklyn. *Paintings and other Works of Art by Women Artists of New York and Brooklyn.* Brooklyn: J. J. Little & Co., 1890.

Museum of Fine Arts, Boston, Print Department. *Exhibition Illustrating the Technical Methods of The Reproductive Arts from the IV Century to the Present Time, with special Reference to the Photo Mechanical Processes. January 8 to March 6, 1892.* Introduction by S. R. Koehler. Boston: Alfred Mudge & Son for the Museum, 1892.

Pennsylvania Board of World's Fair Managers. *Pennsylvania Art Contributions, State Building, Art Gallery, and Woman's Building, World's Columbian Exposition.* Harrisburg: Edwin K. Meyers, State Printer, 1893.

World's Columbian Exposition, Chicago. *. . . . Official Catalogue. . . . Pt. 10, Department of Fine Arts; pt. 14, Woman's Building.* Chicago: W. B. Conkey Co., 1893.

Museum of Fine Arts, Boston, Print Department. *Exhibition of American Engravings and Etchings (June to October, 1893).* Boston: Museum of Fine Arts, 1893.

Cotton States and International Exposition, Atlanta, Ga. *The Official Catalogue of the Cotton States and International Exposition, Atlanta, Georgia, U.S.A., September 18 to December 31, 1895.* Atlanta: Claflin & Mellichamp, 1895.

Pennsylvania Cotton States and International Exposition Commission. *Pennsylvania at the Cotton States and International Exposition, Atlanta, Georgia, September 18-December 31, 1895.* Harrisburg: Clarence M. Busch, State Printer of Pennsylvania, 1897.

The Grolier Club, New York. *Catalogue of a Collection of Engravings, Etchings and Lithographs by Women, exhibited at the Grolier Club, April 12 to 27, 1901.* Introduction by Frank Weitenkampf. New York: The Grolier Club, 1901.

The Chicago Society of Etchers, Chicago. *The Chicago Society of Etchers, Annual Exhibition, Art Institute of Chicago, . . . (1911-1941).* Chicago: Chicago Society of Etchers, 1911-41.

Worcester Art Museum, Worcester, Mass. *Catalogue of an Exhibition of Works by American Etchers Under the Management of the Chicago Society of Etchers, January 14-February 12, 1912).* Chicago: Chicago Society of Etchers, 1912.

California Society of Etchers, San Francisco. *Annual Exhibition. . . .* San Francisco: California Society of Etchers, 1913-20.

Albert Roullier's Art Galleries, Chicago. *Catalogue of an Exhibition of Selected Examples of Original Etchings by the Foremost American Etchers, March 9-13, 1914.* Chicago: R. R. Donnelle & Sons Co., 1914.

Panama-Pacific International Exposition, San Francisco. *Official Catalogue (Illustrated) of the Department of the Fine Arts. . . .* San Francisco: Wahlgreen Co., 1915.

Albert Roullier Art Gallery, Chicago. *Catalogue of an Exhibition of Selected Examples of Original Etchings by the Foremost Living American Etchers, May 10-13, 1916.* Chicago: R. R. Donnelle & Sons Co., 1916.

The Brooklyn Society of Etchers (Society of American Etchers), Brooklyn. *. . . Annual Exhibition, . . . (1917-1951).* Brooklyn: Brooklyn Society of Etchers (Society of American Etchers), 1917-51.

National Arts Club, New York. *[Annual] Exhibitions of Living American Etchers, (1922-1933).* New York: [National Arts Club], 1922-33.

The North Shore Arts Association of Gloucester, Mass. *Catalogue, . . . Exhibition, (1922-1940).* Gloucester, 1922-40.

Philadelphia Sesqui-Centennial International Exposition, Department of Fine Arts, Philadelphia. *Paintings, Sculpture and Prints in the Department of Fine Arts. . . .* Philadelphia: Philadelphia Sesqui-Centennial International Exposition, 1926.

The Society of American Etchers, Inc. (formerly the Brooklyn Society of Etchers). *Seventeenth Annual Exhibition, November-December, 1932.* Brooklyn: Society of American Etchers, 1932.

Gerdts, William H. *Women Artists of America, 1707-1964. The Newark Museum, April 2-May 16, 1965.* Newark, N.J.: Newark Museum Association, 1965.

East Hampton Guild Hall, East Hampton, N.Y. *East Hampton: The American Barbizon, 1850-1900. May 10-June 8, 1969.* East Hampton: Guild Hall, 1969.

North Carolina Museum of Art, Raleigh, and Salem Fine Arts Center, Winston-Salem. *Women: A Historical Survey of Works by Women Artists. Salem Fine Arts Center, February 27-March 19, 1972; North Carolina Museum of Art, March 25-April 20, 1972.*

Vassar College Art Gallery, Poughkeepsie, N.Y. *The White Marmorean Flock: Nineteenth Century American Women Neo-Classical Sculptors; April 4-April 30, 1972.* Introduction by William H. Gerdts. Catalogue by Nicolai Cikovsky, Marie Morrison, and Carol Ockman.

Walters Art Gallery, Baltimore. *Old Mistresses: Women Artists of the Past. April 17-June 18, 1972.* Catalogue by Ann Gabhart and Elizabeth Brown. Baltimore: Walters Art Gallery, 1972.

The New York Public Library, New York. *Women Printmakers Past and Present, February 1, 1973-September 19, 1973.* New York: The New York Public Library, 1973.

Pennsylvania Academy of the Fine Arts, Philadelphia. *The Pennsylvania Academy and Its Women, 1850 to 1920, May 3-June 16, 1973.* By Christine Jones Huber. Philadelphia: PAFA, 1973.

Bermingham, Peter. *American Art in the Barbizon Mood.* Washington, D.C.: Smithsonian Institution Press for the National Collection of Fine Arts, 1975.

San Francisco Fine Arts Museums, San Francisco. *Women Artists: A Review of the Permanent Collection.* San Francisco: San Francisco Fine Arts Museums, 1975.

Museum of Fine Arts, Boston, Department of Prints and Drawings. *American Prints 1813-1913; April 12-June 15, 1975.* Essay by Clifford S. Ackley. Boston: Museum of Fine Arts, 1975.

DePauw, Linda Grant, and Conover Hunt, with the assistance of Miriam Schneir. *Remember the Ladies, Women in America, 1750-1815.* New York: Published in association with The Pilgrim Society, 1976.

Elvehjem Art Center, University of Wisconsin, Madison. *Americans at Home and Abroad: Graphic Arts, 1855-1975.* Madison: Elvehjem Art Center, University of Wisconsin, 1976.

Harris, Ann Sutherland, and Linda Nochlin. *Women Artists: 1550-1950.* New York: Alfred A. Knopf, Los Angeles County Museum of Art, 1976.

The Museum of Modern Art, New York. *The Natural Paradise, Painting in America 1800-1950.* Ed. Kynaston McShine. Essays by Barbara Novak, Robert Rosenblum, and John Wilmerding. New York: Museum of Modern Art, 1976.

Whitney Museum of American Art, Downtown Branch, New York. *19th Century American Women Artists, January 14-February 25, 1976.* Introduction by Judith Bernstein, Madeline Burnside, Jeanette Ingberman, and Ann Sargent Wooster. New York: Whitney Museum of American Art, 1976.

East Hampton Guild Hall, East Hampton, N.Y. *Artists and East Hampton: A 100-Year Perspective; A Bicentennial Exhibition, August 14-October 3, 1976.* East Hampton: Guild Hall, 1976.

Hills, Patricia. *Turn-of-the Century America: Paintings, Graphics, Photographs, 1890-1910.* New York: Whitney Museum of American Art, 1977.

Weisberg, Gabriel P., and Ronnie L. Zakon. *Between Past and Present: French, English, and American Etching, 1850-1950.* Cleveland: Cleveland Museum of Art in cooperation with The Federal Reserve Bank of Cleveland, 1977.

Zeitlin & VerBrugge Booksellers, Los Angeles. *Women Artists, Works of Art on Paper.* Los Angeles: Zeitlin & VerBrugge, 1977.

Museum of Fine Arts, Boston. *Art and Commerce: American Prints of the 19th Century.* Boston: Museum of Fine Arts, 1978.

Withers, Josephine. *Women Artists in Washington Collections. January 18-February 25, 1979.* College Park, Md.: University of Maryland Art Gallery and Women's Caucus for Art, 1979.

The Montclair Art Museum, Montclair, N.J. *The New York Etching Club; American Etchings from the Collection of William Frost Mobley, March 18-April 29, 1979.* Curated by Maureen O'Brien. Montclair: Montclair Art Museum, 1979.

Gerdts, William H. *American Impressionism, January-March, 1980.* Seattle: Henry Art Gallery, University of Washington, 1980.

Wilmerding, John. *American Light; The Luminist Movement, 1850-1875; Paintings, Drawings, Photographs. An Exhibition Held at the National Gallery of Art, February 10-June 15, 1980.* Washington, D.C.: National Gallery of Art, 1980; New York: Harper & Row in association with the National Gallery of Art, 1980.

Whitney Museum of American Art, Downtown Branch, New York. *The Working Woman, 1840-1945. March 12-May 28, 1980.* New York: Whitney Museum of American Art, 1980.

Cosentino, Andrew J., and Henry H. Glassie, *The Capital Image; Painters in Washington, 1800-1915.* Washington, D.C.: Smithsonian Institution Press, 1983.

Johnson, Jan. *Prints by Women Artists, Catalogue 3, Winter 1984.* Montreal, 1984.

Mead Art Museum, Amherst College, Amherst, Mass. *The Quiet Interlude: American Etchings of the Late Nineteenth Century; Prints from the collection of Rona Schneider.* Amherst: Mead Art Museum, Amherst College, 1984.

O'Brien, Maureen C., and Patricia C. F. Mandel. *The American Painter-Etcher Movement.* Southampton, N.Y.: Parrish Art Museum, 1984.

Bruhn, Thomas P. *American Etching: The 1880s; January 21-March 10, 1985*. Storrs, Conn.: William Benton Museum of Art, University of Connecticut, 1985.

Cape Ann Historical Association, Gloucester, Mass. *Stephen Parrish; October 25, 1985 through January 31, 1986*. Essay by Rona Schneider. Gloucester: Cape Ann Historical Association, 1985.

Associated American Artists, New York. *Prints by Women: A Survey of Graphic Work by American Women Born Before World War II; Held in Conjunction with The 14th Annual Conference of The Women's Caucus for Art, February 5 through March 1, 1986*. New York: Associated American Artists, 1986.

Division of Graphic Arts, National Museum of American History, Smithsonian Institution, Washington, D.C. *G. A. 100; The Centenary of the Division of Graphic Arts; An exhibition at the National Museum of American History. . . .* Washington, D.C.: National Museum of American History, Smithsonian Institution, 1986.

Fairbrother, Trevor J., with Theodore E. Stebbins, Jr., William L. Vance, and Erica E. Hirshler. *The Bostonians; Painters of an Elegant Age, 1870-1980*. Boston: Museum of Fine Arts, 1986.

The Annex Galleries, Santa Rosa, Calif. *A Selection of American Prints: A Selection of Forty Women Artists Working Between 1904-1979, October-November, 1987*. Santa Rosa: Annex Galleries, 1987.

Tufts, Eleanor. *American Women Artists 1830-1930*. Introductory essays by Gail Levin, Alessandra Comini, and Wanda Corn. Washington, D.C.: International Exhibitions Foundation for The National Museum of Women in the Arts, 1987.

Articles

(Arranged chronologically)

"Etchings by Her Majesty and H. R. H. Prince Albert." *The Art-Journal* 10 (December 1, 1848): 351-52.

A Christian Pastor. "Women Who Remain Unmarried." *The Ladies' Repository* 21 (January 1861): 7-11.

Durand, John. "Woman's Position in Art." *The Crayon* 8 (February 1861): 25-28.

"Woman in America." *The Eclectic Magazine* 68 (June 1867): 678-86.

Brewster, Anne. "American Artists in Rome." *Lippincott's Monthly Magazine* 3 (February 1869): 196-99.

Russell, J. Scott. "What Should Women Study?" *Appleton's Journal of Popular Literature, Science, and Art* 1 (May 29, 1869): 276-77.

"John Stuart Mill on the 'Subjection of Women.'" *Appleton's Journal of Popular Literature, Science, and Art* 1 (June 19, 1869): 372-73.

"Art-Work for Women." *The Art-Journal* 23 (March 1872): 65-66; (April 1872): 102-3; (May 1872): 129-31.

Hamerton, P[hilip] G[ilbert]. "Mr. Ruskin on Etching." *The Portfolio* 5 (February 1874): 25-29.

"The Great Exhibition: What Women Have Done for It." *The New York Times*, June 4, 1876, 1.

[Brownell, William C.] "The Art Schools of Philadelphia." *Scribner's Monthly* 18 (September 1879): 737-50.

"Some Lady Artists of New York." *The Art Amateur* 3 (July 1880): 27-29.

Wright, Margaret Bertha. "Art Student Life in Paris." *The Art Amateur* 3 (September 1880): 70-71.

"The Exhibitions. III. Second Annual Exhibition of the Philadelphia Society of Artists." *American Art Review* 2, pt. 1 (1881): 103.

"Exhibitions and Sales. Philadelphia." *American Art Review* 2, pt. 2 (1881): 41.

Natt, Phebe [Phoebe] D. "Paris Art Schools." *Lippincott's Monthly Magazine* 27 (March 1881): 269-76.

"Art Instruction for Women." *The Art Amateur* 5 (October 1881): 110.

"The Etching Club's Exhibition." *The Art Amateur* 6 (March 1882): 70.

Elliott, Charles W. "Woman's Work and Woman's Wages." *The North American Review* 135 (August 1882): 146-61.

Champney, Lizzie W. "In the Street of the Little Augustines." *Our Continent* 2 (August 9, 1882): 134-40.

Miller, L[eslie] W. "An Art for Enthusiasts." *Our Continent* 3 (January 24, 1883): 97-112; (January 31, 1883): 137-41.

Sigma [Earl Shinn]. "Art in Philadelphia; Exhibitions of the Society of Artists and the Society of Etchers. *The Art Amateur* 8 (February 1883): 60.

Van Rensselaer, M[ariana] G[riswold]. "American Etchers." *The Century Magazine* 25 (February 1883): 483-99.

"The Etching Club's Exhibition." *The Art Amateur* 8 (March 1883): 82.

"Pictures by American Women in the Paris Salon." *The Art Amateur* 9 (August 1883): 46.

Bates, Will O. "Art in the West." *The Continent* 4 (September 19, 1883): 353-62.

"Exhibition of the New York Etching Club." *The Art Amateur* 10 (March 1884): 82.

Scott, Leader [Mrs. Lucy E. Barnes Baxter]. "Women at Work: Their Function in Art." *The Magazine of Art* 7 (1885): 98-99.

"Our Female Artists; Fair Hands under whose touch the Canvas Glows and Lives; Mrs. Greatorex's Contributions to History and Mrs. Nicholl's Venetian Genius–Miss Bertha Von Hillern, Pedestrienne and Artist–Brilliant Miss Becket and Impressionistic Miss Cassatt." *The World*, March 15, 1885, 4.

Nobill, M. Riccardo. "The Académie Julian." *Cosmopolitan Magazine* 8 (May 1886): 741-52.

"The Fine Arts: The Water-Colorists and the Etchers." *The Critic* 7 (February 5, 1887): 69.

Greta. "The Etching Club Exhibition." *The Art Amateur* 16 (March 1887): 76.

————. "Etchings in Boston." *The Art Amateur* 16 (March 1887): 76.

"Landscapes and Portraits; The Grand Spring Display at the Academy of Fine Arts." *Philadelphia Inquirer*, March 10, 1887, 6.

"New Prints." *The Art Amateur* 16 (April 1887): 199.

"The Fine Arts: Art Notes." *The Critic* 11 (October 1, 1887): 167.

"American Women Etchers; Exhibition of Their Work at the Museum of Fine Arts." *Boston Transcript*, November 4, 1887, 3.

"Art Notes." *The Critic* 11 (November 5, 1887): 233.

"The Fine Arts: The New York Etching Club." *The Critic* 12 (February 11, 1888): 71.

"The Fine Arts: Art Notes." *The Critic* 12 (March 31, 1888): 158.

"The Fine Arts: Women Etchers at the Union League." *The Critic* 12 (April 21, 1888): 195.

"Artistic Professions for Women." *All the Year* 43 (September 29, 1888): 296-300.

"The Society of American Etchers." *The Critic* 13 (November 24, 1888): 261.

Greta. "Art in Boston." *The Art Amateur* 20 (January 1889): 28.

"Exhibitions by Artist Etchers." *The Art Amateur* 6 (March 1889): 70.

"Exhibitions by Artist Etchers." *The Art Amateur* 20 (April 1889): 118.

Campbell, Helen. "Certain Forms of Woman's Work for Women." *The Century Magazine* 38 (June 1889): 217-29.

"The Print Publishers." *The Collector* 1 (November 15, 1889): 15.

"The Artist and the Etcher." *The Collector* 1 (March 1, 1890): 66.

"The Print Sellers." *The Collector* 1 (March 15, 1890): 76.

Haden, Sir Francis Seymour. "The Art of the Painter-Etcher." *19th Century* 28 (May 1890): 756-65.

Peterson, Alice Fessenden. "American Art Students in Paris." *New England Magazine* 2 (August 1890): 669-76.

[Lowndes], Marie Adelaide Belloc. "Lady Artists in Paris." *Murray's Magazine* 8 (September 1890): 376-84.

Ferrero, William. "Woman's Sphere in Art." *New Review* 9 (1892): 554-60.

"The Art Student in Paris." *The Art Amateur* 27 (June 1892): 10.

White, Frank Linstow. "Younger American Women in Art." *Frank Leslie's Popular Monthly* 33 (June 1892): 538-44.

Carter, Susan N. "Women in the Field of Art-Work." *The North American Review* 155 (September 1892): 381-84.

White, Frank Linstow. "Our Women in Art." *The Independent* 44 (August 25, 1892): 7; (September 1, 1892): 6-7.

Hooper, Lucy H. "Art Schools of Paris." *Cosmopolitan Magazine* 13 (November 1892): 59-62.

"Women's Art Exhibition in Paris." *Fortnightly Review* 58 (November 1892): 628-37.

Miller, Florence Fenwick. "Art in the Woman's Section of the Chicago Exhibition." *The Art-Journal* 89 (1893): xiii-xvi.

"The World's Fair: Pictures Accepted in Philadelphia." *The Art Amateur* 28 (March 1893): 117.

Champney, Elizabeth W. "Woman in Art." *The Quarterly Illustrator* 2 (January-March 1894): 111-24.

Smillie, James D. "Etching and Painter-Etching." *The Quarterly Illustrator* 2 (July 1894): 260-63.

Cook, Clarence. "Art-Schools and Art-Missionaries." *The Monthly Illustrator* 4 (April 1895): 81-88.

Dillaye, Blanche. "Women Etchers." *Philadelphia Press*, November 27, 1895, Women's Edition, 17.

Pennypacker, Sarah C. "Paris Art Schools." *Philadelphia Press*, November 27, 1895, Women's Edition, 17.

"Paris Art Schools." *Harper's Weekly* 39 (November 30, 1895): 1145.

Alliger, Lila Graham. "For the Girl with Aspirations Towards Art." *Outlook* 54 (September 5, 1896): 432.

Jarvis, Stinson. "The Truly Artistic Woman." *Arena* 18 (1897): 813-19.

Wheeler, Candace. "Art Education for Women." *Outlook* 55 (January 2, 1897): 81-87.

Carlyle, Florence. "American Art Student in Paris." *Citizen* 4 (June 1898): 75.

M., D. S. "Women Artists." *The Saturday Review* 87 (February 4, 1899): 138-39.

Merritt, Anna Lea. "A Letter to Artists: Especially Women Artists." *Lippincott's Monthly Magazine* 65 (March 1900): 463-69.

Brinton, Christian. "Queen Victoria as an Etcher." *The Critic* 36 (June 1900): 501-10; 37 (July 1900): 2, 34-43.

DeForest, Katharine. "Art Student Life in Paris." *Harper's Bazar* 33 (July 7, 1900): 628-32.

Randall, E. A. "Artistic Impulse in Man and Woman." *Arena* 24 (October 1900): 413-20.

Two Brothers. "Art and the Woman." *Macmillan's Magazine* 83 (November 1900): 29-34.

Rowland, Geraldine. "The Study of Art in Paris." *Harper's Bazar* 36 (September 1902): 756-61.

Holland, Clive. "Lady Art Students' Life in Paris." *International Studio* 30 (January 1904): 225-33.

Weitenkampf, Frank. "Special Collections in American Libraries: The S. P. Avery Collection of Prints and Art Books in the New York Public Library." *The Library Journal* 29 (March 1904): 117-19.

Morris, Harrison S. "Philadelphia's Contribution to American Art." *The Century Magazine* 69 (March 1905): 714-33.

Edgerton, Giles [Mary Fanton Roberts]. "Is There a Sex Distinction in Art? The Attitude of the Critic Towards Women's Exhibits." *The Craftsman* 14 (June 1908): 239-51.

Weitenkampf, Frank. "Some Women Etchers." *Scribner's Monthly* 46 (December 1909): 731-39.

Campbell, Jane. "Plastic Club's Part in Nurturing City's Art." *The Philadelphia Record*, October 9, 1910, 2-3.

Brinton, Christian. "Women Painters of America." *Woman's Home Companion* 38 (October 1911): 18-19.

Beaux, Cecilia. "Why the Girl Art Student Fails." *Harper's Bazar* 47 (May 1913): 221.

"Art Schools for Girls." *Literary Digest* 46 (May 3, 1913): 1010-11.

Hoeber, Arthur. "Famous American Women Painters." *The Mentor* 2 (March 16, 1914): 1-11.

Weitenkampf, Frank. "Appreciation of Etching." *The Century Magazine* 95 (February 1918): 572-81.

McCabe, Lida Rose. "Some Painters who Happen to be Women." *The Art World* 3 (March 1918): 488-93.

Pennell, Elizabeth Robbins. "Art and Women." *Nation* 106 (June 1, 1918): 663-64.

Cary, Elizabeth Luther. "The Morning of American Etching." *Parnassus* 4 (March 1932): 5-7.

Pearson, Ralph M. "A Modern Viewpoint: Women as Artists." *Art Digest* 21 (May 15, 1947): 23.

Fern, Alan. "A Half Century of American Printmaking: 1875-1925." *Artist's Proof* 3 (Fall-Winter 1963-64): 14-25.

Welter, Barbara. "The Cult of True Womanhood: 1820-1860." *American Quarterly* 18 (Summer 1966): 151-75.

Breitenbach, Edgar. "American Graphics and Painting in the Late Nineteenth Century; Graphic Arts." *Archives of American Art Journal* 9 (1969): 1-11.

Welter, Barbara. "The Merchant's Daughter: A Tale from Life." *The New England Quarterly* 42 (March 1969): 3-22.

Lerner, Gerda. "The Lady and the Mill Girl." *American Studies* 10 (Spring 1969): 5-15.

Nochlin, Linda. "Why Have There Been No Great Women Artists?" *Art News* 69 (January 1971): 22-49.

Lerner, Gerda. "Women's Rights and American Feminism." *American Scholar* 40 (Spring 1971): 40-237.

Novak, Barbara. "Americans in Italy: Arcady Revisited." *Art in America* 61 (January-February 1973): 56-79.

Miller, E. Jo. "America's Forgotten Printmakers." *Print Collector's Newsletter* 4 (March-April 1973): 1-4.

Lippard, Lucy. "Why Separate Women's Art?" *Art and Artists* 8 (October 1973): 8-9.

Burstyn, Joan N. "Catharine Beecher and the Education of American Women." *New England Quarterly* 43 (1974): 386-403.

Smith-Rosenberg, Carroll. "The Female World of Love and Ritual: Relations Between Women in Nineteenth-Century America." *Signs* 1 (1975-1976): 1-30.

Paine, Judith. "The Women's Pavilion of 1876." *Feminist Art Journal* 4 (Winter 1975-76): 5-12.

Brodsky, Judith. "Some Notes on Women Printmakers." *Art Journal* 35 (Summer 1976): 374-77.

Garrard, Mary D. "Of Men, Women and Art: Some Historical Reflections." *Art Journal* 35 (Summer 1976): 324-29.

White, Barbara Erlich. "1974 Perspective: Why Women's Studies in Art and Art History?" *Art Journal* 35 (Summer 1976): 340-44.

Withers, Josephine. "Artistic Women and Women Artists." *Art Journal* 35 (Summer 1976): 330-36.

Bloch, E. Maurice. "American Watercolors." *Architectural Digest* 34 (April 1977): 82-85; 140-41.

Mandel, Patricia C. F. "A Look at the New York Etching Club." *Imprint* 4 (April 1979): 31-35.

Brodsky, Judith K. "Rediscovering Women Printmakers: 1550 to 1850." *CounterPROOF* 1 (Summer 1979): 1, 3-9, 12-13.

Graham, Julie. "American Women Artists' Groups: 1867-1930." *Woman's Art Journal* 1 (Spring/Summer 1980): 7-12.

Ferber, Linda. "Forgotten American Artists." *Art News* 79 (December 1980): 71.

Hoppin, Martha J. "Women Artists in Boston, 1870-1900: The Pupils of William Morris Hunt." *The American Art Journal* 13 (Winter 1981): 17-46.

Zimmerer, Kathy. "A Century of Women Artists at Cragsmoor." *Women Artists News* 7 (April-May 1981): 9-10.

Havice, Christine. "In A Class By Herself: 19th Century Images of the Woman Artist as Student." *Woman's Art Journal* 2 (Spring/Summer 1981): 35-40.

Wein, Jo Ann. "The Parisian Training of American Women Artists." *Woman's Art Journal* 2 (Spring/Summer 1981): 41-44.

Nunn, Pamela Gerrish. "Ruskin's Patronage of Women Artists." *Woman's Art Journal* 2 (Fall 1981/Winter 1982): 8-13.

Radycki, J. Diane. "The Life of Lady Art Students: Changing Art Education at the Turn of the Century." *Art Journal* 42 (Spring 1982): 9-13.

Schneider, Rona. "The American Etching Revival. Its French Sources and Early Years." *The American Art Journal* 14 (Autumn 1982): 40-65.

Peet, Phyllis. "Emily Sartain: America's First Woman Mezzotint Engraver." *Imprint* 9 (Autumn 1984): 19-26.

Esko, Claudia T. "The Influence of Whistler on American Painter-Etchers." *Imprint* 10 (Autumn 1985): 12-20.

Goodman, Ellen. "Emily Sartain: Her Career." *Arts Magazine* 61 (May 1987): 61-65.